BONE MUSIC

BONE MUSIC
WRITTEN BY STEPHEN COATES.

FIRST PUBLISHED BY STRANGE ATTRACTOR PRESS
IN 2022, IN AN UNLIMITED PAPERBACK EDITION
AND LIMITED HARDBACK EDITION.

TEXT © STEPHEN COATES 2022
ORIGINAL PHOTOGRAPHS BY PAUL HEARTFIELD.
DESIGN BY TIHANA SARE, LETTERFORMAGIC.COM.

ISBN: 9781913689476

DISTRIBUTED BY THE MIT PRESS, CAMBRIDGE,
MASSACHUSETTS. AND LONDON, ENGLAND.

PRINTED AND BOUND IN ESTONIA BY
TALLINNA RAAMATUTRÜKIKODA.

STRANGE ATTRACTOR PRESS
BM SAP, LONDON, WC1N 3XX UK,
WWW.STRANGEATTRACTOR.CO.UK

AUTHOR'S NOTE

AS THIS BOOK WENT TO PRINT, RUSSIA INVADED UKRAINE, BRINGING MASS TERROR, STATE-SPONSORED MURDER, AND THE LIKELIHOOD OF A NEW COLD WAR, BACK TO EUROPE.

CENSORSHIP, EVER-PRESENT TO DIFFERENT DEGREES IN MODERN RUSSIA, HAS MADE A SWIFT AND BRUTAL RETURN TO PRE-PERESTROIKA, ORWELLIAN, LEVELS. JOURNALISTS FACE 15 YEARS IN PRISON FOR PUBLISHING 'FAKE NEWS'; PEACEFUL PROTESTORS CARRYING 'NO WAR' SIGNS FACE IMMEDIATE 20 DAYS DETENTION. LIBERAL RADIO STATIONS HAVE BEEN TAKEN OFF AIR, AND ON LINE ACCESS TO ALTERNATIVE MEDIA SOURCES HAS BEEN RESTRICTED. THE VERY WORD 'WAR' HAS BEEN BANNED IN REFERENCE TO THE INVASION.

WHILE SINGLING OUT SPECIFIC GENRES OF MUSIC AS FORBIDDEN IS PROBABLY NOW IMPOSSIBLE — AND WOULD LIKELY BE REGARDED AS UNNECESSARY — IT WILL BE NO SURPRISE IF SONGS WITH PERCEIVED ANTI-WAR SENTIMENTS ARE CENSORED. IT REMAINS TO BE SEEN WHETHER SUCH CULTURAL REPRESSION CAN BE MAINTAINED, ESPECIALLY AMONGST THE GENERATIONS OF POST-SOVIET YOUTH WHO HAVE GROWN UP WITH INTERNET ACCESS AND OTHER RELATIVE FREEDOMS, BUT THE STORY OF BONE MUSIC SUGGESTS THAT IT WILL NOT.

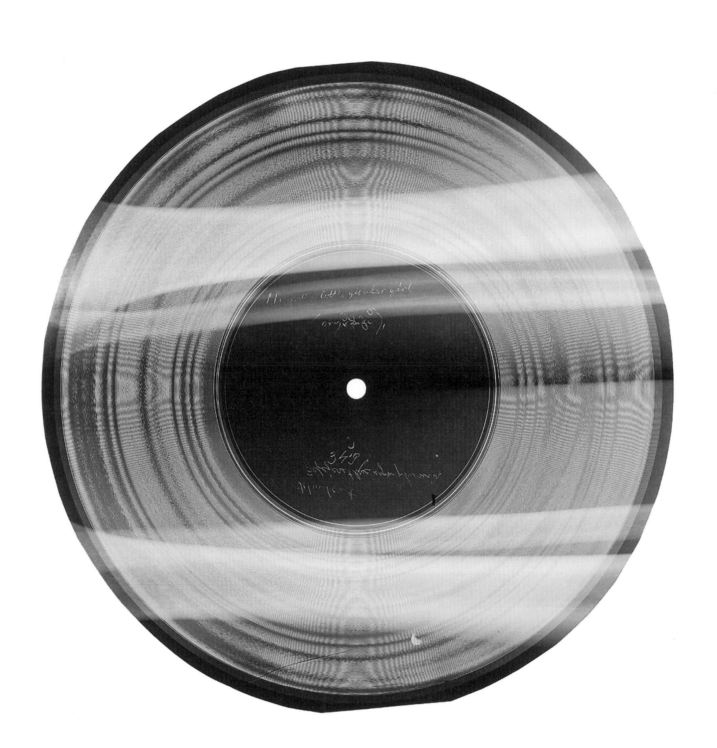

FOREWORD

X-RAYING THE USSR

Sometimes the most enigmatic things that have grown into romantic myths or gained a cult following were born of simple practical necessity.

This is the case with the mysterious 'records on the bones' that were illegally distributed in the USSR from the late forties to the early sixties (in God knows what quantities: as far as I know, there were not even approximate attempts to estimate the scale of the underground operation). Now, thanks to Stephen Coates and his partners in investigation, the long-forgotten story of x-ray music has been given a second life and may receive a well deserved continuation – not as a part of the music industry but just as part of history.

The pre-history of the phenomenon started during the second world war when the USSR, the USA and Britain were, surprisingly enough, allies in their struggle against the Nazis. As a part of the western (predominantly American) support to the USSR, besides fighter planes, tanks and army trucks, there was the 'soft power' package of clothes, movies and records. Not surprisingly, glamorous stuff, like the film *Sun Valley Serenade* and the Glenn Miller Orchestra discs, became enormously popular with desperate post-war Soviet youngsters. But, in 1948, history made another turn and a much colder war broke out. Among its many consequences, was a complete ban on contemporary western culture, including, of course, 'decadent' and 'ideologically harmful' pop and jazz music. The taboo was severe – all Soviet jazz orchestras were disbanded (apart from perhaps the one in a gulag, led by the convict bandleader Eddie Rosner), all 'bourgeois' music vanished from the airwaves, and the saxophone, now considered a dangerous instrument, was strictly forbidden to be played.

Most Soviet youngsters compromised themselves and bent to the new rules for the sake of their careers and well-being, but there was a small community of cultural dissidents who did not want the party to stop. They were called the 'stilyagi'. They were often big city kids, mostly from the intelligentsia or from elite families and were similar in some ways to another hedonist anti-totalitarian subculture of the 20th century – the 'Swingjugend' of 1930s Nazi Germany. Anti-Soviet resistance and politics in general weren't on their agenda; they were about having fun and being cool, and their life was based around three things: music, dancing and dressing up. They listened to jazz, danced boogie-woogie, and looked something like Teddy Boys – with long chequered jackets, tight pants, flamboyant shirts, cravats and greased up hair. And it was the stilyagi who were one of the main producers and consumers of x-ray records (to learn more about the rise and fall of their movement, you may check my books *Back in the USSR: The True Story of Rock in Russia* and *Subkultura*, and see Valery Todorovsky's brilliant movie *Stilyagi*).

The problem was, of course, that highly desirable dance tunes and popular songs were not available at official places – not at record stores, not on the radio and not at live events. Young Soviet jet-setters nicknamed 'The Golden Youth', the children of Communist Party bosses, diplomats, artistic celebrities and the like, had access to the real thing, smuggled western vinyl records, but the huge majority of desperate music lovers in the USSR couldn't afford those. Hence the invention of the x-ray record, the unique and glorious hero of this book.

Stephen Coates – strangely, an Englishman – is now undoubtedly the world's leading expert on this subject, knowing more technical and biographical details of the Bone records story than anyone else. Therefore I won't act as a spoiler and will simply let you dive deep into the parallel reality of the past, where x-ray plates with broken bones were loved for producing divine sounds.

ARTEMYI TROITSKY, PRAGUE 2021

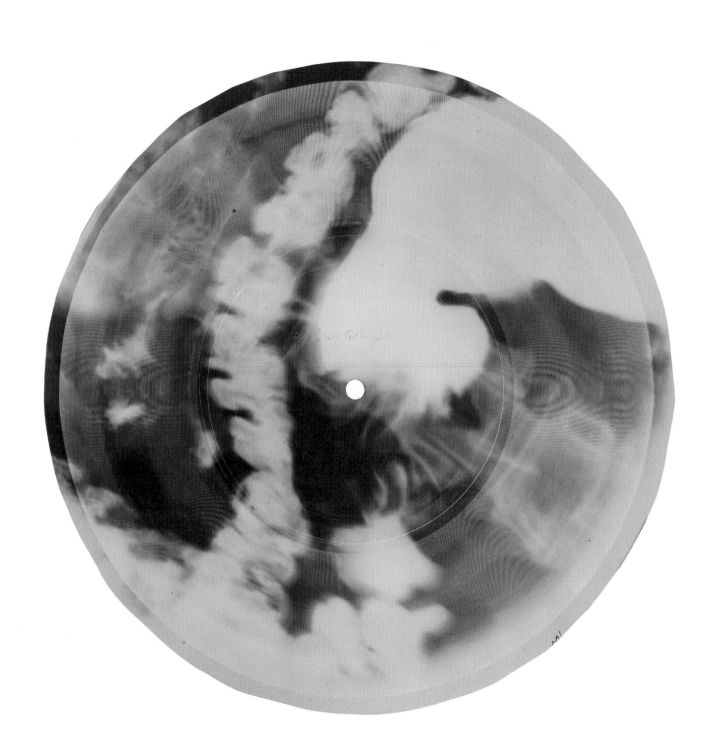

PREFACE

X-Ray Audio: The Strange Story of Soviet Music on the Bone was published by Strange Attractor in 2015. At that time I had been researching the history of x-ray records for about three years. We had no idea then how much interest the story would generate, but the research evolved into an online archive, an international exhibition, a film and a BBC radio documentary. I gave a TED talk and we held many live events, telling the story of the Soviet bootleggers and demonstrating how to cut a live performance to x-ray. We made Bone records of all sorts of artists, including Marc Almond, Jónsi, Thurston Moore, Massive Attack and even Noam Chomsky.

All this is testament to the power of Bone Music.

Bone Music is the successor to *X-Ray Audio* – and it's overdue. I didn't want to just publish a revised edition of the earlier book. In the last few years, I have carried out more research, found more records, conducted many more interviews and gained a better understanding of a culture that was layered with ambiguities and contradictions.

Here then are the stories of (among others) Stanislaw Philon, Boris Taigin, Ruslan Bogoslovsky, Mikhail Farafanov, Rudy Fuchs, Aleksei Kozlov, Nick Markovitch and Kolya Vasin, which is to say of bootleggers and black-market dealers, of underground engineers, musicians and music fans. In this book we see how the technology of the recording lathe intertwines, via the x-ray record, with the histories of the 'Talking Letter' and the flexi-disc, and how Bone records emerged in non-communist Hungary probably before they did in the USSR. We learn something of the troubled histories of jazz and rock'n'roll in the Soviet Union, of the frowned-on foreign dance styles, the forbidden émigré artists and Russian underground songs – and about the role in all this of that officially despised Soviet youth culture known as the 'stilyagi': the '*followers of fashion*'.

As there are only a few official documents about the x-ray underground, this is largely an oral history: we learned much of what we know directly from the people who lived it. They have seen great changes and collecting their testimony felt rather urgent: many of those who bought and sold Bone Music are dead, and those who survive are elderly. Attila Csànyi died in 2016 shortly after we interviewed him. Kolya Vasin died in 2019, apparently committing suicide in St Petersburg (Leningrad as it was known pre-perestroika). Others have grown sick and are less able to pass on their recollections.

Off to one side, the Hungarian x-ray narrative, previously just a footnote, has now been significantly expanded. In various forgotten archives in Budapest we discovered what are probably the world's most extensive collections of x-ray discs, and also learned more about the technique of cutting them – from the writings of the man who literally wrote the manual, István Makai.

Experimenting with that technique over the last few years has been part of the learning process. People, especially young people, love to witness the process of live music being cut onto an x-ray – there is something visceral about it in our digital age, something wonderfully alchemical. Understanding its complexities can only add to the admiration felt for those who practiced it in difficult and often dangerous circumstances.

Perhaps there will be more discoveries about Bone Music. It is no longer the half-hidden history that it formerly was, largely because of the generosity of those who have shared their knowledge and stories. They are stories of human endeavour and of ingenuity as resistance in a time of repression, but also stories of how much music can matter, all held within these wonderfully weird discs with their ghostly skeletal images.

STEPHEN COATES, LONDON, 2022

THEY ARE GHOSTLY IMAGES OF PAIN AND DAMAGE
INSCRIBED WITH THE SOUNDS OF FORBIDDEN
PLEASURE; FRAGILE PHOTOGRAPHS OF THE INTERIORS
OF SOVIET CITIZENS LAYERED WITH THE MUSIC
THEY SECRETLY LOVED; SKIN-THIN SLIVERS OF NON-
CONFORMITY SOAKED WITH DIY PUNK SPIRIT SOLD ON
SHADOWY CORNERS AND IN DARK ALLEYWAYS...

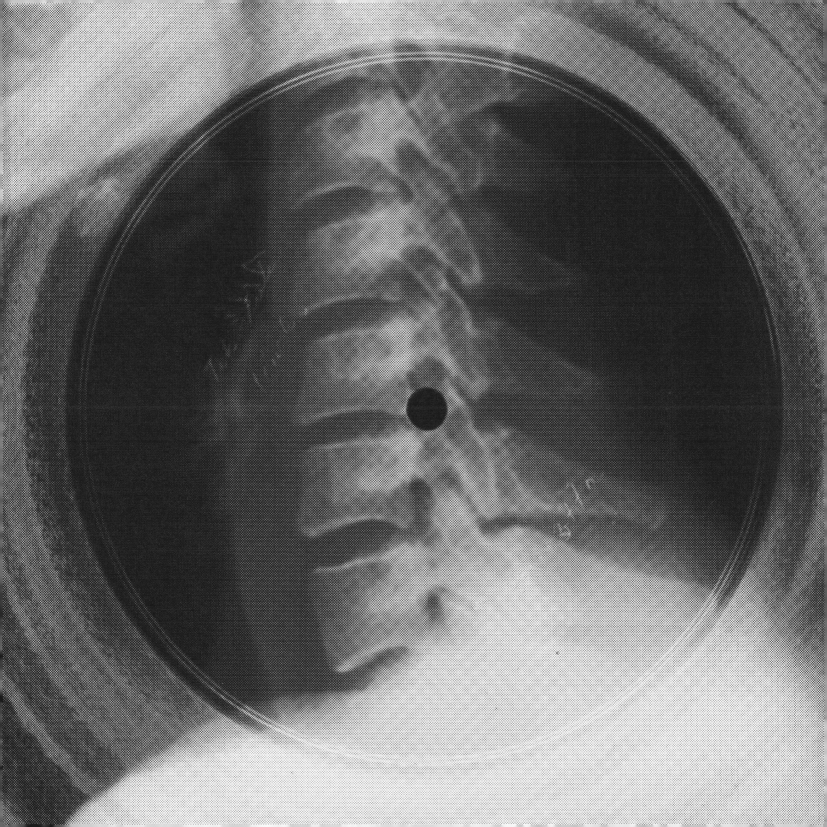

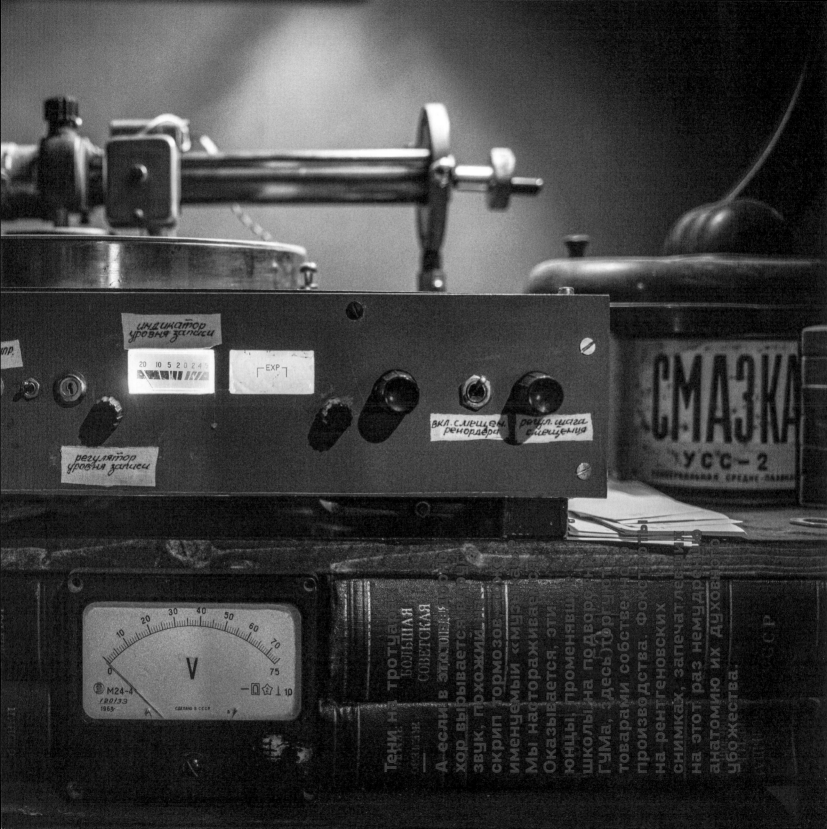

ROENTGENIZDAT: AN INTRODUCTION

A few years ago, while wandering in a market in St Petersburg, I came across a strange disc, somewhat like a scruffy vinyl record. My Russian companions were as baffled by it as I was and the old guy who ran the stall was much more interested in selling me some touristy swag. But I bought it anyway and brought it back to London. When I tried to play it, I discovered it was single-sided, recorded at 78rpm, and contained the 1954 song 'Rock Around the Clock' by Bill Haley and the Comets. But the most remarkable thing was that, when held up to the light, it revealed the image of two skeletal hands. It was a record made on an x-ray.

I knew immediately that I had to find out more: who made it, why they made it, and how they made it. Seeking the answers to those questions became a quest, a journey of discovery into a lost world, in which cold war politics, cultural censorship, bootleg technology and repurposing all coalesced around the irrepressible human love of music.

From about 1946-64, years when culture in the Soviet Union was subject to a censor and when the recording industry was ruthlessly controlled by the state, an underground community of bootleggers defied the authorities by illicitly copying, making and selling records of forbidden songs. Some of them were music lovers, some were entrepreneurial black-marketeers; most were a mixture of the two. They often ran serious risks to feed the appetite of a public hungry for music they actually loved rather than the music they were supposed to love. Remarkably, in the absence of access to conventional means of reproduction and distribution, they were able to build their own recording machines and repurpose a unique form of media: x-ray film clandestinely obtained from hospitals and cut into discs.

Onto the surface of such film, forbidden songs were scratched over images of the human skeleton ('*muzyka na rëbrakh*' and '*muzyka na kost'iakh*' as Russians termed the phenomenon, meaning '*music on ribs*' and '*music on bones*'). Each was a one-off – the image was always unique, and the sound was always different because each copy of each song was cut individually. But they weren't 'editions of one' to be regarded or treated as precious artefacts – sure, the '*Bone Music*' they carried was rare, but the discs themselves were ephemeral, cheap to buy and deteriorated each time they were played. The audio quality was often terrible, but that didn't really matter – for they evoked what people desired and, as we will see, could be transformational for those who listened to them.

The emergence of this underground x-ray record phenomenon was a direct response to cultural repression – to prohibition, to ideological and economic control. The reasons behind these restrictions were complex. Musical censorship in the Soviet Union stretched right back to the Revolutions of 1917 and 1918 – and in fact had existed in the Tsarist era they overthrew. There is no easy route through its baffling labyrinthine history. Styles, rhythms, songs, artists, dances, even instruments, came in and out of official sanction. Exceptions were made and then rescinded. Records of popular stars once sold in every music store were taken out of circulation when those stars became forbidden; singers might suddenly be allowed only to perform a fraction of their repertoire, or to perform but not record. Quotas were issued for how much foreign or dance music could be played on the radio or at social events, and then were continually revised. Frequently, western popular music was completely banned but certain forbidden

LEFT **HOME-MADE SOVIET LATHE, C.1960**

genres might sneak past the censor if presented as parodies, or when performed in films by villains. Composers were sometimes lauded and sometimes excoriated. The prohibitions and the contradictions went on and on and on. But what was guiding it all? Culture was not repressed *per se* in the Soviet Union – and the belief that the arts under the communist system were rendered valueless by repression was a distortion of western cold war propaganda. Even in the worst years of Stalinist oppression, culture in general was highly valued, and much work that was officially sanctioned was of a very high standard. At some level at least, the censor operated as a guarantee of quality, and artists often become more creative when working under limitations. Despite this, the Soviet composers who worked within the system, enthusiastically or otherwise, often remain ignored in the west – including greats such as Isaak Dunayevsky or Nikita Bogoslovsky whose beautiful songs were often popular with refuseniks and apparatchiks alike.

But when it came to popular culture, much of the official music aimed at the masses was not what the masses actually wanted. It seems unlikely that the 1946 sports song '*You Should be Healthy and Take Care of Yourself*' or the 1960s Pioneer song '*Let's Start the Morning Exercise*', would inspire many young people. The production of all songs was entirely controlled: members of the composers' union wrote the music, members of the writers' union supplied the lyrics and a singer was recruited along with a session band to record them at the studio. Personality and individuality were eliminated: in the late 1940s-50s there were no popular stars, there was no place for them in the shadow cast by Stalin's personality cult.

It had not always been so restrictive. Experimentation was actively encouraged in the early 1920s; there were developments in Soviet music at least as radical as any in the west. If new music was deliberately to be made

ABOVE ARSENII AVRAAMOV CONDUCTING 'SYMPHONY OF THE HOOTERS', 1921

for a post revolutionary society, there was a curiosity about how that might express itself, and an openness to the musical forms that could provide the radical soundtrack to a radical new culture. Soviet composers worked with atonal and machine music, fashioning complex abstract pieces using innovative electronic devices. Arsenii Avraamov's acclaimed *Symphony of the Hooters* of 1922 combined factory whistles, sirens, fog horns and artillery volleys with a massed band and choir. Several new electronic instruments were invented around this time, among them Lev Termen's 'thereminvox' (often just known as the 'theremin', after the westernisation of Termen's name). In 1922, the theremin had received Lenin's personal seal of approval and though ironically, it was subsequently abandoned by the Soviets, its signature sound became a cliché of cold war era American sci-fi and horror movies.

Theremin was later to be imprisoned – one of the many musical tragedies of the Soviet era is that the innovators and modernists, at first encouraged, became increasingly marginalised or threatened. Where the authorities initially claimed, publicly at least, to approve of individual expression, they often also hinted at the restrictions to come:

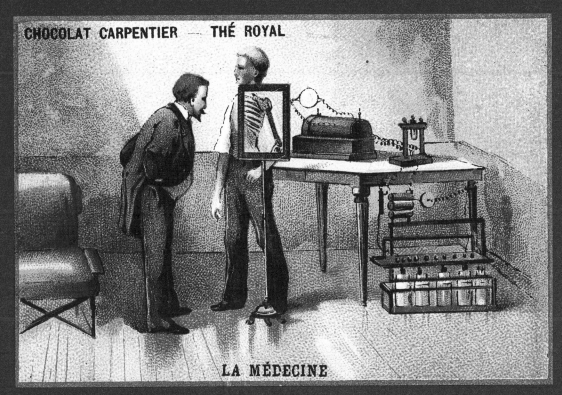

ABOVE CHROMOLITHOGRAPH OF WILHELM CONRAD ROENTGEN LOOKING INTO AN X-RAY SCREEN

On 8 November 1895 Wilhelm Conrad Roentgen (27 March 1845 – 10 February 1923), a German mechanical engineer and physicist, accidentally discovered the wavelength range of electromagnetic radiation that he called 'x-rays'. His experiments showed that these rays would pass through many substances, including human soft tissues, but not through more solid objects such as bone, and that the latter left shadows. Some six weeks later he took a photograph, using Kodak film and x-rays, of his wife Anna's hand — a radiograph. When she saw the skeletal image, she allegedly said, 'I have seen my death.'

Roentgen's discovery rapidly transformed medical practice around the world and was used to identify and to produce images of bone fractures, wounds, swallowed objects and a variety of previously hidden phenomena. Specialist x-ray film evolved over the next century, though today it has largely been replaced by digital imaging.

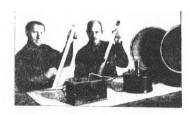

Дешевые „терменвоксы"

В. Ф. Орлов и А. С. Васин

(Радиокружок клуба совторгслужащих Ростова-на-Дону)

Мы сконструировали маленький конкурент «Терменвокса» — музыкальный инструмент, названный нами «Электрофон».

В основу прибора положена генерационная лампы на низкой частоте. Нужны следующие детали:

Трансформатор низкой частоты обыкновенный, междуламповый, включен следующим образом:

1-я обмотка «Н» — анод лампы, «К» — телефон.

2-я обмотка «Н» — прерыватель, «К» — минус накала.

Лампы типа Микро, как наиболее экономные и хорошо работающие в качестве генератора.

Реостат в 25-омов нами введен специально для настройки на определенный тон и подстройки к пианино, так как гриф может быть различен по тонам и игра на аппарате с предварительной подстройкой значительно облегчается.

Блокировочный конденсатор для изменения тембра состоит из группы конденсаторов, включаемых переключателем (емкость от 20 до 100.000 см).

Кроме этого, надо сделать еще прерыватель (типа педали или кнопки на грифе) для «стокатто», и гриф, состоящий у нас из пластинки красной меди и струны из хромоникелина, сечением 0,1 mm или на никелина сечением 0,1 mm (длина 1 m). Гриф можно сделать и иначе: на столе вбить два гвоздя и между ними натянуть струну из никелина диаметром 0,1 mm. Проволока служит реостатом, для переменного контакта может служить мягкий или жесткий провод. Передвижение его по струне даст нужное изменение высоты тона.

Единственным пока что недостатком прибора является отсутствие возможности регулировать силу звука.

В некоторых случаях для получения устойчивой генерации понадобится заблокировать первичную или вторичную обмотку блокировочным конденсатором.

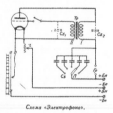

Схема «Электрофона».

емкостью в несколько тысяч сантиметров.

По отзывам наших музыкантов, этот прибор не уступает по чистоте звука «Терменвоксу», в обращении же, конструкции и дешевизне, значительно его превосходит.

Всех товарищей, построивших прибор по нашей конструкции, просим поделиться через печать или с нами непосредственно.

На схему нами получено заявочное свидетельство № 45590.

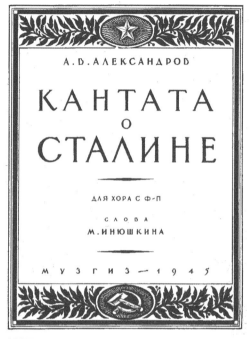

ABOVE 'CANTATA FOR STALIN' MIKHAIL INYUSHKIN, CHORAL SONG SHEET-MUSIC
LEFT 'BUILD YOUR OWN THEREMIN', FROM THE JOURNAL OF RADIO AMATEURS, 1929, NO.9

all culture – be it theatre, film, literature, dance, architecture, painting, poetry, graphic design or music – would be subject to the approval of a censor. Any work, any artist, could be restricted, even forbidden, if not deemed to be in accordance with the ideals of Socialist Realism – by then the regulated cultural expression of Soviet society. Experimental composers and electronic innovators were now condemned as formalist and decadent. Some were driven underground, some were imprisoned and some were shot. The irony was that – despite this hostility to artistic 'élitism' – it was popular culture that would become the most subject to restriction.

It is often difficult to understand what the criteria for the approval of music by the censor actually were. In the end, it seemed that what was acceptable was whatever Stalin and the Soviet ideologues personally liked. According to Rudy Fuchs, a bootlegger and underground record producer in the 1950s-60s, this was mainly Georgian folk songs, straightforward classical music, sentimental movie tunes and idealistic Soviet hymns sung by massed choirs. Dictators – whether of left or right – seem to prefer their music big, predictable and choreographed. They don't like improvisation, they don't like individual expression and they don't like wild exuberance.

One of the genres that suffered most in the Soviet Union was jazz. During the cold war era in particular, first jazz and then rock'n'roll were prohibited outright as

Every artist, everyone who considers himself an artist, has the right to create freely according to his ideal, independently of everything [...] However, we are Communists and we must not stand with folded hands and let chaos develop as it pleases. We must systemically guide this process and form its result.[1]

After Lenin's death in 1924, Stalin dispensed with any ambiguity. As his political control increased, he asserted increasing cultural control. With Alexander Zhdanov as his director of cultural policy, it was decreed in 1932 that

1 | Lenin, quoted in Clara Zetkin's 1924 memoir (collected posthumously in Lenin, *O Kulture i Iskusstve*, On Culture and Art, 1938/1956)

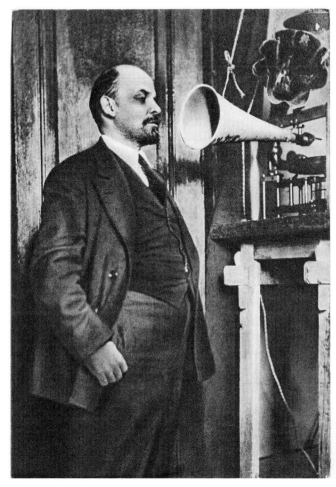

But the x-ray underground wasn't just about jazz, rock'n'roll and Latin music. In fact, most Bone Music was not western at all; it was Russian. Myriad Russian songs that were deeply loved by ordinary people, not just by young western loving malcontents, fell foul of the censor for all kinds of reasons. A whole culture was becoming cut off from its roots, and a pressure began to build, fuelled by an intense desire for all that was forbidden.

Something had to change.

Bone Music is a story of that change, and of the people who were part of it: of those who made, played and paid for bootleg records on x-ray film. We might call these records 'Roentgenizdat', a fabricated word combining 'Roentgen' (the name of the German inventor and the word generally used for x-rays in the Soviet Union), with 'izdat', a stem connoting private publication. Roentgenizdat places Bone Music within a loose family of dissident cultural activity, including the Samizdat private printing of censored writing, the Tamizdat smuggling of literature for publication abroad and the Magnetizdat sharing of proscribed music via tape that succeeded the x-ray record era. There are differences: x-ray records generally contained material that was copied rather than created, their dissidence was at a pop cultural rather than a high cultural level, and it was at least partly entrepreneurial in its opposition to authority. But in a society where the economy was entirely controlled by the state, any unofficial entrepreneurial activity – black marketeering – was itself an anti-establishment activity.

In addition to this cultural role, *Bone Music* is also part of a history of resistance via technical innovation, DIY improvisation and repurposing. Necessity is the mother of invention, and inventiveness – or '*agility*' as Russians might say – was the norm during the Soviet years. From the 1930s, amateur radio magazines would publish articles on how to '*electrify*' balalaikas or grandma's piano, on

aspects of western culture – as were Latin rhythms like the samba, the rumba and the tango, and even the more sedate US-born foxtrot. With the Latin dance tunes, the issue was less their lyrics and country of origin than the fear they might provoke unwholesome sensuality and distracting passions in young Soviets. But the bans did not reduce their desirability, only their availability, and so increased the demand for them from bootleg buyers.

how to build your own theremin and how to improvise a primitive recording device. From the 1940s, young people at technical clubs began adapting their shortwave radios to receive western broadcasts. Some of them even became '*radio hooligans*', setting up little pirate stations at home, taking risks to broadcast to their fellows. In the 1950s, the 'stilyagi' youths began aping western fashions using whatever materials were at hand – including their mothers' curtains. In the 1960s, when electric guitars were unavailable, would-be rockers improvised electric pick-ups by stealing and adapting the innards of public phones (by the end of the decade, it is said that large numbers of Moscow pay phones could no longer be used because their electronics were now powering underground rock music). Musician Yury Pelyushonok constructed a home-made electric bass using strings stolen from his school piano. Home-made amplifiers were made in after-school workshops. In Minsk in the 1970s, rolls of wide computer tape would be stolen and sliced into sections, to be used in reel-to-reel tape recorders.

X-ray records are palimpsests: objects made for one purpose and reused for another; slivers of flexible film compressed with layers of oppression and culture; badges of individuality and non-conformity, made at a time when music mattered enough to risk punishment, even imprisonment.

And of course, that time is not over – there are still places in the world where music is censored or proscribed. In some Islamic countries, it is entirely prohibited. Musicians have been targeted by death squads in Algeria and Afghanistan and sentenced to death for alleged blasphemy in Nigeria; recording studios have been forcibly closed and producers imprisoned for distributing underground music in Iran – all in the recent past.

But thankfully, many of us live in circumstances where music is virtually free – both in terms of its cost and its lack of restrictions. It is hard to imagine being unable to listen to exactly what we want, when we want, with whom we want. Yet, with their ghostly images of skeletal fragments and their scratchy, distant sounds of long dead stars, these strange records can still prompt questions. Along with the abundance, convenience and accessibility we have gained, has something somehow been lost? Is the value of a song the same, when there is no scarcity, no effort, no cost involved in obtaining it? Can music still function as a means of protest or resistance when it cannot be restricted?

And if by some unforeseen cultural shift or radical change of circumstance, all the songs that we love were taken away? What would *we* give, what would we risk, to get them back?

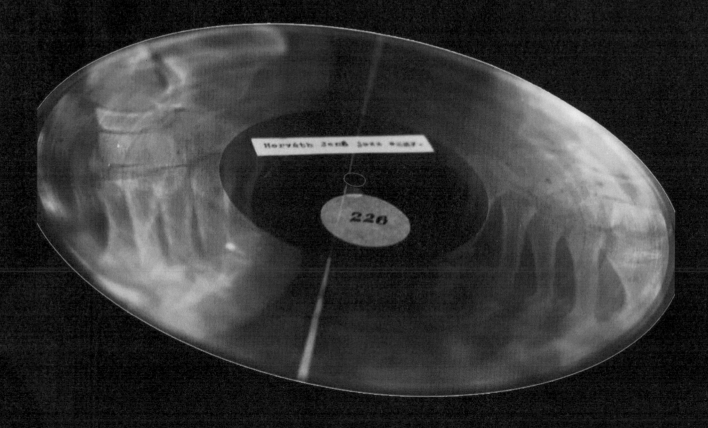

Horváth Jenő jazz ...

226

— Слушай, Женя Горкун, каким же ты видишь мир сквозь узкую прорезь рентгеновского рок-н-ролла? Это тесный и маленький мир теней, воровато озирающихся на людей.

Теней с кличкой "фарцовщики", торгующих поношенным барахлом с иностранными ярлыками. Теней, даже если у них есть имена, как у Геннадия Баранова. А ты, Гена, думаешь, что это и есть жизнь?

Я сейчас... Я сейчас не живу, я только жду сейчас. ЖДУ...

THE SECRET HISTORY OF THE X-RAY RECORD

FROM MALADY TO MELODY

For all their cultural weight, Bone records are flimsy, ephemeral things. They are usually between 15-25 cm in diameter. Nearly all Soviet x-ray discs are single-sided, generally recorded at 78rpm, holding a maximum of three to four minutes of music – frequently just one song. To make them, a circle would be drawn with a compass or around the edge of a plate onto a rectangular x-ray sheet. This was usually cut with scissors so the circumference was often quite crude. Broken hips, shattered knees, arthritic knuckles, dented hands, pierced skulls, and warped rib cages ghost the spiral grooves of the recordings. Nearly everyone was tested for tuberculosis in the Soviet Union in the 1940s-50s, so ribs, sternums and chest cavities often appear. Held up to the light the discs can be startling and beautiful, even when the film has degenerated or when a particular fragment of anatomy cannot be identified. Sometimes there is no image because undeveloped film was used or because the disc was mounted on card for stability.

Records were also cut onto all sorts of other materials, and may have all sorts of strange colours, patterns, pictures and text. But to us there is an eerie peculiarity – a poignancy – about a record with skeletal images. While perhaps less important to their original owners than the music they contained, these images form part of their wonder. It is evident that those who made them often chose where to cut with care – so that for example the spindle hole might appear like a bullet wound or a trepanation scar piercing the centre of a skull. Some have claimed that the preferred method for making the spindle hole was to 'rocket' a cigarette: that is to repeatedly drag on it to get a very hot end and to use this to burn through the centre. However, as early film contained silver nitrate and was flammable, this claim is dubious, and likely an example of a curious 'Bone mythology' that has grown up around the records, like the rumour that it is possible to tell what genre of music a disc contains by whether the image is of a skull, of hands, of ribs and so on. The Soviet discs rarely have labels, but at the centre words are often scrawled or scratched, perhaps a song title, or a genre description – 'foxtrot' or 'tango' – plus occasionally the artist's name. But even when there is text, that isn't necessarily an accurate guide to the music. As time went by, less discerning producers got involved; they may simply not have known the specific details of songs they were copying, while unscrupulous dealers might discreetly write the name of a requested tune or artist on a random record so as to pass it off as the genuine article to a naïve customer.

The records are thin – sometimes so thin that it's hard to believe they could be cut. Grooves were often so shallow that repeated plays quickly wore them out, especially when the wrong sort of needle was used. Many people were still using wind-up gramophones with steel needles in the 1940s and early 1950s, so the discs only lasted a few plays before being torn to shreds. While some can still sound remarkably good, even when freshly made, the audio quality was often marred by hiss, distortions, skips and warping. A disc might have been cut on a poor machine, by unskilled hands or by

19

copying from an existing x-ray record, the sound worsening with each generation. Kolya Vasin, a music-mad kid who often bought Bone Music in the early 1960s, described buying such a record, bringing it home, playing it and finding it was as if *'you had music playing in one ear and someone crunching biscuits in the other.'*

But it didn't seem to really matter. Nick Markovitch – another music-mad kid in the 1950s – brought a beautiful old portable gramophone player to our meeting a couple of years ago, wound it up and put on one of his original records. It sounded terrible. It was almost unlistenable, but Nick was smiling – it was as if the thin ribbon of melody that could just about be discerned through the wall of noise, hiss and crackle was leading him back to his youth, to a time when that song meant so much. Just as with kids today playing music aloud through a mobile phone speaker, it wasn't about the audio fidelity but about the vibe: the association, the thrill of the new or the exotic – and in this case, the forbidden. Nick told us that it was a shock in later years when he heard what the songs he had loved on x-ray sounded like on bona fide records.

It is impossible to know how much Bone Music was produced, let alone the number of buyers – there are no official accounts of such quantities. The laborious one-at-a-time nature of the process must surely have put a cap on quantity, compared with the mass-production methods available for conventional record pressing, and with the home-taping of later years. So claims of millions of discs seem unlikely – but we know that the market expanded far beyond the original cliques of music aficionados in Leningrad and Moscow to include ordinary punters all around the country. Probably hundreds of thousands were made.

Another conundrum is this: are the records that survive representative as to the content of what was originally recorded? Or were the most popular songs the ones played to

destruction? Dead records would generally be thrown away – why keep items that would be incriminating if discovered? Genuine discs turning up today have usually lain forgotten in attics, at the bottom of drawers or hidden in record sleeves; some as obsolete remnants of a long gone era, some perhaps treasured and kept as mementos of lost youth. A few were lovingly customised like pieces of outsider art. One in my collection, a late 50s home-made picture disc, shows Stalin knocking his successor Khrushchev on the head with his tobacco pipe. The scrawled caption in Georgian (Stalin's native tongue) reads : *'Idiot, you fucked it all up!'* A joke, but a risky one even in the more relaxed era following the tyrant's death.

BONELEGS

The word 'bootleg' – while not recognised in the USSR – is probably the best way to describe the Soviet x-ray records. The word derives from the 18th century smugglers' practice of hiding illicit wares in their boots and entered wider use during the Prohibition era in the US, referring to illegally made and sold alcohol. As early as 1929, it was also used with regard to music, when the US magazine *Variety* described a huge market in *'bootleg disc records'*. These were what today would be called *'pirates'* – meaning counterfeit copies of officially available releases sold at a cheaper price. In 1950, jazz magazine *Downbeat* described a widespread business in the US of *'bootlegging'* jazz records. They contained material that was unavailable, either because it was deleted or because it was unsanctioned outtakes and live recordings. Like the later *Basement Tapes* by Dylan or Bowie's *Ziggy's Last Stand*, this kind of illicit release is what we have come to understand as a bootleg record.

The Soviet x-ray discs exist somewhere between pirates and such unsanctioned records. They were usually copies of existing material unavailable in the USSR. Occasionally they were counterfeits of official songs traded because they were

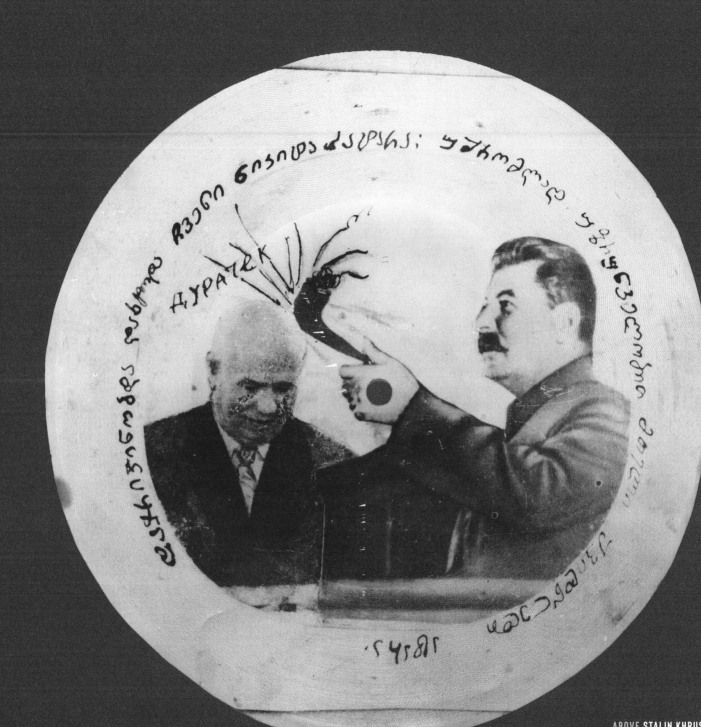

ABOVE **STALIN KHRUSHCHEV**
BONE RECORD, LATE 1950S

cheaper or more easily obtained – but the vast majority were at the least unofficial and usually banned outright. Of course those copied from American and British discs would have been illegal in the west too – for copyright rather than for ideological reasons – but copyright as we know it didn't exist until 1972 in the USSR and there was no intention to pass them off as the genuine article. Quite the reverse: for some at least, part of their appeal was that they were symbols of non-conformity made outside the Soviet system.

REVOLUTIONS IN BONE

But why did Bone Music need to exist? Why was popular music forbidden at all? With jazz, and the rock'n'roll that followed it in the cold war years, the easy answer is that they were the product of the enemy. But the history of jazz in the USSR is complex; for decades, prohibitions waxed and waned, periods of tolerance were followed by waves of brutal repression, right back to the 1920s.

ABOVE **VALENTIN PARNAKH, EARLY 1920S**

Valentin Parnakh, the Russian Futurist poet who saw Louis Mitchell's Jazz Kings at the Trocadero in Paris 1921, is credited with being the first to introduce jazz to the Soviet Union. In 1922, Parnakh brought various western instruments, including a banjo and a xylophone, to Moscow, to form '*The First Eccentric Orchestra of the Russian Soviet Federated Socialist Republic*', an innovative troupe that performed accompanied by dancers – and without any issue. Immediately after the Revolution, various dance

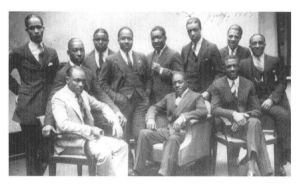

ABOVE **SAM WOODING AND HIS ORCHESTRA, 1925**

styles had been imported to the USSR: the ragtime and the foxtrot from the US, the can-can from France and the tango, originally from Argentina, all became popular. As in the US, these dances had taken hold in immigrant and working class communities, and were then adopted by the bohemian elite as a sophisticated way of thumbing their noses at the establishment. For a while in the USSR, jazzy music was also played by foreign bands – for example, a 1926 touring '*negro operetta*' featuring Sam Wooding and the Chocolate Kiddies caused a sensation with concerts attended by Stalin and Shostakovich. Even homegrown equivalents were looked on favourably and sometimes heard at official congresses.

But it was short-lived. According to historian Richard Stites, the trouble started when dancing became widely popular. As wild Latin or gypsy rhythms got bodies swaying, claims were made that the passions they aroused might distract young people from focusing on the communist cause. In May 1922, at the conference of the Komsomol, the primary, highly political Soviet youth organisation, it was argued that the foreign dances' '*petty bourgeois values*' were poisoning the young, while in 1924 Glavrepertkom (the committee for the regulation of shows and repertoires) initiated a propaganda assault on the foxtrot

as a 'physiological perversion'. The Russian Association of Proletarian Musicians (RAPM) went on to declare that it was '*the dance of slaves, dumb and submissive*' and that the tango was '*built on erotic teasing... the music of the weak, the music of the impotent*'.

How can it be that what to our mind seem innocent pastimes, provoked such intense reaction in the totalitarian mind? Was it really just the fun, the occasional wildness, the exuberance? Perhaps another, more political issue was that where a couple were literally cheek to cheek in a private romantic intimacy, the state and all its ideology were excluded, unimportant, meaningless – an intolerable image in a totalitarian communal society.

Eventually certain dances were banned outright and a pogrom launched to eliminate anti-social elements who were indulging in them. Children from higher class families were arrested and some exiled from Moscow in the 'affair of the foxtrot'. One, the daughter of General Danilov, wrote a poem from the Tyumen prison in 1924, possibly in genuine remorse, but more likely in hope of release:

> *Oh, foxtrot, foxtrot:*
> *All curse you.*
> *You are the reason for our troubles.*
> *We danced our way to this crude prison*
> *And to the worst of accusations.*
> *Oh, foxtrot, foxtrot,*
> *Stronghold of dark powers!*
> *Guaranteed to provoke harsh reactions,*
> *You are a source of counter-revolution,*
> *Its hope and foundation!*
> *Our sad fate is a lesson for everyone*
> *On how to respect the homeland*
> *So if you are asked to dance a foxtrot,*
> *Say: 'Sorry, I don't dance!'*[2]

2 | Sourced by Maksim Kravchinsky

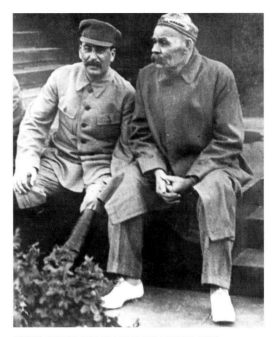

ABOVE **JOSEPH STALIN AND MAXIM GORKY, 1932**

In 1928, the novelist Maxim Gorky, now the leading Soviet ideologue for social realism, would witheringly dismiss jazz as bourgeois music associated with homosexuality and drugs while western popular culture in general was a sign of '*the catastrophe of capitalism*'. There can be no doubt, given the fevered intensity of his writing on the subject, that he *understood* the power of jazz. An official clampdown began and Komsomol youth patrols started to police the dance halls and youth centres to enforce conformity and cut out transgression.

Nevertheless, this type of hysterical repression was often followed by periods of relative tolerance. During 1932-36 (the so-called '*Red Jazz*' age), both western and Soviet style jazz bands became popular in many cities. Band leader Alexander Tsfasman (who was known as 'Bob' and had an American wife) became one of the richer musicians in the USSR while the singer Leonid Utyosov became hugely successful after starring in movies such as 1934's *The Jolly*

Fellows where he scatted jazzy ditties, But from 1936, as the purge of the 'Great Terror' took hold, the official attitude turned vicious.

Many players were beggared and harassed, driven onto the streets, arrested on stage or deported to gulags. It was a desperate time to be a musician who loved jazz. Utyosov and Tsfasman only survived by transforming their sound into inoffensive ballroom styles. The Russian saxophonist Aleksei Kozlov later described how in 1967 he was commissioned to write a piece on Utyosov for the magazine *Sputnik*. By then the old singer was rather forgotten by the younger generation, but Kozlov, for whom he remained a hero, visited his apartment hoping to interview him about jazz. He was cautiously admitted but it seemed that the old traumas had left their scars and that the old fears ran deep. Despite the more liberal climate of the time, Utyosov was suspicious of his visitors, evasive, reading from prepared answers and seemingly anxious not to say the wrong thing.

During World War Two, the tide briefly turned back again, as the US entered the conflict as Russia's ally against the common German enemy. In addition to the vehicles, planes and military equipment provided under the American Lend-Lease scheme, all kinds of other US products appeared in Soviet cities – including films, clothes, songbooks and records. *Sun Valley Serenade* and *George's Dinky Jazz Band* played to packed crowds in cinemas. Swing was heard on the radio and played for soldiers at the front, even at official functions. But again the respite was brief. After Churchill's 1948 Fulton speech and the Soviet response to it triggered the cold war, the ideological stranglehold was reasserted. The US was re-confirmed as public enemy number one, with Britain a close second. Still pursuing Zhdanov's 1946 campaign against cosmopolitanism, Stalin now attempted to scrub every aspect of modern western influence from Soviet life. Severe measures were taken against contemporary western art, style and music. Jazz was again declared decadent, ideologically dangerous, pro-capitalist, and inimical to the values of Soviet people. Formally banned, it abruptly disappeared from broadcasts, cinema, dancehalls and music stores. Improvisation was forbidden, valved trumpets and trumpet mutes were suppressed – and the saxophone, that most harmful of American devices, was proscribed, with the infamous claim that '*it is just one step from a saxophone to a dagger*'. A decree was made that those who had a saxophone must hand it in to a collection point for destruction. Satirical cartoons in magazines like *Krokodil* portrayed '*Capitalists*' as devils with sticks resembling saxophones in shape. It is rumoured that there were attempts to straighten saxes out – to make them more 'Russian', like the clarinet.

After 1948, most of the dancebands playing jazz ceased to exist, or were forced to play a drastically changed repertoire of traditional polkas and waltzes. In a repeat of the previous Terror of the late 1930s, many of the country's best players – like trumpeter 'Eddie' Rosner, the 'Soviet Louis Armstrong' – were arrested and sent to Siberian prison camps. Some died there. Those that survived often did so under the most extraordinary circumstances; perhaps in gulags whose bosses organised musicians to play at their private parties, or sent them on trophy tours to other gulags while their fellows were worked, starved or frozen to death. After he fell from grace and was arrested, the Soviet star Vadim Kozin only avoided such a fate because the gulag boss's wife, Alexandra Gridasova, a fan, picked him out when he arrived at a prison camp in Magadan in 1944.

Soviet jazz did manage to live on – just. Some brave musicians, exiled to remote cities like Kazan for rehabilitation, managed to carry on playing, even occasionally on local radio far from the watchful eyes and ears of central control.

Meanwhile, an invisible battle of the cold war airwaves was raging. In 1948 President Truman authorised a dedicated Russian service on Voice of America (a station that had been part of the Office of War information service) to '*increase mutual understanding between the people of the United States and the people of other countries*' – in other words, to broadcast anti-communist propaganda with news and music. VOA played jazz by black bandleaders and mixed-race players alongside reports of the US civil rights movement, to counter Soviet propaganda portraying the US as a deeply racist state in which black people were downtrodden. At the same time, Radio Free Europe and Radio Liberty (both funded by the CIA until 1972) broadcast the voices of people from inside the eastern bloc to convince Soviet audiences of the cultural superiority and material benefits of life in the west. From 1953, President Eisenhower ramped up the stakes by declaring that '*psychological warfare*' should be employed against the USSR, and include the promotion of art forms like abstract expressionism and jazz – both of which were presented as specifically American expressions of individual freedom. Soviet propaganda tried to respond in kind – a clip from the film *The Mannequin Factory* shows a gorilla making an abstract painting and jazz dancers wildly cavorting, alongside various other foolishnesses and iniquities of capitalism.

But when it came to popular music, this was an asymmetrical battle – while no young people in the west were interested in Russian songs, official or unofficial, the music broadcast on shows like VOA's *Jazz Hour*, presented by Willis Conover, had an eager audience amongst Soviet youth. Despite the huge amounts of money, technology and energy the authorities devoted to jamming the transmission with a howling electronic signal, young jazz fans would tune in via adapted shortwave radios.

But occasional tunes caught on radio were not enough: in all eras, young people everywhere want to listen to what

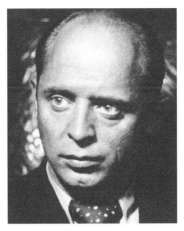

ABOVE VADIM KOZIN PRE-ARREST

VADIM KOZIN WAS NO JAZZ, ÉMIGRÉ OR UNDERGROUND SINGER. HE LIVED IN RUSSIA ALL HIS LIFE AND PERFORMED IN THE KREMLIN FOR THE HIGHEST MEMBERS OF THE INNER PARTY.

He was once as famous in his homeland as Frank Sinatra was in the USA; a star whose records were sold in every Soviet music store, and who for a time was one of the richest private individuals in the Soviet Union.

On 16 May 1944, Kozin was arrested by the NKVD on charges of homosexuality and 'anti-Soviet agitation'. It is likely that the fact of his sexuality (which had been known about since the 1920s) was just used as an excuse to bring him down because he had been in conflict with a high-ranking Soviet official, possibly Beria. Or it may be that he had become too rich, too famous, too well loved. After all, there was only room for one star in the Soviet Union, and that was Stalin. Kozin was dragged from his luxurious, ostentatious lifestyle at the Metropole hotel in Moscow and transferred to the brutal conditions of a far eastern Siberian prison camp. He was arrested for a second time in 1955 after secret police discovered diary entries critical of Soviet food shortages and sentenced to further exile. Even after his release years later, he was unable – or unwilling – to return to Moscow to revisit the scenes of his former glory, He died in 1991 in Magadan at the age of 91. His deeply loved songs and beautiful voice would have been sorely missed when his repertoire was withdrawn after his arrest – making them an ideal candidate for bootlegging.

PYOTR LESHCHENKO'S MUSIC FEATURES ON X-RAY MORE THAN ANY OTHER ARTIST.

He was hugely popular before the war and made many records. His émigré status, lifestyle and passionate performances may have provoked the disapproval of the authorities, but they never diminished his popularity with ordinary people. On the contrary, when his records were played, people would listen and sometimes fall silent. Bootlegger Rudy Fuchs says that Leshchenko's mysterious, otherworldly voice awoke romantic thoughts of some imaginary, happy elsewhere in those who heard it, and as nobody knew much about him, he attained an almost mythical status. His life story was a classic Soviet-era tragedy. Despite being born in 1898 into a Ukrainian peasant family, he was vilified as a 'White' Russian émigré of noble blood, and thus anti-Soviet. A musical child, his star rose through foreign travel and theatrical shows until he became so popular that he was known as the 'King of Russian Tango' and performed for nobility in his own cabaret in Bucharest. As well as tangos, his repertoire contained highly popular gypsy songs, Russian romances and foxtrots. During the war, he was accused of being a Nazi sympathiser and, despite attempting to return to the Soviet Union in 1951, was arrested and sent to a prison camp in communist Romania. His Russian wife Vera was extradited and sent to a hard labour camp for 'marrying a foreigner'. She was released three years later, unaware that he was still alive. He died or was killed shortly afterwards, without them meeting again.

ABOVE PYOTR LESCHENKO ON GOLDEN
DOG GANG BOOTLEG DISC C.1950

they like, when they like and with whom they like. As a youth in Kazan, the writer Vasily Aksyonov would spend hours fiddling with his wireless receiver in an attempt to catch even a snatch of jazz. With the appearance of x-ray discs, he could play it at will:

From the moment I heard a recording of 'Melancholy Baby', a pirate job on an x-ray plate, I couldn't get enough of the revelation coming to me through the shadows of ribs and alveoli.

In the post-war years, these kids provided a ready market in the Soviet Union for the Bone bootleggers.

SONGS OF THE ÉMIGRÉS

They were not alone. Articles on the culture of x-ray bootlegs often talk exclusively about '*jazz on bones*' and '*rock on ribs*' and imply that the records were weapons in a dissident attempt by malcontents to '*smash the system*'. This is seductive because it makes the story of Bone Music a story about *our* music, a narrative that confirms our version of cold war history: we had all the good stuff and they weren't allowed to get it. But this is only partly true. Certainly jazz and rock'n'roll appeared on many, many Bone records, and the western-loving stilyagi youths who bought them were defiantly anti-establishment, if not actually dissident; but in fact the majority of the x-ray discs that survive contain Russian music. Some of it could be called jazz-influenced, but the haunting melodies, old-fashioned rhythms and sometimes dramatic, sometimes innocuous lyrics are not western. Nor do they seem particularly anti-Soviet; this music was forbidden because it was the repertoire of forbidden émigré artists – or simply because it was in genres that were unacceptable. Just as swinging jazz and Latin rhythms were dangerous for their sensuality, the so-called Russian tango and

gypsy stylings of the émigré singers were considered far too flamboyant and wild for the serious attitude culture should be cultivating in the young.

These émigré musicians were among those Russians who had sought sanctuary in the west in waves of exodus. Maxim Kravchinsky, who has written in detail about the history of forbidden Soviet song, says that the bloody construction of a new society following the Revolution brutally trashed a whole generation of artistic talent and culture. Millions of white army officers, nobles, clergy and artists were exterminated, died from hunger or ended their lives in prison. Huge numbers fled – by the end of the 1920s up to three million – including many artists. In London, Paris, Berlin and New York, some continued to write, paint and make music for those in exile and were a source of forbidden songs back home, via Bone recordings.

SOVIET SOUL MUSIC

Whilst the main purpose of recording on x-ray was to supply copies of recordings of jazz, rock'n'roll and émigré songs, it had a further function, more in tune with Samizdat proper: the distribution of music that had no chance of being recorded in the first place.

The Soviet regime was always very aware of the power of the popular song. Lists were made of gramophone records produced during the Tsarist era that were to be withdrawn. In 1925, the OGPU (the predecessor of the KGB) took control over the import and distribution of records, declaring that those with '*monarchical, patriotic and imperialistic content, of a pornographic nature or disparaging towards peasants*' were to be confiscated. Promoters of concerts were obliged to assign a seat near the stage to a member of the OGPU to monitor what was performed live.

In June 1929, the All-Soviet Conference of Musicians pronounced Russian romance a '*counter-revolutionary*'

genre – an edict that was used to censor the repertoire of both émigré singers and Soviet musicians. RAPM became responsible for music censorship, and each year, books listing forbidden and permissible songs were produced. Musicians who performed ideologically incorrect music – that is for entertainment, rather than to encourage the building of a new society – were demonised by RAPM in its journal:

We proletarian musicians, cultural workers and Komsomols, should meet our enemy face to face. It is vital to realise that our main enemy is both strong and dangerous: jazz, gypsy songs, story songs, criminal songs and of course the tango and the foxtrot. These apologies for music deprave the proletariat and try to ingrain petty bourgeoisie attitudes towards true music, art and life in general. This enemy must be defeated![3]

Lev Lebedinsky, one of RAPM's chief ideologues, elaborated: the rhythm of these gypsy ('tsyganochka') songs '*dull the mind and suppress the will of the communist worker*'. He compared the female performers to prostitutes and recommended that '*a wooden stake be driven through the heart*' of such music.

From now on, all performers had to go through an accreditation procedure every six months. If their repertoire did not comply with the requirements, they were forbidden to perform. They then had two choices: change profession or become a busker. Hundreds ended up on the streets in Moscow alone. Some were sent to gulags, among them Boris Prozorovskiy, Yuriy Yurovskiy and Boris Fomin (composer of the tune that would become 'Those Were the Days' in the west). Others, including the hugely popular poet Sergey Yesenin, committed suicide. The singer

3 | *The Proletarian Musician* (No.5, 1929)

Vladimir Sabinin died on the stage of the Leningrad opera house in 1932, either by shooting himself or from poison. In the early 1930s, Maxim Gorky declared that any artform critical of the Soviet system should be banned. Yet the ideology was continually being undermined, and not just because it was so out of tune with what people wanted. Hypocrisy was rife. At Stalin's request in 1937, Leonid Utyesov performed forbidden songs at a banquet in the Kremlin. Officially Isabella Yurieva, one of the greatest Soviet tango singers, was only allowed to perform a few songs from her repertoire of hundreds until the 1960s, yet as she recalled in an episode from the mid-1930s:

It was late, after midnight, when a phone rang in my flat. A voice said: 'Comrade Yurieva, a car will arrive for you and you will perform a concert. You are not allowed to refuse.' The car arrived and drove me through the empty streets of Moscow and we entered the Kremlin. I sat, neither alive nor dead, in the banqueting hall between the famous tenor Kozlovskiy and a good-natured and smiling Kalinin [Mikhail Kalinin, one of the leaders of the Communist Party]. Before I was called to the stage, Kalinin leaned over to me and whispered: 'Isabella Danilova, please don't mind us. Sing the gypsy songs! No need to bother with Soviet songs!'

You can kill the singer but you can't kill the song, forbid a tune, but not force people to forget it. Musicians could be ruined, exiled and destroyed, and those who continued to love gypsy romances, bourgeois tangos and foxtrots shamed, expelled from the Komsomol, even sent to prison, but somehow the songs survived. They lived on by being sung in the trenches during the war, at home in the kitchen with a guitar, in the communal courtyards behind the apartment blocks where most underground culture was passed from

ГЛАВНЫЙ КОМИТЕТ ПО КОНТРОЛЮ ЗА РЕПЕРТУАРОМ

Б. 3/171

РЕПЕРТУАРНЫЙ УКАЗАТЕЛЬ

XXIв.
Р-41

СПИСОК РАЗРЕШЕН-
НЫХ И ЗАПРЕЩЕННЫХ
К ИСПОЛНЕНИЮ
НА СЦЕНЕ ПРО-
ИЗВЕДЕНИЙ

ТЕ А КИНОПЕЧАТЬ
1929

ABOVE LIST OF PERMITTED AND PROHIBITED SONGS ISSUED BY THE COMMITTEE FOR THE CONTROL OF REPERTOIRE, 1929

generation to generation – and, of course, in the gulags.

Rudy Fuchs: *'They were kept alive by good people, human voices singing with accompaniment, together with their friends, old Russian songs, forgotten songs, criminal songs – kept alive in prisons, in concentration camps. They tried to kill it, but that culture lived on, among the prisoners.'*

Songs sung secretly became one of the few forms of private protest against the waves of repression.

They were symbols of remembered or imagined better times; times without starvation, times without random raids, times without people being indiscriminately arrested, shot on the streets or being denounced to save someone else's skin. Sheet music for the most popular was circulated and sometimes exported, so that émigré singers could record it, and their recordings smuggled back in to be copied onto x-ray.

There were many styles of these *'blatnaya pesnya'* (criminal songs) or *'ulichnaia pesnia'* (street songs): the tragic romances, the comical 'Odessa' ditties originating in the Black Sea port, erotic skits, tavern ballads, the gulag and the thieves' songs. Some dated back to the years before the Revolution, some were based on Sergey Yesenin's poems, others had new words written to old tunes or were original

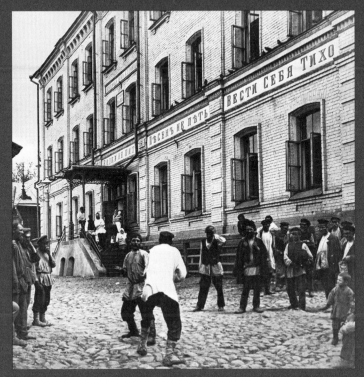

ABOVE 'DO NOT SING SONGS. DO NOT DRINK VODKA. BE QUIET.'
A FIGHT IN THE COURTYARD OF A DOSSHOUSE

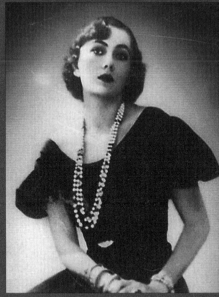

ABOVE ALLA BAYANOVA B. 1914 EMIGRE
PERFORMER OF RUSSIAN ROMANCES, C.1930S

Eleonara Filimina, a Russian singer and journalist, described how ordinary Russian people passed on these songs that expressed their soul, their attitude to their world:

'The Soviet people had a tradition of gathering after work or on weekends in their yards, thanks to the fact that there were a lot of communal flats where the apartments were small and we lived crowded, many of us together. The people were very sociable. They would go out into the courtyards of their buildings and sit and sing these songs together. And at the pioneer camps too... They used to sing them after bed-time, you know, unofficially, and at student gatherings, on construction sites; these songs accompanied any kind of unofficial meeting of people – even in the kitchens.

'During the years of repression, the intelligentsia were in gulags, along with ordinary convicts. They heard the criminal songs and the prison folk songs, and when they came out of prison, they sang them, along with the criminals, in the same yards. The boys, the girls, the neighbours heard them and were happy to learn and to sing them too.

'The Soviet state was trying to show a candy-wrapper – that everybody's happy, everything's fine, there are no problems, it will be a brilliant future. But these songs were about the realities of life, how people really lived. They were about betrayals of love, about suffering, about how people were sent to prison you know. There were all sorts of things in them. Everything was expressed in the songs. That's why they were forbidden.

'We called them "yard songs".'

compositions by underground singers or prisoners. Their lyrics told stories of love, lust, violence, death, revenge, criminality, the heartbreak and hurts of ordinary folk. They might contain slang or swearing (both of which were frowned upon) or make vulgar jokes at the expense of the Kafka-esque cruelties of the Soviet system. They were the songs of the people with tunes that everybody knew, tunes that many still know in Russia; songs such as 'Murka', about a female gang member who betrays her fellows and is murdered.

There were raids, arrests and round ups
We were snitched on and betrayed
We swore we'd root out the dirty squealer
And swore we'd make them pay

So I go on an assignment
To some swanky drinking place
And look who's there – it's Murka
Armed with gun and lipstick face

Murka, what you been up to?
Didn't I treat you good?
With furs and jewels, my treasure
Was that somehow not enough?

My dear, my darling Murka
The gang gave you our trust
And you fed us to the filth
Well, now you'll bite the dust![4]

By the 1950s, almost every family had at least one member in prison, making the music that was written and played there take root in the collective cultural imagination. Inna Klause has written of the songs composed by convicts such as Svetlana Shilovaa, a young sculptress, sentenced to hard labour in a camp near Pot'ma in 1950-53:

The NKVD-Troika has rolled me flat
And brought me into their camps,
And has christened me in my absence:
With a number instead of a name.
And so I went around there moaning;
Why do I have such a fate?
I'm still quite young,
And in freedom, spring frolics...
But love also peers into prisons,
Igniting hearts,
And I, number 234,
Have fallen in love with number 632.
But around us are only watchmen,
I cannot kiss my beloved...

...And I have hidden my love,
Locked it with a golden key...
And my beloved, number 632
Lies in a grave without a name.
('A Grave with No Name')[5]

Such songs were forbidden because they revealed the dark truths beneath the ideologues' vision. Their very existence was an affront, an act of resistance to that vision. The dissident writer Andrey Sinyavsky wrote that, in a nation of convicts past and present, criminality united the people in a way that the ideology could not; the criminal *blatnaya pesnya* songs could even be described as '*Soviet soul songs*'. They certainly share something in common with the early blues and protest songs of black America. In the context of the x-ray underground, we might say that they were truly the essential Bone Music.

As Stalin ratcheted up the stranglehold, the combination of a very limited supply of music that ordinary people yearned for– whether it be jazz, rock'n'roll, émigré songs

4 | Author's translation

5 | 'Music and musicians in soviet labor camps during the period of Stalinism' – Dr Inna Klause

or blatnaya pesnya– and changing attitudes amongst the young created an unstoppable incentive for an underground market to arise. The trauma of World War Two, the '*Great Patriotic War*' as it is known in Russia, had fractured many things, and one was the sense of continuity of collective revolutionary purpose. By the late 1940s, more and more people felt disconnected from the shared fervour of the early Soviet years. Young radicals may have implemented the Revolution, but the firebrands of that earlier experimental age were now old, many of them conservative and viciously repressive. The ideologues' attempts at a proletarian culture increasingly failed to ignite passions or even entertain the proletariat. Perhaps ordinary people didn't mind so much if the avant-garde was destroyed but they stubbornly refused to abandon their own music. Despite all the prohibitions and prescriptions, there was an intense appetite for forbidden popular culture of all kinds. Grudging concessions allowed certain popular singers such as the ideologically dubious Utyesov to perform but they had limited effect. Young people in particular wanted a soundtrack for their own lives, not to be singing boring patriotic songs about someone else's.

And in Leningrad in 1946 they got it, via a combination of technical ingenuity, entrepreneurial savvy and anti-establishment daring.

BONE HACKING

The Soviet music industry was ruthlessly controlled, as were its means of distribution. There was just one state record company (known from 1964 as Melodiya), shops selling gramophone records operated under license, and the import, sale and broadcast of foreign music were totally regulated. Only approved personnel and musicians in dedicated studios could use official recording and audio equipment. The complex technology and specialised materials required for disc manufacture were subject to the sanction of the authorities. The means needed to operate at any scale outside the system were simply not available. This all meant that independent production was virtually impossible.

Nevertheless, around 1946, a few guys in Leningrad began producing their own records, firstly for themselves and their friends and then for a wider public. They had become '*bootleggers*': anti-establishment music-loving chancers whose defiance was as much technological and entrepreneurial as it was cultural. Perhaps the nearest equivalents we have are computer hackers – young, skilled, mischievous, disruptive, dismissive of authority and of the older generation's values.

Using home-made recording devices, the bootleggers operated clandestinely in empty apartments, secret workshops and dachas (the country cottages commonly used as weekend homes by urban Russians of all classes). Here they produced quantities of discs with forbidden tunes. These were passed to dealers who sold them on to eager customers at discreet locations around the city. As public awareness of their wares increased, operations expanded to other cities; new groups started up and the underground production of music began to spread throughout Russia and other Soviet states.

This was all made possible when a means of making recordings outside the official studio and record company system (first popularised in independent Hungary before the war) became known to a few technically savvy music fans in the USSR.

Most of the rest of this book is devoted to their story.

MAGNETIZDAT

The era of Bone Music lasted from the 1940s until the early 1960s, and was killed off, not by prohibition or punishment but – as has often been the case in the history of musical media – by technological change. When Nikita Khrushchev came to power after the death of Stalin in

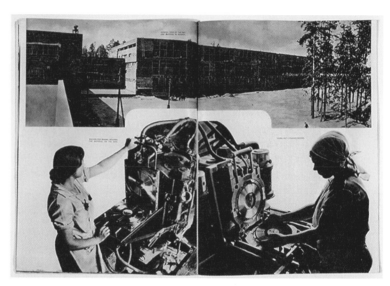

1953, he denounced his predecessor's vicious excesses, and sought a more peaceful coexistence with the west. He instigated a general cultural and commercial thaw, a more liberal period that lasted from the 20th Party Congress in 1956 until his removal in the mid 1960s prior to the Brezhnev era. After Khrushchev's landmark visit to the US in 1959, all kinds of consumer items became more available to the Soviet public – including magnetic reel-to-reel tape machines. Tape had been used professionally in the 1950s, but was beyond the reach of the ordinary citizen until the early 1960s, when domestic machines became affordable.

But by the end of that decade, almost every family had a Tembr, an Astra, a Nota or a Yauza5, and the production of Bone Music had stopped virtually dead. With magnetic tape machines, it was possible to record at length, at home and at high quality. No need now for repurposed x-rays, for laboriously self-built recording machines, for dubious dealings with street-corner distributors – and little value now in a product that often sounded terrible and fell apart quickly.

Music continued to be censored of course, but now a new kind of underground production began: that of 'magnetizdat', the widespread clandestine sharing and sale of bootlegs on tape. A street culture of illicit recording was replaced by a home culture of illicit recording. It is another baffling aspect of the Soviet system that the authorities – after putting so much effort into the prohibition and punishment of those who made and sold x-ray records – now allowed people to have tape machines, especially since it remained illegal up until perestroika to own a private printer or photocopier. The quantity of magnetizdat tapes circulating dwarfed that of the roentgenizdat discs: Artemyi Troitsky estimates that bootleg reel-to-reels numbered in the tens, if not hundreds, of millions. Tape also made possible the widespread recording of blatnaya

ABOVE SOVIET RECORD PLANT, FROM USSR IN CONSTRUCTION MAGAZINE, 1939

music and protest songs. Underground singers could be captured with high fidelity in improvised apartment studios. Copies of copies of copies of master tapes could be made without too much drop in quality.

This interplay between simple DIY recording technology and cultural liberalisation created the ground for the emergence of such underground singers as Arkady Severgny, Alexander Galich and Vladimir Vysotsky, all of whom became famous without releasing an official record. Galich and Vysotksy were at the centre of the 'Bard' movement (which had some similarity to the folk movement in the west); they were intellectuals with guitars, well educated, talented, singing songs partly based on folklore and blatnaya, partly based on classical Russian poetry, and sometimes with satirical anti-Soviet lyrics. They became beloved of the intelligentsia rather than merely of rebellious young hipsters. Galich was expelled from the USSR in 1974, dying in mysterious circumstances in Paris three years later. Vysotsky became very famous as an actor as well as a singer, but died of drug and alcohol related issues in 1980.

ABOVE BOOTLEG REEL TO REEL TAPES, 1960S-1970S

Here, by the 1970s, was the medium for the emergence of an authentic homegrown underground Russian rock culture, and that allowed bands such as Time Machine and Aquarium to gain huge popularity. It would explode further still in the 1980s, as the convenience and economy of the tape cassette made underground stars of such bands as Kino and helped spread popular cultural values on a mass scale. Combined with the gatherings of people at underground gigs out of sight of the authorities, cassette culture played a crucial part in perestroika.

It was the final flowering of a growth in musical resistance, the seeds of which were planted by the activities of the x-ray bootleggers. Bone Music, though the least widespread of all these forms of dissident music production in the USSR, was the first and the most remarkable; it began during the times of greatest repression and was the most dangerous to practice. The artefacts it has left us with remain striking and poignant testament to the ingenuity and enterprise of those who refuse to be dictated to about the music they should and shouldn't love.

Besides Hungary, x-ray records have been found in Belarus, Armenia, Georgia and Czechoslovakia. An elderly correspondent, born in Latvia and now resident in Tel Aviv, described how as a teenager she had obtained forbidden Yiddish music from a student who cut Bone records on his own home-made machine. But this kind of underground production seems to have been less common in other eastern bloc states. Perhaps prohibitions were less rigidly enforced there; perhaps listening to proscribed music was made easier by the earlier availability of tape machines. There was active pirating of western music onto audio postcards and plastic flexi-discs in Poland in the 1960s-70s, but this seemed to enjoy a semi-official sanction.

Copying music onto x-ray did continue through the 1960s in some places in the Soviet Union, perhaps by amateurs who had built their own lathes, or who lived in out-of-the-way locations where tape was less easy to obtain. And illicit or underground lathe-cutting also seems to have evolved. Gleb Vashenko, a Latvian émigré living the US, notes that, as a child in the 1980s, he helped his father in the mass production of fake LPs from the west, using multiple lathes. Gleb's jobs included the sharpening of the sapphires in the cutting heads of the lathes using a bespoke machine his father had designed for the purpose. But these counterfeits were far more sophisticated than any Bone disc. They were recorded at 33rpm onto sheets of industrial modern plastic, and were sold with faked covers that matched the western originals.

THERE ARE RUMBLINGS, WAILS AND HOWLS LIKE THE SMARTING OF A
METAL PIG, THE SHRIEK OF A DONKEY, OR THE AMOROUS CROAKING OF
A MONSTROUS FROG. BESTIAL CRIES ARE HEARD, NEIGHING HORSES,
WILD SCREAMING, HISSING, RATTLING, WAILING, MOANING, CACKLING.
THE INSULTING CHAOS OF INSANITY PULSES TO A THROBBING RHYTHM.
LISTENING TO THIS SCREAMING MUSIC FOR A FEW MINUTES, ONE
INVOLUNTARILY IMAGINES AN ORCHESTRA OF SEXUAL MANIACS LED
BY A MAN-STALLION BEATING TIME WITH AN ENORMOUS PHALLUS. THE
MONSTROUS BASS BELCHES OUT ENGLISH WORDS; A WILD HORN WAILS
PIERCINGLY, CALLING TO MIND THE CRIES OF A RAVING CAMEL; A DRUM
POUNDS MONOTONOUSLY; A NASTY LITTLE PIPE TEARS AT ONE'S EARS;
A SAXOPHONE EMITS ITS QUACKING NASAL SOUND. FLESHY HIPS SWAY,
AND THOUSANDS OF HEAVY FEET TREAD AND SHUFFLE. THE MUSIC OF
THE DEGENERATE ENDS FINALLY WITH A DEAFENING THUD, AS THOUGH
A CASE OF POTTERY HAD BEEN FLUNG DOWN FROM THE SKIES.

MAXIM GORKY:
PRAVDA, 18 APRIL 1928
'ON THE MUSIC OF THE DEGENERATE'

RIGHT IMAGES OF HUNGARIAN
X-RAY DISCS BY JOSEF HAJDU

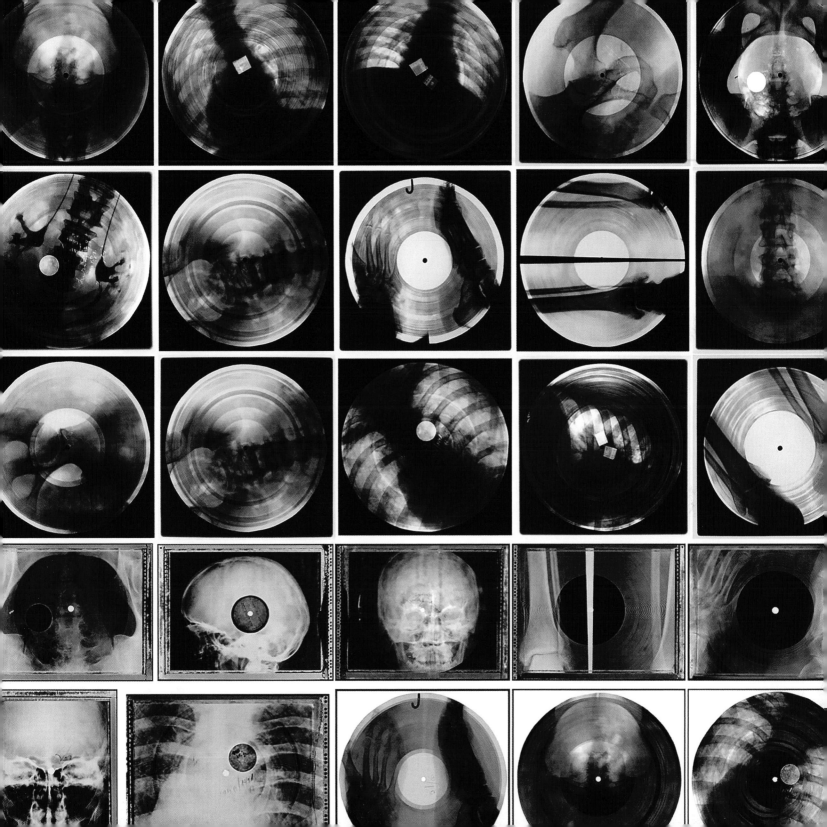

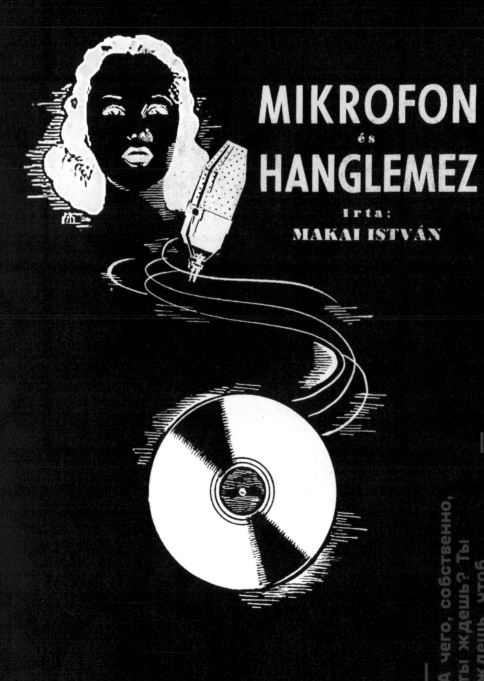

MIKROFON
és
HANGLEMEZ

Irta:
MAKAI ISTVÁN

— Вот, кстати, скажу. Я, когда была пионером... Пионером. Это было давно, это было, когда я учился в школе, в средней школе. Я собирал колоски.

— А чего, собственно, ты ждешь? Ты ждешь, чтоб без тебя встали гидростанции и заколосилась пустыня, без тебя? Но ведь, когда твои сверстники совершат это чудо, тебе не будет места среди них.

BUDAPEST BY BONE

BELOW MIHÁLY BABITS AND SOPHIE TÖRÖK, 1928

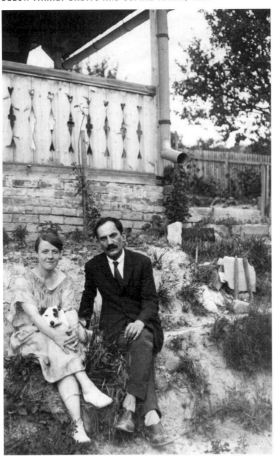

THE BONE ARCHIVISTS

The x-ray records of the Soviet Union are more famous, but the greatest collections of Bone Music are in Budapest, in various archives. So let's look now at where it may have all begun, in non-communist Hungary in the 1930s.

In the years after World War Two a woman with a suitcase slowly picks her way along pavements between bombed-out buildings, in the devastation of central Budapest. She stops at a particular house, rings the bell and waits. She is dressed in clothes that had once been expensive, even glamorous, but are now tattered and dishevelled. When the door of the house opens and light spills out, a man, looking puzzled at first, greets her with startled recognition before ushering her inside.

Sophie Török (born Ilona Tanner) was a prize-winning poet and literary hostess, and István Makai was a sound engineer running a small independent recording studio. She would visit him many times – and always with a particular purpose in mind, to commission him to make recordings from the radio, and from live performances by her friends. He made these recordings onto x-ray.

Was Makai the first to consider using radiography film as a recording base? It's impossible to know. Certainly he was the first to write about it in detail. Throughout the 1930s, in articles for the Hungarian magazine *Rádiótechnika* and in his own books, he described with great enthusiasm techniques that enabled other audio engineers and interested hobbyists to make recordings directly to disc. These included instructions on microphones and amplifiers, schematics on how to adapt gramophones to record – and even how to build a basic recording lathe from scratch. An inveterate experimenter, Makai trialled various alternative surfaces to record onto, before settling on the cheapest, x-rays, because they could easily be obtained from the nearby Szent János hospital.

As the shadow of coming conflict crept across Europe and the commercial blank Decelith or Pyral discs that Makai used professionally became increasingly difficult to obtain, x-rays increasingly became his medium of choice and the one he recommended to others. His writings gained a small, eager audience and he became the central mentor in a growing community of DIY amateur recording enthusiasts in Budapest.

In an interview in the 1970s, one of these, the record collector László Blahunka, recalled working with his father, who was one of the very first Hungarian radio amateurs. They learned their techniques from Makai's writings:

We constructed a recording machine in the 1930s. The equipment consisted of an amplifier, a simple microphone and the machinery of an old phonograph for moving the 'cutter head'.

László and his father obtained their x-ray film from a relative who worked at a hospital, and over the years amassed a collection of almost 1,000 recordings of radio broadcasts. Unlike the Soviet x-ray bootleggers of the 1940s, the Blahunkas and the other Hungarian recording amateurs were not making records for any illicit purpose but simply for entertainment – perhaps to copy dance tunes ('to play at tea parties', Blahunka said) or to collect interviews, theatrical pieces, speeches, political conversations and foreign news from the radio. This, after all, was a time when the magic of the new technology of radio was inspiring amateurs all around the world.

THE X-RAY POET

A poet herself, Sophie Török had also married one, Mihály Babits, Hungary's poet laureate. They were at the centre of Budapest's intellectual and bohemian world and counted many other writers and artists amongst their circle, including the composer Béla Bartók.

In the early 1930s Bartók had employed Makai to make transfers from his field recordings of Hungarian folk music, visiting him at his Artton-Hungarian Studio on Apponyi Square carrying a little rucksack filled with phonograph wax cylinders. Once Török made Makai's acquaintance, she would regularly come to his apartment on Ganz Street, to commission him to make recordings of performances by Bartók and others that were broadcast on the radio as well as political speeches and her husband's poetry. Sometimes she asked him to bring his equipment to the Babits household to record the voices of their writer and poet friends *in situ*.

After several years, Török had built up a substantial archive of recordings – but the artistic life of Budapest was fragmenting as war tore Europe apart and the political scene worsened. Bartók strongly opposed the Nazis and Hungary's alliance with Germany, and in 1940 fled to the US. In 1941 Babits died of cancer. Enlisted into the army as a reporter, Makai took one of his lathes with him to the eastern front. In his absence, Török continued making recordings with Makai's wife. But after the war, when the communists came to power under the Russian occupation, the cultural climate in Hungary began to change further. Now repression and censorship took hold, just as it had in the Soviet Union. The works of pre-war intellectuals including poets and artists like Babits came under suspicion. János Sebestyén, a journalist involved in the later restoration of x-ray recordings, would report in his 1970s radio shows that zealots at the station had destroyed more of its archive of recorded works than had the Red Army, declaring them to be 'products of Imperialists'.

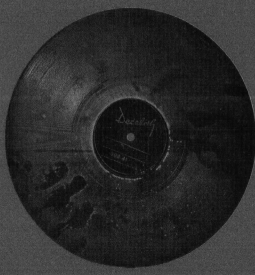

'It is very interesting, entertaining and touching that we can record friends and relatives speaking, singing or when they play instruments; and that we can play these back whenever we want to... There are different materials that we can use for recording and we have tried many of them. During our experiments we have come across a very interesting material that works well. This is used x-ray film.'

István Makai, Rádiótechnika I. évf. 5.szám 1936 július (Vol.1 No 5. July 1936)

ABOVE DECELITH DISC, HUNGARY, LATE 1930S
LEFT DETAIL OF DECAYING HUNGARIAN BONE RECORD

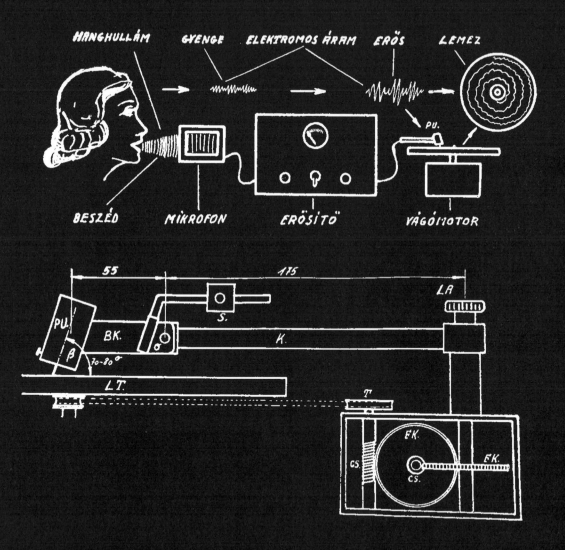

HANGHULLÁM GYENGE ELEKTROMOS ÁRAM ERŐS LEMEZ

PU.

BESZÉD MIKROFON ERŐSÍTŐ VÁGÓMOTOR

55 175

LA

PU. BK. S. K.

β 70-80°

LT.

T

EK.

CS. CS. EK.

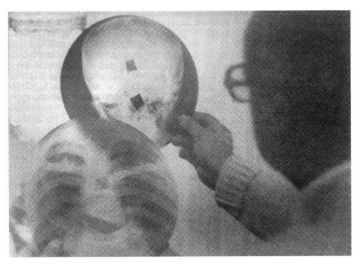

ABOVE LEFT LÁSZLÓ BLAHUNKA, 1979
ABOVE RIGHT ISTVÁN MAKAI'S LATHE AT SOPHIE
TÖRÖK'S APARTMENT, FROM HIS MANUAL, 1938
BELOW ISTVÁN MAKAI'S DOUBLE RECORDING LATHE
WITH X-RAY DISCS

'The custom-made record is most similar to photography. Anyone who knows the uplifting nature of photography can easily understand the even more beautiful and often emotional features of an individual record. Just as a photograph reveals an idealised moment, so a record recalls the sound of a voice or a musical performance, to re-create the illusion of reality. A collection of such records will always be there for our entertainment, memory and pleasure, to help forget our daily worries and sorrows. Now that I'm releasing this little piece of work, for my part I wish you true joy and happiness.'

Dedication in István Makai's manual for self-recording, Budapest 1939

Most of the private x-ray recordings of the Hungarian phono-amateurs have also vanished. Of those that survived the conflicts of war and revolution, many were destroyed by their owners. In the growing cold war climate of suspicion and fear, people were terrified they would be suspected of hoarding pre-Communist documents – or even of espionage if their recording machines were found. Others were hidden away, but often disposed of years later, by family members unaware of their historical importance.

Sophie Török's life began to deteriorate rapidly. Her liberal values were completely at odds with the new communist regime, and she published no poetry after 1948. She made one final visit to see Makai, at his home on Keleti Károly Street. Makai's wife reported being very distressed at her condition. Once a leading light of Bohemian society, this glamorous literary hostess was now so poor she couldn't afford to have her own gramophone fixed, and had brought some of her x-ray records to play on theirs. The Makais watched as she sat wearing headphones, listening in floods of tears as the haunted sounds and ghostly images of the discs evoked a life she had lost.

She lived on alone in a semi-ruined apartment. Sarolta Koháry, who met her at a sanatorium around this time described her as '*depressed, nervous, physically collapsed, unable to walk straight, falling from one illness to another*'. Fear of being associated with her husband meant people were reluctant to be seen with her. She would die in 1955, but in 1952, concerned for Mihály's legacy, she had arranged that her entire archive of documents and manuscripts – including about 110 x-ray discs – was sealed and placed in the Hungarian National Library archives. Fearing it might be destroyed on ideological grounds if examined, she stipulated that the collection was not to be opened for 25 years.

When this was finally unsealed in the late 1970s, many of the x-ray records had dissolved into powder, or been damaged by secretly being played on gramophones with the wrong needles. A few were salvageable, and these were cleaned and transferred to tape in 1977 by János Sebestyén and engineers at the state radio station. They revealed unique recordings of Béla Bartók speaking, a 1936 performance of his one-act opera *Bluebeard's Castle* and examples of his piano technique as he played the music of Mozart, Bach, Beethoven and Chopin. Nothing too radical perhaps, but a pleasure for Bartók scholars only tempered by the knowledge that so much more had been lost.

Makai made many recordings for other clients, and for himself. About 200 were rescued from a dumpster in a city street after he died. By sheer luck these too found their way into the hands of János Sebestyén, and are now also kept in the National Library archive. They provide a fascinating glimpse into Makai's life – as a music lover, radio enthusiast, war correspondent, and recording innovator. During the late 1940s-50s, when magnetic tape was hard to obtain, various other technicians were also using x-rays, sometimes with a transportable lathe, to make field recordings of gypsy dance music in the Hungarian countryside. There are various small collections of their discs in other archives in the city: some at the radio station, some in the state literary archive and a few in the folk music archive.

István Makai died in 1970. Some of his equipment survived, but was played with by his grandchildren and according to János Sebestyén became inoperable. The documents and discs that he left behind, alongside the tragic story of Sophie Török, reveal how x-ray records defied the state censors while also, probably unintentionally, preserving their culture for future generations.

HUNGARIAN BONE JAZZ

*A gentle and rather fragile old man sits by the
baby grand piano in an elegant apartment a block
away from the Buda River. He picks up various
x-ray discs and holds them up to the light flooding
in from the window. Having just returned from a
hospital examination, their images hold a particular
significance and the music they contain,
a particular poignancy.*

Before his death in 2016, Attila Csànyi, a musician and
jazz historian, produced three albums of Hungarian jazz
drawn from around 80 x-ray records he had collected.
While the discs made by Makai, the Blahunkas and the
community of Budapest amateur recorders were mainly
drawn from radio, Csànyi's discs were part of a small
– and unique – Hungarian tradition of recording live
performances direct to x-ray.

ABOVE ATTILA CSÀNYI PLAYING JAZZ PIANO, 1959

Attila collected his discs over a period of 50 years, some
from the very musicians who had made them, who shared
stories of how they were recorded.

In the late 1930s, Iván Zágon and Radics Gábor – two
students at the University of Technology and Economics,
who went on to be famous players on the Hungarian jazz
scene – were asked to perform on radio. They wanted to
play the broadcasts to friends later, so asked for help from
their tutor Pető László, who had built his own lathe and used
x-rays as Makai had prescribed. He later built another lathe
for them, so they could make live recordings themselves at
the private jazz club they started at the university in the
1940s. They produced many discs there just for pleasure –
it wasn't dangerous to play jazz in Budapest until after the
Red Army occupation, when US and UK-influenced music
began to be repressed.

Post-censorship, x-ray recording would play a crucial role,
capturing for posterity the clandestine styles of Zágon and
Gábor and other jazz musicians. There were several bands
who – despite playing publicly in officially acceptable bland
pop genres – proved surprisingly good at jazz improvisation
on x-ray. Their recordings were made quietly and privately
in small studios like Makai's, on home-made machines – or
at shops like the one called 'Take Your Own Voice Home', on
Joszef Boulevard. Here the owner had installed a lathe and
microphone for people to make souvenir recordings (just
like the Soviet '*Talking Letter*' studios described later).

The discs that Attila collected were only a fraction of
what was recorded. When he visited the homes of old jazz
players to examine those they had kept, he found that many
had become unplayable or crumbled to dust. Those that
survived demonstrated something important: while he had
assumed Hungarian jazz to be entirely derivative of US
and UK styles, these x-rays, from the 1930s-50s, revealed a
distinctive Hungarian style influenced by gypsy music and
traditional tunes.

In the Soviet Union such music would be cut onto multiple x-rays for underground distribution and sale, but in Hungary this wasn't always the case. According to older Hungarians, purchase of illicit records might be possible in 'Ceglédi', a secret shop in the courtyard of a house on Rákóczi Street during the late 1950s-60s. Jozsef Hajdu, a photographer who made a series of beautiful images from Bone records he discovered at the national radio station, says that a few also occasionally turned up in specialist record shops. Ferenc Malcsiner, a sound engineer who knew István Makai, also found home-made records at flea markets and record fairs in the 1970s. As in the USSR, though a little earlier, the era of Hungarian x-ray recordings ended in around 1955, when new reel-to-reel recorders rendered them obsolete.

Can a connection be made between the Hungarian and the Soviet discs? Certainly it's possible that Makai's writings on x-ray recording technique made their way to the USSR in the 1930s. Descriptions of the process could sometimes be found in the Soviet magazine *Radiofront*, one as early as 1936. Or is this an example of how certain technological innovations emerge simultaneously but independently when the time is right? After all, many Russians will claim that it was Popov who invented radio, not the Italian Marconi...

JAMPECEK

The Hungarian equivalent of the Soviet stilyagi kids, were the 'jampecek', a word used derisively from the late 1920s to variously describe disaffected youth, gang members, spivs, slackers, teenage dandies, hooligans, beats or hipsters. Like the stilyagi, the jampecek of the 1950s-60s sported flashy US influenced clothes and hairstyles, partied, disdaining the values of their parents and generally annoyed the establishment. But in the more liberal climate of post-war Hungary, they were apparently able to get their fix of the music they loved from Radio Free Europe, from magnetic tape bootlegs and from the conventional vinyl records that were smuggled in from adjacent countries.

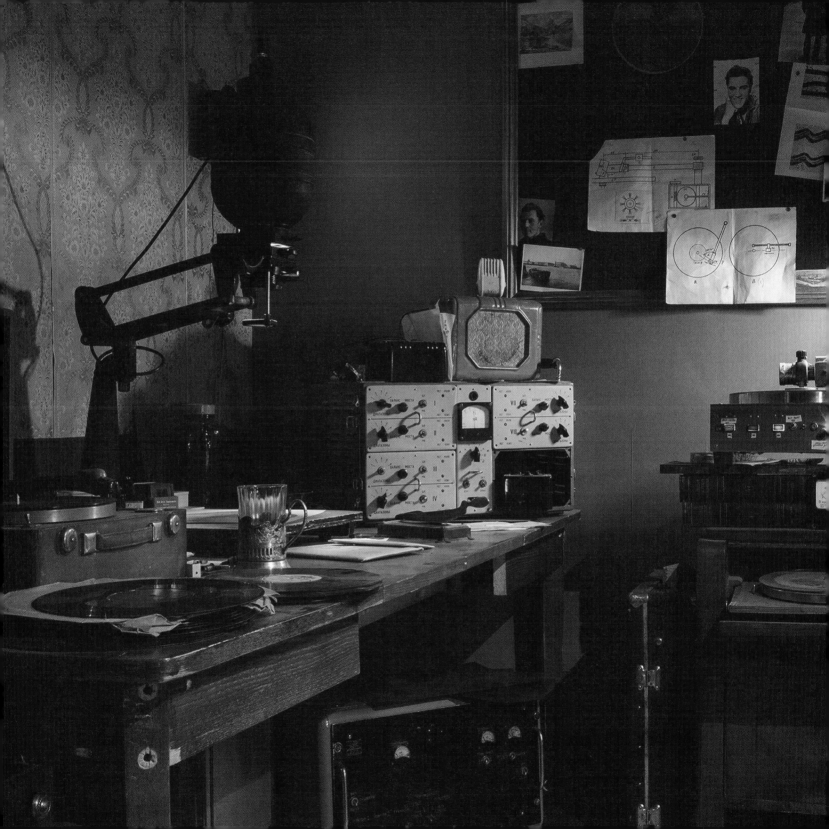

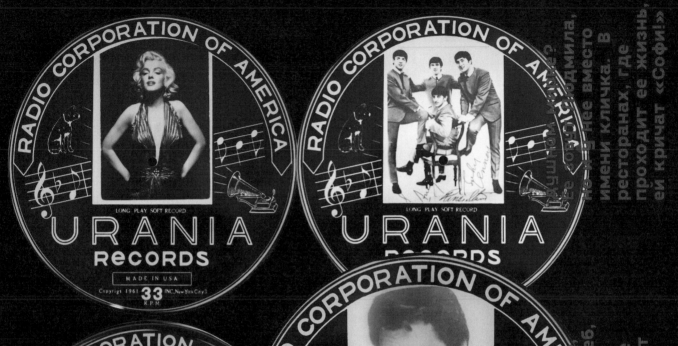

RADIO CORPORATION OF AMERICA

LONG PLAY SOFT RECORD

U R A N I A

RECORDS

MADE IN USA

Copyrigt 1961 **33** INC. New York City 3
R.P.M.

RADIO CORPORATION OF AMERICA

LONG PLAY SOFT RECORD

U R A N I A

RECORDS

RADIO CORPORATION OF AMERICA

LONG PLAY SOFT RECORD

U R A N I A

RECORDS

MADE IN USA

Copyrigt 1961 **33** INC. New York City 3
R.P.M.

RADIO CORPORATION OF AMERICA

LONG PLAY SOFT RECORD

U R A N I A

RECORDS

MADE IN USA

Copyrigt 1961 **33** INC. New York City 3
R.P.M.

ей кричат «Софи»
проходит её жизнь,
ресторанах, где
имени кличка. В
её вместо
соблазнила,

еще в этом
тени мелькают
ешь. Какие же
который ты
свой хлеб,
алтайский
дважды убирал
Саша Крюков
ровесник
А вот твой
белой булкой
исчерпывается
с хлебом
знакомство
Дальнейшее
Колоски. И новое

HEROES OF THE SOVIET UNDERGROUND

THE GOLDEN DOG GANG

The tiny old Russian lady serves black tea and pastries on a decorated tray. Her impeccably tidy apartment is decorated like an old-fashioned country cottage despite being 12 stories up a crumbling 1960s brutalist tower in the St Petersburg suburbs. The only things that don't fit in the traditional interior are the strange picture-disc records mounted in frames on the walls. After tea and small talk, she shows the small study where her late husband worked. Among the books, records and files are various photographs in which a serious young man looks out at the viewer, sometimes smart, sometimes bohemian, sometimes with a quiff, sometimes with long hair – but always stylish. From a drawer the lady takes a handwritten notebook – her husband's memoirs.

Born in 1928, Boris Ivanovitch Taigin (real surname Pavlinov) was many things during his lifetime: a tram driver, a cinema projectionist, a publisher of Samizdat poetry, a poet himself, a songwriter, a convicted criminal – and an x-ray bootlegger. He was once a member of the Golden Dog Gang – who would create and give its name to what would perhaps be Leningrad's first and greatest Roentgenizdat record label. Taigin's memoirs are the only detailed first-hand account we have of the birth of the Bone Music underground in the city.

LEFT GOLDEN DOG GANG PICTURE DISC BONE RECORDS 1950S

He first came across bootleg music in 1946 when he bought a Leshchenko song on an illicit disc – but his involvement really got going in 1947 when he met another 18-year-old music lover, Ruslan Bogoslovsky. One day earlier in the year, Bogoslovsky had walked into the photographic co-operative at 75 Nevsky Prospekt, perhaps to have his portrait taken, perhaps intrigued by the advertisement claiming a talking-letter machine had been installed there and that a wonderful new service was being offered – the opportunity for ordinary people to speak, sing or play and make a gramophone record. There at the Zvukozapis (sound recording) studio, he heard a beautiful old Russian tango playing on a gramophone. He loved tango, but it was rare to hear such music in the Soviet Union in those days.

The guy operating the studio, Stanislaw Philon, was considered a specialist in the field of sound recording. Accounts of his origins vary. He may have been a Polish refugee fleeing the Germans, one of the multitudes in transit during the chaos of World War Two or he may have been a wounded veteran. In Leningrad, he was given an employment opportunity by the Inkooprabis co-operative, which provided employment for disabled soldiers and injured artists.

ABOVE **BORIS TAIGIN, 1953**

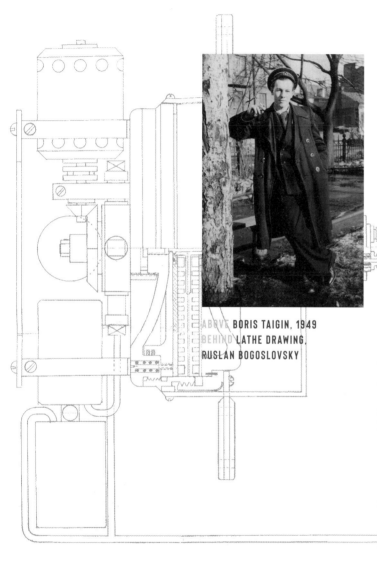

ABOVE BORIS TAIGIN, 1949
BEHIND LATHE DRAWING,
RUSLAN BOGOSLOVSKY

Soviet lathes were still rare in 1947, and Philon seems to have been using a German Telefunken model to make the recordings. This was probably a war trophy – perhaps a strange choice compared with the more obvious booty, but all sorts of goods had been brought back en masse by the victors. Perhaps it had been used by a war correspondent at the front to record reports onto discs to be archived or played on the radio.

Bogoslovsky asked Philon about the tango and whether he could buy it. Philon declined, but told him to come back later when the shop was closed. Business was booming, though not from sales of photographic portraits or novelty recordings. Deploying the Telefunken for a purpose quite other than that advertised, Philon was copying gramophone records of music prohibited by the Soviet censor. Customers were coming to buy the discs, either for themselves or to sell on. He had in effect become a bootlegger – that was where the real money was to be made. Bogoslovsky returned to the shop as instructed, and to his delight Philon sold him a copy of the tango. The sound wasn't so good but it didn't matter. It was wonderful to have it at all.

This was a decisive moment in the history of the Soviet x-ray underground. Like Taigin, Ruslan Grigoryevich Bogoslovsky was born in Leningrad in 1928, and had already led a colourful life. He had worked for a while riding a motorbike in a circus, before enrolling on a radio mechanic's course and teaching himself electronics. In addition to his technical savvy, he was passionate about music. Befriending Philon, he began hanging out at the studio, where – just like at western record stores – young music fans were starting to gather. He and Taigin loved the forbidden songs of Pyotr Leshchenko, Vadim Kozin and Konstantin Sokolsky. They despised the official Soviet propaganda songs. After a while, they got involved with Philon's night-time production activities.

Nevertheless, Bogoslovsky considered Philon's discs rather poor quality, and one day suggested to Taigin that it would be great to obtain a recording lathe and cut their own – particularly as there was so much demand. Taigin loved this idea but couldn't see how it was possible: even if they managed to locate another lathe on the black market, where would they get the money to buy it? But he underestimated his friend's resourcefulness. Bogoslovsky showed him some papers. Over a period of weeks, he had quietly made sketches and measurements of Philon's Telefunken and had used them to produce a full set of working drawings. He now believed he had enough information to build a lathe himself. They retired to the Bogoslovsky family dacha in the village of Toksovo outside Leningrad, where his father, an engineer who had been awarded a medal by Stalin, had a fully equipped workshop.

The drawings were passed to a metal turner to make parts, while Taigin sourced bits from old gramophones, drills or telephones and sapphires were bought from the flea market for the cutting head. By late summer they had a fully functioning home-made machine – a fact Bogoslovsky was keen to show off to the unfortunate Philon. They tested it and, after a few experiments, made their first bootlegs. They sounded amazing.

Philon's monopoly was broken. Worse, the new recordings were so good that his dealers and buyers began migrating to Bogoslovsky's and Taigin's operation. Demand soared and they began to work at night to meet it. They were so busy that Bogoslovsky had to invite another friend, Eugene Sankova, a musician and photographer, to join them. Bogoslovsky was audio engineer and record cutter, Taigin obtained the gramophone records to copy as well as the used x-ray plates, while Sankova took care of labelling and graphics. Taigin and Sankova also began to record songs – some original, some in the popular blatnaya style.

As the market for their discs grew and the knowledge of how to cut onto x-ray spread, others set up underground facilities. According to Taigin, rival bootleggers were selling inferior records, with pops, hisses and blocked grooves that would only be discovered when the customer got home. To distinguish their product, the friends christened themselves the Golden Dog Gang – in Russian 'Zolotaya Sobaka', a jokey reference to Nipper, the dog that listens to the gramophone on the HMV record label – and Sankova designed a special Golden Dog stamp to be applied to the discs they made. In an increasingly competitive market, this label was a guarantee of quality, ensuring their pre-eminence as the underground x-ray producers of choice for the discerning forbidden music fan.

They also came up with another remarkable innovation – the picture-disc x-ray bootleg. Radiography film has two layers: the lower is the light sensitive emulsion upon which the skeletal image is created; the upper is the protective transparent layer that takes the grooves. They devised a way to separate this top layer and to stick it onto a card disc with a picture on it. The result was both robust and beautiful, and similar to the 'sound letters' or audio postcards that later became popular. Sankova would design the pictures – exotic hybrids that collaged details from western record labels, Russian text and saucy photos of US film stars. They often used images of Marilyn Monroe or other glamorous Hollywood actresses regardless of the music on the disc. Customers loved them, many believing they were genuine records from the west. Bogoslovsky was so proud of this innovation that he boasted of it to Philon – who now began using the technique to make his own competing picture discs, for the 'Leningrad Art Recording Studio', as he began calling his operation.

For two or three untroubled years, the Golden Dog Gang, the Leningrad Art Recording Studio and various other underground outfits flooded the city with the music eagerly desired by local fans. Bogoslovsky built more lathes –

to increase production and to sell to others. Some apparently found their way to Moscow, the Caucasus and beyond. The x-ray underground began to spread. But inevitably this burgeoning illicit activity attracted the attention of the authorities, and early in the morning of 5 November 1950, the OBKhSS – the Soviet financial police – swooped. With the help of informants, and working late into the night, they arrested everyone involved in the manufacture or sale of Bone records, filling the cells at the Palace Square police station with around 60 people. Bogoslovksy was caught as he made rendezvous with a dealer-turned-informer. Taigin was taken at his parents' apartment. All the recording machines, the gramophones, all the original records being copied and all supplies of x-ray film were confiscated. In the following days, Soviet newspapers carried vengeful articles condemning the bootleggers for 'destroying the soul of Soviet youth' and glorying in their arrest.

In his memoir, written in the early 2000s, Taigin claimed that they hadn't expected to be arrested or that the government would really care what they were doing – and that perhaps the real problem was that nobody was buying the official records anymore. This was a new type of crime – but was it ideological, or entrepreneurial? At first the Golden Dog Gang were charged under a law against speculators, which had a punishment of up to seven years imprisonment, but the police couldn't make it stick. There was even an attempt to prosecute them for pornography because of the racy photos on the picture discs. Eventually, 11 months later, in September 1951, a trial was held and Bogoslovsky, Taigin and Sankova were found guilty of the 'production and distribution of gramophone records on x-ray film with recordings of émigré Russian repertoire'.

Bogoslovsky got three years. Taigin and Sankova were further charged with the 'composition, performance and recording onto disc of songs of the criminal genre'. They got five years each.

During the trial the judge tried to ridicule them, accusing them of trying to destroy the ideological education of young people. Goaded, the ordinarily shy Taigin stood up and made an impromptu speech. He shouted that politics and music should not be mixed, that they weren't dissidents but music lovers, and that next time they wouldn't be caught. There was uproar in the court, with members of the public applauding. Court officials tried to calm things down and Taigin was forbidden from speaking again. In addition to his prison sentence, he was awarded five years exile in Siberia, the severest punishment then available.

Fortunately for the Golden Dog Gang – and for many Russians – history intervened. In March 1953, Stalin died. His demise brought a collective cultural sigh of relief and ushered in the social reforms and limited freedoms granted under his successor Khrushchev. One of these was a general amnesty. Over a million non-political prisoners were released early from the camps, the Golden Dog Gang among them.

JAZZ OVER STALIN

On his return to Leningrad, Bogoslovsky immediately built a new recording machine and resumed activities. The halt in production had left Leningrad's young music fans hungry for records, and they bought everything the bootleggers could turn out. Taigin now seems to have taken more of a back seat, perhaps because of the risk. He later said that the system destroyed many people, but that in prison he wrote more songs and poetry than ever. Bogoslovsky had also put his time to good use, somehow finding information in the camp library that helped develop his technical knowledge. He now started to cut records at 33rpm: his skill making it possible to fit several songs onto one disc while maintaining audio quality.

Production took place in various rented spaces and empty apartments in the city, as the bootleggers tried to keep a

step ahead of the authorities – but in 1957 disaster struck again. Probably trying to save his own skin, a dealer, one Vterevshegosya, informed on Bogoslovsky, who was re-arrested, tried, found guilty and sent to the White Pillars prison camp for another two years.

Yet again undeterred on release, he announced at a homecoming celebration held by his friends that in parallel with resuming the cutting of Bone records, his goal was now to produce hard black vinyl discs indistinguishable from authentic records. Once more he had used his time in prison well and studied the details of vinyl record manufacture. Now living in a shared apartment on Mayakovsky Street, he executed his clandestine activities in the bathroom at night. He conducted various electrochemical experiments and, using various re-purposed bits of equipment, set about building a home-made record press with a hand-pump attached to a plunger and a galvanised steel bath. This made building a recording lathe look like child's play.

Borrowing bona fide western gramophone records from Albert Erofeev, a collector friend, Bogoslovsky used a chemical process to take master moulds from them – before returning them intact except for the labels, which had all turned slightly brown. Shortly afterwards, he showed Taigin and Sankova two 45rpm single records with large holes in their centres, just like those used in western jukeboxes. Playing them they heard 'Mack the Knife' and 'Rock Around the Clock' sounding to their amazement and delight exactly like the originals.

Bogoslovsky now began to release a series of long-playing 10-inch records, with tunes by Bill Haley, Louis Armstrong, bandleaders Glenn Miller and Ray Anthony, child actor and musical prodigy Nino Tempo, and Pyotr Leshchenko. All had magnificent sleeves and branded labels made by Sankov; all were almost impossible to distinguish from the originals. They were sold at the flea market and even under the counter at record stores. The buyers were understandably delighted.

Pressing records is very different than writing them with a lathe. It does not use film like x-rays; instead it requires polyvinyl chloride as a soft base into which the master moulds are stamped. The raw material was virtually impossible to obtain privately in the Soviet Union, so how was Bogoslovsky sourcing it? Daring and ingenious as ever, he was using an extraordinary method, which realised his dream – but proved his downfall. The official state music stores sold records of the speeches of Soviet leaders – very cheaply, to encourage citizens to listen to them. To provide the base for his own bootlegs, Bogoslovsky somehow devised a means of heating and softening their surface to flatten the grooves. He was cutting jazz and rock'n'roll from the west right onto records of Stalin and Lenin's speeches.

For a year or so, all went well, until a shop worker – suspicious of unnatural sales activity – tipped off agents of the OBKhSS supervising the official stores on Nevsky Prospekt. No one ever bought the records of Stalin and Lenin's speeches, yet Bogoslovsky was ordering hundreds. The assistant that Bogoslovsky sent to buy them, one Yumankulova, was placed under surveillance, arrested and pressured to talk. The police caught Bogoslovsky red-handed at work with his press. He was arrested and tried yet again – this time in 1960 under the counter-revolutionary article 58 of the Criminal Code 'for destroying recordings of V. I. Lenin's speeches in order to replace them with western music – in particular, rock'n'roll' and also for 'production of western records without a licence'. Netted in the same bust, Rudy Fuchs would later stress the irony of this charge of piracy, given that Soviet state record company Melodiya went on to produce records of western music without permission or any payment to the copyright holders, effectively becoming a bootleg operation itself.

Part of Bogoslovsky's defence strategy revolved around the prosecution not being able to distinguish between his records and the originals. A comparative test was made, the

judge herself was unable to tell the difference, such was the quality of the counterfeits. This was a testament to his skill – but it didn't save him. He was sentenced to another three years. Yumankulova got a suspended sentence and probation. Apparently, and with what was surely a bitter irony for both of them, Bogoslovsky would share a prison cell with one of the officers who had arrested him and confiscated his records, before falling foul of the secret police himself.

Bogoslovsky managed to negotiate early release on health grounds, but was warned that if he carried on his bootlegging activities and was caught, he wouldn't be going home again. When he emerged after the third term, he did give up making records – not because of the punishments he had suffered but because the world had changed. The x-ray bootleg era was over. There was no longer any need, or market, for his records. He remained involved with underground music production on magnetic tape, helping his friend Victor Smirnov build a studio to record the baritone Sergey Nikolsky singing criminal songs and compositions by Taigin. Later, with Rudy Fuchs, they recorded another singer, Arkady Severgny, who was to become one of the most famous underground music stars of the 1970s.

Bogoslovsky died in 2003 at his family house on the shore of Lake Hepo-järvi. His son Sergey remembers that even after his involvement in bootlegging, he remained fiercely independent, operating various businesses on the fringes of legality right up to perestroika. Sadly, a fire at the house in the 1990s destroyed most of his collection of records and equipment. Without doubt, he was an extraordinary character, technically gifted, stubborn – or brave – to the point of recklessness, not particularly ideologically motivated yet deeply anti-establishment in his attitude. He also seems to have acted as a kind of mentor to others in the field of unofficial recording. Fuchs described him as the '*hero of Soviet underground record production*', while

Taigin said:

Today, when we can have as much music as we like, we should still remember and bow low to the man who laid the first stone in the foundation of our musical freedom. He did this in the darkest and most terrible years of hard repression, when the mortally wounded red dragon, foreseeing its end, became brutal to the point of extreme savagery, without regard for anyone or anything. And yet this infinitely courageous and purposeful man Ruslan Bogoslovsky was able to defeat this fiend of hell!

Ruslan was able to light up the darkness of the swamp with records from which masterpieces of forbidden music emanated like rays of sunlight. Today there are very few people who even remember him. But his efforts in the fight for musical freedom were so enormous that it would be right for him, as the pioneer of that struggle, to have his own monument!

Eugene Sankova, an alcoholic, was found dead in a chair with his accordion after drinking bootleg liquor mixed with cleaning fluid in the 1970s. Taigin went on to become a publisher of samizdat literature, including important work by the dissident Nobel Prize-winning poet Joseph Brodsky. He died in 2008.

RIGHT **RUSLAN BOGOSLOVKSY, 1960S**

LIKE EVERY DECENT ENTERPRISE, THEY HAD THEIR OWN SUPPLIERS OF RAW

MATERIALS. A GIRL OF UNCERTAIN AGE, A CLINIC RECEPTIONIST WITH HAIR CURLED

UP LIKE A SHEEP, INVARIABLY APPEARED SEVERAL TIMES A WEEK WITH A BAG OF

X-RAY FILM UNDER HER ARM. THEY HAD THEIR OWN SALES AGENTS TOO. THE FIRST

AMONG THEM WAS RODION FUCHS... EVERY DAY THIS 'INTELLECTUAL' HUCKSTER

TOOK OUT A LARGE PACK OF DISCS IN HIS YELLOW FOLDER AND RETURNED WITH

THE SAME FOLDER, NOW FILLED WITH CRISPY BILLS. EACH FIRM TRIED AS HARD AS

THEY COULD TO BEAT THEIR COMPETITORS. THUS, THE 'ROCK ON BONES' (X-RAYS)

WERE GRADUALLY REPLACED BY LUXURY FILMS WITH PICTURES FEATURING GIRLS

TEMPTING EVERYONE WITH SEDUCTIVE POSES AND PROMISING LOOKS, HALF-

NAKED OR 'AU NATUREL'. THESE BRANDED RECORDS WITH NAKED BEAUTIES HAD

BEEN PRODUCED USING PHOTO EQUIPMENT AND FOREIGN MAGAZINES. BUT ALL

WAS SURPASSED BY RUSLAN BOGOSLOVSKY, WHO MASTERED THE MANUFACTURE

OF SOLID LONG-PLAYING DISCS, APPARENTLY PRODUCED BY 'LONDON RECORDS'.

OBVIOUSLY, THIS BUSINESSMAN BENEFITED FROM HIS LONG EXPERIENCE, WHICH

HAS ALREADY TWICE BROUGHT HIM TO THE DEFENDANT'S BENCH

ABOVE WRITTEN BY GEORGY BALDISH FOR A 1960 EDITION
OF THE LENINGRAD NEWSPAPER SMENA (CHANGE),

'The Breakers of Souls' article detailed Rudy's
involvement, Bogoslovsky's crimes and
(unusually since the majority of bootleggers
were male) the participation of a female.

RIGHT 'SHADOWS ON THE PAVEMENT'

ребят и волнения перед экзаменами в техникуме, любящих глаз мужа и первого бормотания такого вот Сережки? А ей, Нине, хочется, чтобы и ты узнала это.

Неужели, Люся, ты сама хочешь обворовать себя, отказавшись от всех обычно человеческих радостей: дружбы заводских

Как же так вот вы не работали? Как же вы жили, ходили по ресторанам, так одевались/ Неужели вам все это не противно?

BONE THUGS AND HARMONY

A handsome older man opens the door of a Moscow apartment. In contrast with the bleak concrete exterior, inside it is wonderfully warm and richly decorated with stained wooden floors, paintings and hand-carved furniture. He serves tea and snacks and settles down to talk. Jazz plays quietly in the background. Flicking through an old photograph album, he half-proudly, half-shyly laughs as he shows images of a young man in the 1960s-70s: a sportsman with Hollywood star good looks posing by a pool, a victorious athlete being awarded a medal at a competition.

THE BIRTH OF A BOOTLEGGER

Mikhail Farafanov, champion swimmer, was once an x-ray bootlegger. In his survey of the vinyl bootlegging in the west in the 1960s-70s, Clinton Heylin described those involved as '*people operating in the twilight zone of insatiable demand for a lot of pleasure and a modicum of profit*'. The early classic bootlegs – Dylan's *Great White Wonder*, for example, or the Rolling Stones' *Live'r Than You'll Ever Be* – were made by music fans who gradually woke up to the commercial potential of their product and had enough entrepreneurial flair to exploit it. They were naturally anti-establishment and enjoyed the cachet of being cognoscenti introducing rare musical treasures to other fans; they also wanted money and enjoyed getting it at the expense of '*the man*'. As time went by, and as the potential profits became more apparent, all sorts of other, less freewheeling, less musically

ABOVE **MIKHAIL FARAFANOV (ON RIGHT), 1950S**

motivated types got involved, and bootlegging became a fringe black market enterprise. Pretty much all of this could have been said of the Bone Music bootleg business that originated in Leningrad in the late 1940s.

As a port city closer to the west than to the central control of Moscow, Leningrad had always been somewhere where cultural innovation began. As Rudy Fuchs put it: '*Everything started in Leningrad, and then afterwards it went to Moscow, and after Moscow everywhere. Russian underground culture always starts in St Petersburg.*'

Boris Taigin and Ruslan Bogoslovsky were just 19 when they started bootlegging. At first they circulated in a loose network of young producers and dealers, who all knew each other and could earn something from doing something daring and cool. '*It was business, but monkey business,*' Rudy Fuchs said.

But as demand grew through the 1950s, knowledge of the techniques spread to Moscow, Ekaterinburg, Kiev, Rostov-on-Don, Baku, Erevan and Odessa – and a new generation of bootleggers appeared. They often operated in small outfits working together under a leader, sometimes in co-operation, sometimes in competition. Novices learned the ropes and then turned 'professional'. Sergei Malakov heard about music on x-rays in 1951 as he served three years in

a prison camp after a drunken fight with the police. On release he sought out the Leningrad bootleggers, worked with Ruslan Bogoslovsky, raised enough money to commission a recording lathe and started cutting records himself.

When *Smena* ran its withering article '*Breakers of Souls*' after a police bust in 1960, Bogoslovsky was named alongside Leonid Babayev ('Lech Golden Hand') and Mark Bobrik ('The Old Man'), as examples of those who had risen from being Bone dealers to running their own enterprises.

Historian Thomas Glanc reports that right up until the early 1960s in Gelendžik there were two 'recording studios', run by a pair of brothers of Greek origin, who apparently earned enough money to buy a Mercedes, albeit one that had been a war trophy.

Other bootleggers worked at home individually, using home-made needles and primitive machines, some of them skilled amateurs like Nick Markovitch's friend Victor Lomanovich, an engineer who built a lathe and cut records for himself and his circle.

Born to an army colonel in 1937, Mikhail Farafanov knew an entire family of bootleggers in the Novogireyevo suburb of Moscow: father, mother and three sons all cutting records day and night. When the father fell asleep, the sons started working. Mikhail's own journey to becoming a bootlegger began early – he fell in love with jazz as a child at the end of the war in Berlin where his parents were stationed:

There was a Polish priest there. The Americans gave him a lot of 78rpm records. My mother approached him and said 'Schumann? These go to you. Beethoven? To you. Jazz? That goes here, to me.' So she sorted out a pile of jazz records.

When they returned to Leningrad, he listened to the records over and over on the family gramophone, until they wore out or broke. When he moved to Moscow aged 15, older kids showed him how to use an adapted shortwave radio to tune into jazz on western stations: he loved Radio Liberty and Willis Conover's *Jazz Hour* on the Voice of America in particular. He would interrupt whatever he was doing to go onto the balcony to try catching the signal whenever it broadcast.

He liked to frequent record stores; he couldn't get jazz there but he enjoyed opera and some classical music too. In 1954 he was in a shop in Sretenka Street when a man quietly approached him, touched him on the shoulder and asked, '*Want some Leshchenko?*' He was rather shocked – such émigré music being considered anti-Soviet. Leshchenko wasn't really his thing but he said he'd buy some anyway. The guy, Valentine Lavrov, sold him an x-ray record. They met again and became friends. Valentine introduced him to the world of Bone Music, and they worked together for a while. Valentine made the records, Mikhail sold them and they split the income into agreed shares. Eventually they fell out over the quality of the records; Mikhail, a perfectionist by nature, became embarrassed trying to pass off poorly made discs on customers. He decided to go solo:

I was alone, a 17-year-old boy in huge Moscow. I started mixing with a crowd of young people a little older than me. Over time, I got to know people who were making records, so I started to look for opportunities myself and eventually bought a recording machine.

THE SOURCE OF FORBIDDEN SOUND

Even when Mikhail managed to get a machine, he had to find material to copy to x-rays with it. In the late 1940s

and early 1950s, this was mostly on gramophone records from various sources. During the war, when the Soviets and the US had been allies, it had been possible to find US records in Moscow and Leningrad. Later, returning soldiers brought all sorts of booty with them – including western records, just as Mikhail's parents had done. And some were still in circulation. Rudy Fuchs said that his friends also used older peoples' collections – since their parents and even grandparents might have pre-war discs with music that was now prohibited. A lot of it still sounded contemporary to their ears and was still in demand. Mikhail recalled:

> *Early jazz records could be found but they were very rare. I remember a collector, Mr Volkov. He was an old man and he had a lot of records. When I first went to his place, he had a huge room about 60 metres square, and they were all piled up there, I recorded lots of music from him.*

Another post-war source was the surviving stock of the '*experimental labels*'. These were various small production houses that operated as private businesses with official approval in the 1930s and 1940s. Some were set up to deal with local demand, others specialised in a particular area: flexible discs, movie soundtracks, radio recordings, theatre performances and so on. In the 1930s, one, the Experimental Manufacturing Plant NKMP in Moscow, produced copies of western records by such artists as Caruso and recorded original material by Russian stars like Vadim Kozin.

For a few years, the repertoires of hugely popular forbidden émigré artists such as Pyotr Leshchenko, Konstantin Sokolsky and Alla Ballanova were copied from discs made with masters stolen from the Latvian Bellacord Electro record plant. After the Red army took control of

ABOVE SHOPPERS AT AN OFFICIAL SOVIET RECORD STORE, USSR IN CONSTRUCTION MAGAZINE, 1939

Latvia in 1940, Vladimir Zaikin, the boss of LEF, a Leningrad label that produced movie soundtracks, obtained permission to travel to Riga to seize the master discs and unsold stock. He got away with using them because his customers were often the party élite and their families.

The discs were known as '*camouflage*' (shtampovki) records – for secrecy, they had no proper labels, just a glued-on paper sticker with the name of the song. From 1944, as his profits and confidence grew, Zaikin expanded production beyond the original stolen catalogue, pressing a much wider repertoire of foreign dance music and recordings from western radio broadcasts. Rudy Fuchs said that the records he made were called '*stutterers*' (zaika), partly a play on his name and partly because so many were pressed that the quality began to drop, causing needles to skip.

The LEF pirates were distributed extensively via bribed officials and record store staff and a lot of money was made. But, as the commercial potential became evident to workers at LEF's plant, they started to make and sell their own copies. Zaikin tolerated or ignored this, probably to keep them quiet, but his activities started to

ABOVE **BEATLES BOOTLEG, C.1973**

attract attention, perhaps because he was becoming too reckless or perhaps because his wealth made him a target. He was arrested, sentenced to hard labour for profiteering and died in a prison camp. The money he had made mysteriously disappeared, and the remaining records vanished.

This supply of looted and pirated discs dried up but the bone bootleggers had other sources. As it was permissible to import some records officially from abroad, émigré music could be smuggled in under camouflage. A pasted over label on a record from the Stinson Record company for example might say that it was by Vertinsky, who was acceptable, but the recording would actually be by Leshchenko, who was not. Such original discs were expensive, but many bootlegs could be made from each.

For jazz and rock'n'roll, trade with foreign tourists was a possibility. Mikhail Farafanov knew a Lithuanian guy who had a connection with an American who supplied him with records and other contraband. These so-called 'fartsovshchiki' (black marketeers) were a presence in every major city right up until the end of the Soviet era. Lots of young Americans came to Moscow for the International Festival of Youth in 1957 and the American National Exhibition of 1959. The fartsovshchiki would loiter outside tourist sites and international hotels, where they could waylay the foreigners with offers of souvenirs and currency at preferable rates. And of course they would offer to buy western clothes, magazines and music.

ABOVE **SOVIET RADIO TOWER, IN RADIOFRONT MAGAZINE**

Another source were the sailors and traders who had permission to travel to the west or to eastern bloc countries where prohibitions were more lax. If they could buy jazz and rock'n'roll abroad there were plenty of eager customers ready to pay a good price on their return.

For those who operated far from port cities like Leningrad, the 'Golden Youth' privileged children of high-ranking apparatchiks, industrialists, diplomats and inner party members might be able to help. Unlike most young Soviets kids, they had access to all sorts of western consumer items, including clothes, food, electronics, literature – and records that they might sell or rent to bootleggers. In his memoir *In Search of Melancholy Baby*, the writer Vasily Aksyonov described how in 1952, as a rough and ready 19 year old from Kazan he was thrust into high society at a Moscow party. There he was stunned to see beautiful young people wearing American clothes, smoking Camels and Pall Malls, chatting in English and dancing to Louis Armstrong, Peggy Lee and Woody Herman: '*There was a US Radiola and a whole pile of US jazz records. Not poor copies on x-rays, but real, actual, black vinyl records.*' One girl, the daughter of a KGB officer, asked him a potentially dangerous question: '*Don't you just love the States?*' Too nervous to risk an incriminating answer, he fell silent. '*Well I do*' she said '*I hate the Soviet Union and adore America!*'

Increasingly, jazz and rock'n'roll were recorded directly from western broadcasts, despite the efforts of the authorities to block them. Radio was seen as a particular danger because pro-western speech and information could be transmitted alongside cool tunes. Though factories were ordered to remove the components that enabled short-wave reception in radios, spare parts were available on the black market, and there was always some technically adept kid happy to fix them up at one of the amateur engineering clubs.

The KGB organised a complex system to try to jam foreign broadcasts by transmitting signals of electronic noise on the same frequencies. Huge transmission towers were constructed around Moscow requiring massive amounts of power (and water to cool them). In an escalating battle of the airwaves, the US responded by increasing the strength of the signals broadcast from Berlin. Jamming came at a vast price for the USSR – estimated in 1958 to be greater than the entire budget for domestic and international broadcasting combined. It was also of limited effectiveness; it was impractical to jam broadcasts continuously and regardless, signals could often be picked up depending on proximity to the border – or even depending on the weather conditions.

As reel-to-reel machines became more available in the late 1950s, bootleggers increasingly used them to record the source audio before cutting it to x-ray. For Mikhail Farafanov, tape was a lot more flexible and easier to use in the field:

I had a tape machine. Sometimes I was recording from discs; sometimes I was recording from radio broadcasts. The BBC was jammed and the Voice of America and of course Radio Liberty – that was the most hostile radio station and the first to be jammed. But I went to Leningrad, Riga, and Vilnius

to find any kind of source to record. I went with my recorder to the south to Sochi and I climbed up the highest point to install the antenna to better catch the signal at night.

Another source, particularly for the forbidden blatnaya songs so loved in the camps, was live performances. These would be recorded to tape and then copied onto x-ray. Singers whose first recordings were made this way included Serge Nikolsky and Arkady Severgny, who later became an underground star. And immortalising oneself on *'the ribs'* even became quite fashionable in the 1950s. The Golden Dog Gang would record Olga Yakovlevna Lebzak, an actress from the Pushkin Theater who liked to sing criminal songs in bars. Viktor Nabutov, a sports commentator who was widely known in the USSR as a goalkeeper for Leningrad's Dynamo soccer team, recorded a number of street songs. When dealers selling the recordings on x-ray were arrested and gave up his name, he faced a heavy prison sentence and expulsion from the Communist Party. He managed to get away with a year's ban from broadcasting – probably because of his public popularity.

If original authentic material could not be obtained, well, there were other ways to satisfy demand. Pyotr Leshchenko was so popular as a singer that a Moscow baritone with a beautiful and similarly tender voice, Nikolai Markov, was hired to record 40 songs from his repertoire. They were

copied onto x-ray and successfully passed off as being by Leshchenko (one, 'The Cranes', often considered a quintessential Leshchenko tune, and much in demand among Bone buyers, was never actually recorded by the master himself).

On another occasion, unscrupulous dealers pretended to have recordings by Nikolai Rybnikov, a famous Soviet cinema actor. Again, a singer with a similar voice was hired to impersonate him, but the x-ray records became so popular that they drew the attention of the KGB. Rybnikov was 'invited' for an interview at the Lubianka. Fortunately a voice expert managed to convince the police that it was not he singing.

DISC-ORGANISED CRIME

Clinton Heylin's description of bootlegging as 'disorganised crime' seems as apt in the USSR as it was in the west. This was a business that combined the love of music, risk, inventiveness, skill, chaos, greed and a deeply anti-establishment attitude in varying amounts. Rudy Fuchs said:

We weren't doing it only for money, but for adventure. Good romantic adventures! We were young. It was our energy.

Mikhail Farafanov said:

To be honest, my first motivation was money and I did well. It brought me a good income; I made a lot sometimes. When you make things well, you'll always have an income. And the thing is, you see, I was 18 years old – I was very energetic. Secondly it was a desire to introduce people to jazz, which I loved so much.

Mikhail had to struggle with the latter ambition: most people were only interested in the émigré songs they already knew, and had to be slowly coaxed into buying jazz.

I tried to promote it but I had little success of course because the Russian ear wasn't yet prepared for boogie-woogie, Glenn Miller, Harry James, Louis Armstrong, Duke Ellington and so on. But I tried... with 'St Louis Blues', perhaps or a famous tune. I would mention Leshchenko or Vertinsky, or the name of the song, for example 'Tatiana'. Sometimes I would even sing: 'Tatiana, do you remember the golden days?' There was a famous film Vagabond *with an incredibly popular Indian actor Raj Kapoor, who sang the song 'Awara Hoon'. I used to sing; 'Awara Hoooon!' and that got them interested. They would always buy that and maybe something from Leshchenko. Then the next day they would come and buy something else, maybe jazz, and then become my regular customer.*

The trade seems to have followed a similar trajectory to the sale of soft drugs in recent decades. At first records were passed round privately hand-to-hand, or bought and sold at a few specific places by those in the know. As demand and business expanded, dealers took to the streets in shadowed courtyards and alleyways, and to the 'baraholka' flea markets, where all sorts of black market illicit trade was done. In 'Undercover Music', an article for an April 1956 edition of the *Leningrad Evening* newspaper, the writer M. Medvedev named and shamed dealers caught in the act:

Who are they, these knights of illicit business, selling records?...
The operator of an electric crane I. V. Fomin, who lives in apartment number 52 on Krasnaya Konnitsa

street, was holding a record with the romance 'I Am Waiting For You', by Izabella Yurieva. And under this record, he had a whole set of others – on x-ray film – with pictures showing half-naked girls...

'These are not my records,' Fomin explained.
'A friend gave them to me to hold.'
'What friend?'
'Just someone...'
'How long have you known this friend?'
'I don't really know him at all'
The fear of being exposed forced Fomin to shield himself from the camera lens with his hand...
We don't know who is engaged in the forbidden business, at whose home all these [records] are made. It is also unknown who supplies the underground sound-recording studios with x-ray film. The militia should immediately become interested in all of this.

After Stalin's death, and in the more liberal Khrushchev era, the risks began to diminish and dealers became bolder. In his venomous *Smena* article Georgy Baldish related how – rather than just lurking in parks or squares – they were brazenly approaching would-be buyers in the Leningrad Melody youth store, bragging about the quality of their wares and competing with others:

Having witnessed a competitor's failure, a representative of a rival firm springs into action: 'The Immortal Leshchenko's "Nostalgia", only five and a half rubles! Melodic and sentimental. I also have "A Glass of Vodka", "At the Samovar with my Masha".'
Two businessmen, the Kravchenko brothers (nicknamed 'The Tatars'), whose sixth sense tells them that Leshchenko wasn't to the customer's taste, enter into the negotiation:

'Ha-ha! That's kids' stuff. Old junk. Don't listen to them. Madam, you are being deceived. It's cheap crap on the bones. I have authentic, branded "Intercontinental", "Victoria" records, "London"... Shall I wrap them up for you?'

The 'Intercontinental' and 'Victoria' records mentioned were the ingenious picture discs made by the Golden Dog Gang from separated x-rays; the 'London' records were the sophisticated black vinyl counterfeits that Ruslan Bogoslovsky was producing. The dealers may have been operating with the collusion of the shop, which was raided several times, but nevertheless survived until the 1960s, when it was finally seen off by the advent of home-taping.

Ambitious traders did not stay local but followed the money. During the summer, some would go south with suitcases full of records, to such holiday resorts as Sochi, where there were always plenty of holidaymakers with money to spend. People would joke that they returned with the suitcases full of cash. Vitka Shustry (Victor Kalistratovich Panyshev according to his ID) was named as a '*top flight shark*', a kind of Mr Big, who was distributing records round the country. Records sold in Minsk in Belarus were brought from Leningrad. Mikhail Farafanov travelled to the northern mining city of Vorkuta where he had friends and could sell records to the miners. This town was a brutal place north of the Arctic Circle, but workers there were relatively well-paid and eager for things to spend their wages on:

The miners were making good money and they were throwing it away. They were young people who didn't really think about their future. I went to the hostel twice a month on their payday, and walked around the rooms offering my goods.

A major advantage that Bone records had over conventional discs was their flexibility: they could be concealed under a shirt, up to 25 on each side (perhaps another reason they were known as 'ribs'). That many could be uncomfortable, so Mikhail devised a way to carry more, by adapting a tennis-racket case and attaching it around his back under his coat. After a while, for safety, he began to hide it – say behind a radiator in a communal hallway. That way he would only be making offers to potential customers, and the police wouldn't be able to do much beyond question him and move him on. When someone who wanted to buy a disc approached him and an agreement had been made, he would tell them to wait for a minute, go off and bring back the pack of discs, so they would not see where he was hiding it.

Bootlegging is a shady business and illicit trade attracts all sorts of participants. Just as in the west, as the appetite for illicit music increased, individuals with purely mercenary intentions joined the party. There was a certain cachet in being a music dealer, and if you were already involved in illicit trading, why not participate in this new hip growing market? There was money to be made and customers were unlikely to complain or ask for their cash back if unsatisfied.

With more ruthless characters getting involved there were new dangers – and not just from the increased attention they attracted from the police. Nick Markovitch tells an alarming story of a rather naïve attempt he made to become a dealer. Obsessed with émigré songs in Moscow in the 1950s, he frequently bought Bone records from a guy near the GUM arcade. He was generally very law-abiding, but had a more rascally cousin who knew a guy who (for a certain sum) would cut them some discs on his recording lathe. Nick would provide the source music from his collection, the cousin would get hold of used x-ray film and they would do some business. Against Nick's better judgment, they produced about 50 'ribs' of jazz, tango and foxtrots. One evening they made their way to a place where deals were done. The cousin made it plain that they were selling and after a while a couple of men came over to trade.

Terms were agreed and the four of them retired to a private stairwell in a nearby building. Immediately, the men turned nasty, pushed Nick and his cousin up against the wall, pulled out a huge knife and said, showing a certain poetic turn of phrase, *'Give us the ribs or you'll get this in the ribs!'* The boys complied and lost their money, and their shoes into the bargain. They got away unscathed, but 50 years later Nick insisted he has never done anything illegal since.

Farafanov was much tougher and could take care of himself, but even he faced dangers. Rogues would watch to see where he hid his records and try to steal them or his money:

We called them racketeers; bandits just come to rob us. I was a brave guy, I learned how to fight, and I learned how to make a person drop a knife. I had a very heavy fist, and if I hit and they didn't fall, I was surprised. I remember a friend of mine was selling records in a communal entrance hallway once, and I felt like something was wrong. I walked in and suddenly I saw this bandit, holding a sheath knife. He was knocking on the railing like this and saying, "Come on, give me what you've got!" I got into a fight with him, he waved his knife, but I knew a technique like that... You go like this... And his knife fell. We ran out of the doorway.

Once he was even attacked by an irate punter who had bought a record that didn't work from another dealer. Mikhail talked him down, gave him one of his own discs to

try and the guy ended up becoming a regular customer. He said that sometimes people needed to be schooled in how to play the records – told what kind of needle and weight to use, and how to make sure the surface was flat. Mikhail was a good salesman; passionate about music, he didn't believe in cheating people and, as quality mattered to him, he gathered a regular clientele. That made business safer and more reliable and as a rule, if he had success selling in one place, he would stay there because buyers would return to buy more.

He was young, living and working in shared apartments, having adventures, growing up. Meanwhile he was studying and travelling around the country. For a little while, he worked in the mines at Vorkuta (where he was nearly killed in a lift accident). Bootlegging, though exciting, was just a way to survive, not his goal in life. His dream was to be a champion swimmer, but there were no professional paid athletes at the time, so he did what he could to support himself. He received a scholarship and sometimes worked as a fire fighter or a gym teacher at a school – he was an enterprising person. As time passed, he did only as much bootlegging as he needed to:

I only needed money for food, and some entertainment. Life was very cheap; you could have lunch for five rubles with a glass of cognac, a piece of salmon and some salad. So I didn't make records on a large scale. I did as much as I needed to earn money for my life... maybe ten, maybe 20 each evening. In some rare cases, I'd make 30 or more.

In the mid-1950s, after meeting Sasha Likhachev, a technician who worked at the central telegraph station and was also bootlegging, he stopped cutting records and just concentrated on dealing:

We talked, he invited me to eat together, and he made me an offer: "Why don't you buy from me? I'll give you the records. You sell them so well, why not sell mine?" His price was very good, I was better off than making my own records.

Of course sometimes his activities brought him to the attention of the KGB. Although he was never caught making or selling records, a disastrous event happened that was to have far reaching consequences:

I was living in a flat with some young people near the Krasnoselskaya metro station. There were four or five of us, drinking, hanging out with girls, listening to music. People came to buy records and once, when we weren't there, some 10-15 of my records and a radio were stolen. We suspected two guys who lived in the suburbs. I went out there and saw one with my radio. I grabbed him and asked, 'Where are my records?' I chased him and we fought at the railway station. They were probably snitches because they wrote a statement for the KGB, who were happy to have some material against me and brought a criminal case. I was already a good athlete, a good swimmer. I was already in the national team. I was wearing the USSR national team uniform when I went to court. The thief was sentenced to one year, and I was given two years in a camp. It was an extremely difficult time – I went insane with hunger – but thanks to my mother, who obtained a pardon, I only spent 11 months there. Just two months later I set a record for the USSR swimming team, then another six months later I set a European record.

Mikhail had previously had a close shave with the authorities. He and Valentine Lavrov had been caught with forged ID badges trying to get into the American National Exhibition in Sokol'niki Park in the summer of 1959. They managed to get away with it that time, but Valentine was later informed on by one of their circle for making a joke about the authorities at his birthday party. He was sentenced to four years for anti-Soviet agitation. Informers were everywhere. Mikhail had more trouble over records and foreign currency issues later. His awful prison experiences were bad enough, but what was much more devastating was that, as a consequence of his criminal record and despite his sporting prowess, he was forbidden from travelling abroad to compete with the USSR swimming team. In fact, he wasn't allowed to leave the country until after perestroika.

But despite these hardships, the persecutions and the setbacks, he went on to have a successful life. He still swims every day and has won many medals at international competitions in recent years. He remains friends with Sasha Likhachev and with Valentine Lavrov (who became a successful author after his release from prison). He now travels to the US, to London and Budapest. He looks at least ten years younger than his age, his mind is sharp as ever and he glows with energy. The craft that he brought to making x-ray records is evident in his apartment with its fully equipped workshop – in the paintings that adorn the walls and in the art objects and furniture he has made for each room. Looking back, he seems free from bitterness:

It was a wonderful time. I felt I was leading the battle against Soviet authority just as Don Quixote battled the windmills. Music has helped me throughout my life – saved me in the most difficult situations. I love classical music very much but not the way I love jazz.

Jazz is my medicine, it is my strength.

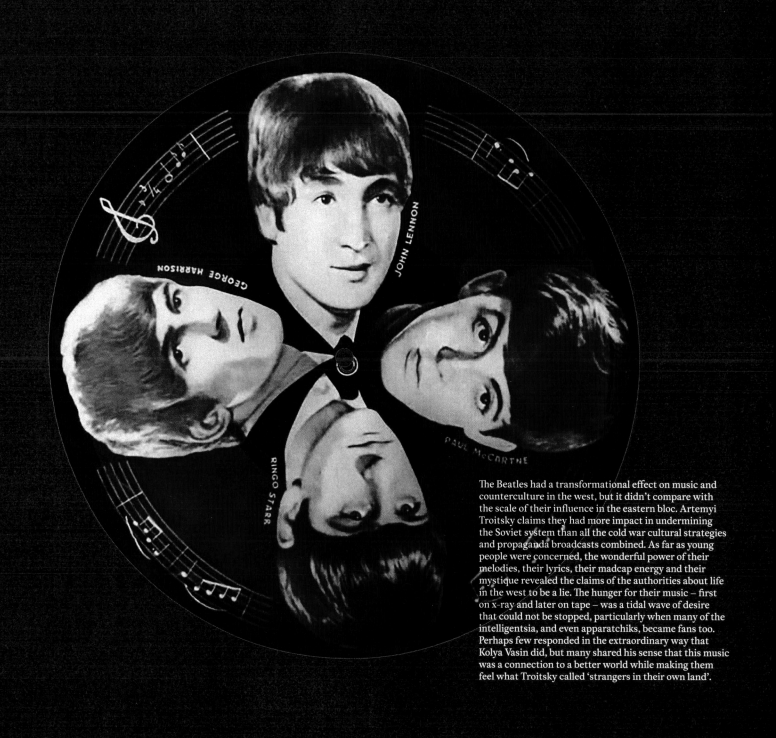

The Beatles had a transformational effect on music and counterculture in the west, but it didn't compare with the scale of their influence in the eastern bloc. Artemyi Troitsky claims they had more impact in undermining the Soviet system than all the cold war cultural strategies and propaganda broadcasts combined. As far as young people were concerned, the wonderful power of their melodies, their lyrics, their madcap energy and their mystique revealed the claims of the authorities about life in the west to be a lie. The hunger for their music – first on x-ray and later on tape – was a tidal wave of desire that could not be stopped, particularly when many of the intelligentsia, and even apparatchiks, became fans too. Perhaps few responded in the extraordinary way that Kolya Vasin did, but many shared his sense that this music was a connection to a better world while making them feel what Troitsky called 'strangers in their own land'.

Смотри, Горкун,
кто еще колошится
там рядом с тобой!
Чья это тень,
для которой все
земные ценности
соединились в
унылом слове
«деньги»? А,
Виктор Пахомов
вечно пьяный и
разнузданный.
Откуда Вы берете
эти деньги?

А мне каждый
день дают
такие... чаевые.

A BONE BUYERS' GUIDE

In a quiet St Petersburg courtyard, behind a graffiti covered wall and a door marked with a hundred slogans of love and peace, there is a temple dedicated to four unlikely gods. The incense perfumed interior is an extraordinary cavern filled with a miscellany of posters, books, esoteric signs, CDs, records, toys, statues – and odd organic altars. Music plays. In the midst of it all sits the high priest of the temple, smiling benevolently at visitors, eager to preach his gospel. All this – the shrines, the objects, the music, the gospel – concerns one subject and one subject alone.

WHAT'S BRED IN THE BONE

Kolya (Nikolay) Vasin was known in Russia as the 'Beatles Guy'. He was born in 1945 in Leningrad after his parents received permission to relocate there from Siberia to work in a collective. In his youth he was an avid purchaser of Bone records. No Russian tunes. He spent whatever money he had on western rock'n'roll. One evening, after a rendezvous with a dealer, he arrived home clutching a newly purchased disc. Excitedly he put it on his mother's blue Jubilee record player, dropped the needle and closed his eyes. As the music began to play, he fell back dumbfounded. The song playing was 'All My Loving' by The Beatles. Something deeply strange had happened. Maybe he had a psychotic episode, maybe he had an epiphany – but from that moment forward, he dedicated himself entirely to The Fab Four, and he never broke faith. He suffered for it: in the 1960s, he was arrested more than once and accused of breaches of social order for promoting Beatles music and organising secret concerts with fellow rock'n'roll fans. He was ridiculed by more conventional citizens and once attacked at the train station by a policeman who, offended by his look, grabbed his long hair and dragged him along the platform while watching commuters laughed. He stayed silent despite the pain and the humiliation in case he was arrested and taken to prison.

He first saw an x-ray record in 1957 when a friend came to his house after school and showed him a disc saying: 'Look Kolya! This is American rock'n'roll!' He took the soft flexible record in his hands, looked at it through the light and saw the image of bones. Immediately, he was fascinated and then, when he put the record on the gramophone and it started spinning, he heard wild singing. He was delighted by the ecstatic screaming voice, and fell back, stupefied. 'Who is this!?' His friend said it was Little Richard and the song was 'Tutti Frutti'. Kolya immediately became a convert at the church of rock'n'roll.

About two weeks later, the same friend asked if he wanted to come to Gostiny Dvor, the grand shopping mall on Nevsky Avenue on Saturday evening: a man he knew would be selling records nearby. They rode the subway from the suburbs, then the tram from Rzhevka for an hour, and somewhere near the Duma area, in a small square with a colonnade, they saw the guy.

I still remember that he came out from behind a column and said 'Come with me,' and we followed him to a dark badly lit corner. There he took out an entire roll of Bone records and started offering them to us, saying, 'That is Bill Haley, this is Little Richard, that is Elvis Presley, what do you want?'
I said: 'Tutti Frutti! Give me Tutti Frutti!'

The guy was a committed rock'n'roll fan who had built himself a lathe and recorded the discs at home. He would sell them on specific days, once or twice a week by the Gostiny Dvor. The records he bought had a dramatic effect on Kolya:

When I played them, I was lifted off the ground,
I started flying. Rock'n'roll showed me a new world,
a world of music, words, and feelings, of life, of a
different lifestyle. That's why, when I got my first
records, I became a happy man. I felt like a changed
person, it was as if I was born again.

CRIMINAL RECORDS

Despite the joys and potential rewards for any young music fan, buying music on the bone was an unpredictable and occasionally risky business. In the early days, dealing was done by personal arrangement among those in the know, but in the more lenient era of the late 1950s, selling became more public as a wider audience for the music grew. Buyers would go to certain locations in the city centre, or to the flea markets as Kolya did, and seek out the dealers.

Typically, a few whispered words would be exchanged and dealer and customer would retreat to a doorway to make a trade. A wad of up rolled up x-rays would be slipped from a sleeve or from under a shirt. After further discussions, one or two would be selected and passed over. For a buyer in search of illicit listening pleasure, there were limited choices. It wasn't like going to a record store and leafing through a selection before making a choice. For a start there wasn't time: these deals had to be done quickly. It was a case of a few muttered words: '*Jazz? Tango? American? Rock'n'roll?*' – or perhaps an artist or a particular song would be requested. Money would change hands. Deal done, the buyer would hurry away, clutching their prize, perhaps going straight home to play it, fired up with anticipation and curiosity. The seller would wander nonchalantly back to their position, looking out for the next punter and keeping an eye out for the police.

No one really knew what they had bought until they listened later. Sometimes they were disappointed; unscrupulous dealers took advantage of naïve customers – for instance if some innocent kid asked for a particular song they didn't have, the dealer might tell them to wait, disappear into the shadows, write the name of the song on any old disc and re-emerge, apparently clutching what had been requested. But at other times, punters would be surprised, delighted, perhaps even completely transformed, as Kolya had been when he first played The Beatles. In the late 1950s in Moscow, there were several locations where dealers could be approached: the arcade of the GUM shopping centre; in an alleyway off Arbat Street; alongside the TSUM department store; by a corner of Dzerzhinskaya Square. In 1960, Bone records were even being sold in the toilets at the first official jazz club in Moscow. They contained rock'n'roll – by then jazz was more tolerated and the club was run by the Komsomol.

Boris Gusev bought records from a dealer on a corner by Red Square in the 1950s – right at the heart of the Soviet establishment. He said that Bone records were like an elixir that made him forget about all the bad things in life. Like many young Soviets he became hooked on jazz when it was played on the radio during the war, and was prepared to risk buying bootlegs to get his fix now it was banned. After getting a record he would rush home, call his friends over and they would listen very quietly so no one else would hear.

Viktor Sukhorukov was not so lucky. He describes how in the early 1960s he went to GUM to buy food. He was just leaving when a guy selling pastries asked if he wanted to buy some Beatles music. Viktor was nervous but agreed. The price was two rubles, the equivalent of a kilogram of sausages. The dealer took a big roll of x-rays from his sleeve. He gave Viktor one and told him to hide it quickly. Viktor paid and hurried off to the metro sweating, imagining that everybody knew what he had done and worried that the KGB would catch him. He had bought the record even though he didn't have a gramophone and had to go to a friend's house that evening to play it. When they put it on,

they discovered there was only 14 seconds of music and they had absolutely no idea whether that was by The Beatles or not. The rest of the disc was empty. He was terribly ashamed – partly because he had been scared and partly because he had been fooled.

Even when there was a complete song, sound quality was a big issue. Kolya said the records were often full of distortion, hum, skips, scratches and mistakes. When he and his friends got to know a dealer well and could listen at his place before buying, they could be a little more choosy:

We would say: 'This is "with sand"? I won't take it,' or, 'Give it to me half price, it crackles so.' Sometimes you would put a record on to play and the crackling would be almost the same volume as the music. Those records would be far cheaper but they wouldn't be much wanted.

Dodgy records like those were usually the product of poor workmanship, though rock journalist Artemyi Troitsky told me about possible other, more sinister recordings.

There was a lot of talk about fake x-ray records, you know. A customer pays money for a disc and gets home to play it and after a few seconds of rock'n'roll there is suddenly a voice shouting four-letter words in Russian and saying 'So stilyagi you wanted some fashionable music huh? Well go fuck yourself you American-loving idiot!' I never heard one myself but these stories were very common.

It may be that the KGB went to the trouble of recording such discs and pretending to be dealers to deter young

people, if it wasn't a prank by mischievous bootleggers – or perhaps it is just another Bone myth. Mikhail Farafanov said that he couldn't imagine any of the dealers he knew alienating customers by selling them something like that – or wasting their own time making it. Sometimes, things worked out better than expected in unpredictable ways. The jazz pianist Igor Brill says that when he was 14 he went to the GUM arcade to try to buy some jazz on x-ray. He was sold a disc and when he got home was delighted to find that it wasn't jazz but blues. For him, such a record was an education because no sheet music was available – it was how he learnt to play.

What were the risks for a kid buying records? Dealers or those caught making discs faced potential imprisonment and exile, but if young people were caught they would not usually be prosecuted. Their records would be taken away and their name noted down. If they were a member of the Komsomol youth organisation, they might be dressed down publicly at a meeting, and repeat offenders would have their careers or studies threatened. That in itself of course could

ABOVE **NICK MARKOVITCH, 1950S**

be life-changing. Igor Brill said his mother was so worried about the records he was buying getting him into trouble that she wrote him a letter to express her fears – even though they shared a single room in a communal apartment.

Kolya was never caught:

I was a crafty boy, smart and I knew how to hide. I knew how to make deals quietly and unnoticed. But I knew a guy who did get caught, by the Druzhiniki, the voluntary police force, who would patrol the area, sneaking around the places where the boys were selling records. He had all his records confiscated and his parents were spoken to. After that he never had anything to do with music again.

Kolya got the cash to buy records from his long-suffering mother, a kind woman and a Christian who worked in a pharmacy. She would give him money before school and tell him every day '*Kolya, here's two rubles. On your break buy yourself some milk and a roll, and eat.*' In Russia where women usually managed the family budget, this was the typical amount given to husbands or children for their daily lunch money. It was also the cost of the standard quarter litre of vodka. Kolya said that you could exchange a record for a small bottle of vodka – at those times a sort of unofficial currency unit. He always spent his lunch money on Bone records.

After the Soviet currency revaluation in 1961 a standard official gramophone record would cost around five rubles and a foreign disc with a forbidden tune probably ten times that. A Bone record would usually cost two rubles, and sometimes just one, depending on demand. Mikhail Farafanov sold them at one ruble a piece but would even discount them to 90 kopecks if the customer bought a few. Before the revaluation, the price was about five rubles. The Golden Dog Gang's beautiful western-style picture discs, 33rpm long players and the black vinyl bootlegs Ruslan Bogoslovsky made were all sold at a premium, of course.

When bought, discs would be carefully kept at home, perhaps wrapped in newspaper and hidden in a drawer. They were fragile so this would protect them and avoid discovery. They would also be traded or swapped, their value determined by the song they contained and by the sound quality.

THE DEVIL HAS ALL THE BEST TUNES

For Kolya and his friends, there was only one thing worth buying: rock'n'roll. They weren't interested in Russian émigré tunes, gulag songs, tango or even jazz. It was the beginning of the 1960s and they wanted the raw, rough exuberant energy of American and British rock: Elvis, Bill Haley, Little Richard and The Beatles. From the moment Kolya first heard these artists he concentrated his energies and resources on buying Bone records with their tunes. For him (and for many other young Soviets), The Beatles in particular represented something extraordinary. Appreciation of the band became the arbiter of someone's worth. Anyone – parents, peers, family members, teachers, or officials – who were negative about them would be dismissed as being of no account. Their music was, and remained, a spiritual matter for Kolya.

For many Soviet kids, x-ray discs with their strange, spectral sounds were not just carriers of music, they were

the carriers of a dream, symbols of something completely other: in the midst of all the greyness, the restrictions, the confines of censorship and control, they represented one thing above all else – freedom.

Kolya '*emigrated*' from the Soviet Union to what he called the '*free territory of Russia*', whose capital was the Temple of Love, Peace and Music, in a couple of rooms off a Leningrad courtyard. Every surface was covered with Beatles images, records, books, memorabilia, statues, artwork and the strange organic altars he had made to John, Paul, George and Ringo. He was the high priest of the temple. He was unable to reconcile himself with the fact of John Lennon's death and told me he believed Lennon was still alive and producing music somewhere in Northern Italy, waiting for better times. He kept The Beatles Bone record that had set it all off – but he didn't play it. Even if it would still work, it was too precious. He became well known throughout Russia as the 'number one Beatles fan' and was happy to sit with a Beatles record playing, wreathed in incense, talking to anyone who came to see him about the music that had changed everything:

They are the joy of my life. It is a prize that I thank God for every night, praying 'Thank you Lord that today I listened to such holy music,' and it has been this way these past 50 years. When I heard them I felt something so phenomenal, even the great Little Richard whom I had adored faded for me. They enlightened me; Little Richard was happiness but The Beatles were insanity, something else, the limit, something unexplainable. And I understood everything. Then I started building them a shrine, I felt in them a holiness.

Kolya died in 2019. Apparently he committed suicide by throwing himself off a balcony in a shopping mall. The circumstances are mysterious but it seems something had happened, something that had finally caused him to give up on his long-treasured dream of a permanent official temple to The Beatles in St Petersburg. It was a crazy dream but one that had sustained him through the worst of times, and without it he was unwilling – or unable – to carry on.

PREVIOUS PAGE & ABOVE 1950S CARTOONS SATIRISING STILYAGI FROM KROKODIL MAGAZINE

Замечательно!

Интересно знать, от кого чаевые.

От всех.

Ах вам чаевые дают! И вы их берете?

И я их беру.

THE COLD WAR KIDS

The band takes its place on the stage and strikes up a groove. The audience's scattered clapping intensifies and cheers break out as a slightly bent, slightly fragile figure walks from the wings, picks up his sax and starts to blow. It's a familiar tune – 'Take the A Train' – nothing too radical. It's well done, if polite, and that's fine – people haven't come to be challenged or to hear something experimental; they have come to see the sax player, to share a space with him for an evening. After a short set, the band retire for a break in the dressing room; the old guy sits quietly, slightly apart, reflective, sipping tea. Aleksei Kozlov has done this a thousand times before and in his 85 years, he has pretty much seen it all.

TODAY HE DANCES, TOMORROW HE WILL SELL HIS HOMELAND

In Valery Todorovsky's 2008 hit musical movie *Stilyagi*, the lead character Mats is based on Aleksei – albeit played in a romanticised version of his life. Aleksei grew up in Moscow during the period after the war, an ordinary kid who became a self-taught sax player and eventually one of Russia's best-known jazz musicians. This was also the period when outlandishly attired young creatures, elaborately coiffed and quiffed, first began appearing on the streets of Leningrad and Moscow. For a while, Aleksei was one of them: a 'stilyaga'.

What was a stilyaga? The word first appeared in 1949 in D. Belyaev's derisive piece in the satirical magazine *Krokodil*:

The most important part of their style is not to resemble ordinary people. And as you see, their efforts take them to absurd extremes. The stilyaga knows the fashions all over the world. He's studied all the foxtrots, tangos, rumbas, lindy hops in detail, but he confuses Michurin with Mendeleev, and astronomy with gastronomy... he flutters above life's surface, so to speak.

Often interpreted as 'dude' or 'hipster', 'stilyaga' translates as 'stylist' or 'style hunter' – though 'follower of fashion' perhaps better conveys its meaning. The term was intended to be derogatory, just as 'beatnik', 'hippie', 'punk' and 'goth' were in the west, but was adopted, as they were, as a badge of honour by those it lampooned.

In D. Belyaev's piece are found all the criticisms that would be leveled at the stilyagi: they were anti-socially individualistic; they unpatriotically aped western fashions; they were culturally ignorant and they were shallow. But veteran Russian cultural commentator Artemyi Troitsky says the stilyagi were important because they publicly risked being different at a time when difference could be dangerous. Certainly they originally took their inspiration from the US music and style disseminated during and just after World War Two:

There was a very short but very colourful period when there was a lot of western culture suddenly showering the country. And this culture came from two main sources: we had American cars, food, clothes and even warplanes being sent to Russia in amazing quantities. The Americans as a gesture of goodwill and support sent all this to the Soviet Union during the war.

But there were other things we cared about. After the war, there was a great festive mood in the country, and this mood was in a way supported by the western colour films and comedy movies that were shown.

The most popular of them were musicals, like Sun Valley Serenade *(1941) and* George's Dinky Jazz Band *(1940). 'Sun Valley Serenade' in particular was the movie that the stilyagi style was picked up from.*

Suddenly here was a generation of Russian youngsters who wanted to look like the girls and boys in these films and who loved their big band scores. For a while, there were even clubs where they could gather to dance to an orchestra playing American-style jazz – but by 1948, when the Iron Curtain had dropped and the Kremlin had intensified its 'anti-cosmopolitan' campaign to eliminate western influences from Soviet art and culture, such places were closed. US movies could no longer be seen in the cinemas. But those who had loved their style didn't want to stop. As clothes could not be imported from the west, the stilyagi started making things themselves, the guys initially wearing super-wide trousers and getting their mothers and sisters to knit sweaters with reindeer designs, or to cut wildly patterned neckties from curtain fabric. This style evolved until it settled around a version of the British Teddy Boy or *Grease*-era US 1950s rock'n'roll look. Now the boys favoured trousers with narrow legs, thick crepe-soled shoes, loud patterned shirts and garish jackets; the girls wore heavy make-up, heels, pant suits or brightly coloured short skirts; they sported elaborate hairstyles with quiffs and perms.

It was a cartoonish version of the original but it certainly stood out in the USSR, as it was intended to, when they paraded up and down a big city avenue chewing gum made of paraffin wax and talking loudly in their own lingo. Argot is another way for any subculture to distinguish itself and the stilyagi developed a jargon contemptuous of the clichés that peppered official parlance, combining anglicised Russian, criminal slang, vulgarity and hip US talk. They called Nevsky Prospekt '*Broadway*'; apartments suitable for private parties

'huts'; they called each other American names like '*Bob*', '*Bud*', '*Eddie*', '*Polly*' and '*Betsy*'. Vasily Aksyonov said there was a time when he and his friends spoke to each almost entirely in quotes from US movies. In a society where conformity and hegemony were enforced, this sort of behaviour was objectionable – and that of course, was part of the point.

Boogie-woogie, swing and jazz were the stilyagi music of choice until rock'n'roll arrived. Policy makers specifically targeted jazz but despite all the edicts and anti-jazz invectives in state media, young people remained desperate and determined to get their hands on it. Aleksei Kozlov was fortunate enough to have a modern portable gramophone player that his father had bought him, plus a small collection of now-prohibited pre-war records. Some were the jazzy styled Russian tunes of Leonid Utyosov, Alexander Tsfassman and Eddie Rosner; others were gypsy tangos by Pyotr Leshchenko, Alexander Vertinsky and Isabella Yurieva. There were even some recordings of western music – Duke Ellington, the Mills Brothers, Ray Noble, Harry Roy and Eddie Peabody. Some of these he had inherited, some he had bought and he was also able to pick up more modern stuff like Glenn Miller and the Benny Goodman Orchestra by trading with kids whose fathers had brought them back from Germany. He even stole a few records at school social evenings when teachers would invite children to bring in music from home. He would covertly leaf through what was brought, noting the rare and special discs, the war trophies amongst the boring stuff he had no interest in. He would distract the Komsomol member playing records and hide the ones he wanted until later.

It was not difficult, two or three select records went under my collar and down my back. Then before the evening ended, they were carried out of school under my shirt and hidden in a place in the yard to be retrieved the next morning without risk.

КОМСОМОЛЬСКИЙ ПАТРУЛЬ

НЕ ЗА УЗКИЕ БРЮКИ,
А ЗА ХУЛИГАНСКИЕ ТРЮКИ.

ABOVE POSTCARD WITH CARTOON SATIRISING STILYAGI

He knew there were places where these records would be truly appreciated – played on a portable player in the yards behind the communal apartment block with his buddies or at the secret stilyagi parties he started to attend. Looking back, he justified the theft by the fact that those he stole from didn't really know or care what they had, whereas to him these records were an inspiration and became invaluable in his musical education.

Some stilyagi were children of the higher party ranks, the privileged 'Golden Youth' jet set who were the main source of information about the west because they could travel abroad or get hold of western magazines and records. Others were from families of the intelligentsia – the children of doctors, engineers and teachers – and there were also some ordinary working class kids. As has often been the case, pop culture, music and style acted as a class leveller in ways that ideology could not. As the 1950s wore on, there were stilyagi in most big Soviet cities: in Leningrad and Moscow of course, but also in Baltic capitals like Riga. Even in smaller towns there were a few, though they were a tiny minority there and were probably more subject to harassment.

MONKEYS AND CROCODILES

Troitsky says the scale and influence of the stilyagi movement were disproportionate to their numbers because of two things: first, because they looked so different and provoked scandal, and second, because they featured so heavily in state propaganda, a perfect focus for anti-western campaigns via critical articles, newsreels and an extraordinary number of satirical cartoons. *Krokodil* in particular lambasted them, as craven hostages to western influences, work-shy spongers overindulged by foolish parents, narcissists wasting their time with freakish dancing and parading in peacock attire while their productive peers and conscientious compatriots got on with the serious work of building the new socialist utopia. They were often shown as parrots or monkeys (a faintly racist reference here to jazz players). Yet to our eyes, those depicted in these cartoons simply look cooler – and seem to be having much more fun than their peers. A slew of propaganda films rammed home the hostile message, ridiculing dancing to the twist or to boogie-woogie and highlighting anti-social behaviour. In Roman Grigoryev's 1955 *The Happiness of Difficult Roads*, dancing stilyagi (real or acted) are pitched against upright examples of wholesome Soviet gymnasts, while in the *Leningrad Newsreel* (1956, No.6), a stilyaga harassing an upright Soviet girl reading in the park is detained by sober members of the Komsomol. A performance by comrades Kuznetsova and Bokalov of the city police department of the heavy-handed satirical duet 'Stilyaga' follows:

Valyusha, do not scold him
Maybe he is a lost parrot?
Or maybe when he was little,
Someone dropped him on the floor?
Can he be sick, poor thing?
No, he's just a Stilyaga!
Stilyaga! Stilyaga!

Infantile as it seems here, this kind of ridicule could take on a more sinister hue. Awarded the title of Honoured Artist of Russia in 1995, the celebrated singer Nina Dorda recalled her sufferings in the late 1940s-50s. Towards the end of the war, she had joined the Pokrass brothers' dance jazz band, performing for troops at the front, and even singing on a submarine. But after the 1948 prohibition of improvisation and instruments that were '*elements of bourgeois culture alien to socialist morality*', the band was broken up, and she found herself on the street and hungry; nobody would employ a former '*jazz*' singer. Desperate, she took a job in a restaurant singing approved repertoire whilst standing stock still – her performance was being monitored by the NKVD, as was the audience. Later, although never really a stilyaga herself, she drew disapproval as one of the first young women to drive the sporty GAZ-M20 *Pobeda* (*Victory*) car in Moscow. She was prevented from going on foreign tours for being wayward, for not going to Komsomol meetings and for being '*an individualist*', and was even recommended for re-education by the Minister of Culture.

In 1954, in the more liberal atmosphere following Stalin's death, Dorda joined Eddie Rosner's orchestra playing polite ballroom '*soviet jazz*'. Rosner had just returned to Moscow after eight years in a gulag. He was broken, fearful and suffering from scurvy, a terrible condition for a trumpeter, yet his humiliation was not quite over. The orchestra wasn't allowed to play in major venues, the press were forbidden from mentioning him and the 'Stilyaga' satirical song was included in his set. At the end of each chorus, to the delighted laughter of the audience, the entire orchestra would turn to him pointing and shouting '*Stilyaga! Stilyaga!*'

ROCK AROUND THE BLOC

The stilyagi were the Soviet example of a family of youth subcultures sprouting throughout the eastern bloc, each fuelled to different degrees by western pop culture,

ABOVE **EDDIE ROSNER, 1946**

ADOLPH IGNATIEVICH ROSNER, KNOWN AS 'EDDIE' ROSNER, WAS A BERLIN-BORN JEWISH JAZZ TRUMPETER WHO FLED GERMANY AS THE NAZIS CAME TO POWER.

Like many others buffeted by the tides of war and shifting political borders of eastern Europe, he ended up marooned in the USSR. His big band, the 'State Jazz Orchestra of the USSR', toured entertaining troops and party members with Stalin's approval. Nicknamed the 'white Louis Armstrong' for his rendition of 'St Louis Blues' (and given the seal of approval by Louis himself), Rosner became rich and was made an Honoured Artist of Belorussia. But in 1946 he made a catastrophic mistake by trying to escape to Poland across the Ukraine border with his family. The newspaper *Izvestia* published a devastating article, describing him as a 'third-rate cabaret trumpeter mired in servility to the west'; he was charged with conspiracy to insult the fatherland and sentenced to ten years in a gulag in Siberia. Just like Vadim Kozin, Rosner was saved by the gulag boss, a fan who allowed him to form a band to entertain prisoners and officials on tours of the gulag system. He was amnestied after Stalin's death, along with a multitude of other non-political prisoners.

movies and music. As noted above, Hungary had the *jampecek*, while in Poland there were the *bikiniarze*, in Czechoslovakia the *potapka* and in Romania the *malagambisti*. All dressed in an ersatz western style and aped US mannerisms. Like their western counterparts, and the earlier French 'zazous' or German 'Swingjugend' (swing kids), they all used music and clothes to distinguish themselves from the older generation, and from their more conventional peers.

Antagonism to these cold war kids was partly based on their espousal of foreign values, but was also part of a general social anxiety, shared in the west, about youth culture. Following the end of rationing and the miseries and sacrifices of war, a new kind of young person was emerging: the teenager. On the one hand they were seen as a new and attractive group of potential consumers and on the other, as anti-social tearaways, hooligans, disrespectful of their elders, ungrateful, spoilt, entitled, lazy, immoral and a sign of the decay of society. On top of the perennial suspicion of the young by the old, there was an understandable shock at the effects that increasing affluence, global communication and the questioning of moral certainties were having. That shock was largely expressed through the media – with hysterical features and alarmist op-eds often focused on the harmful effects of rock'n'roll.

In the US, rock'n'roll was described as the 'devil's music' – just as the blues had been before it – and drew rabid conservative ire and several outright bans. In 1956, the city authorities in Santa Cruz, California announced an absolute prohibition on rock'n'roll at public gatherings, claiming the music to be '*detrimental to both the health and morals of our youth and community.*' This ban came after a party at which a crowd was '*engaged in suggestive, stimulating and tantalising motions induced by the provocative rhythms of an all-negro band*'. Similar bans followed in Asbury Park in New Jersey and San Antonio in Texas. The evidently racist

ABOVE **BILL HALEY AND HIS COMETS, 1956**

IT IS DIFFICULT TO OVERESTIMATE THE EFFECT THAT BILL HALEY AND THE COMETS AND 'ROCK AROUND THE CLOCK' HAD ON KIDS IN THE EASTERN BLOC. IN THE USSR, THE SONG ATTAINED AN ALMOST MYTHICAL STATUS AND WAS A FAVOURITE ON X-RAY (IT WAS ON THE FIRST BONE RECORD THAT I CAME ACROSS).

Its lyric – 'One two three o'clock four o'clock rock' – might not seem particularly anti-Soviet, but the invitation to ignore everything in favour of non-stop dancing provoked the authorities as much as it delighted the stilyagi; it was an overt rejection of the older generation's work-orientated morality and a celebration of fun carried along by the raw energy of electric guitar and pounding drums.

The song had a revolutionary effect in the west too, galvanising the British teenagers who heard it blasting from cinema speakers over the opening credits of the US high school drama *Blackboard Jungle*. 'Jiving' had been banned from British ballrooms in the 1950s and the staid BBC declined to play any rock'n'roll (or much jazz) so when the movie *Rock Around the Clock* hit the cinemas, kids went wild, dancing in the aisles. The musician Billy Bragg told me how his aunt and uncle watched it at a cinema in Romford when the police had to be called. Teddy Boys who were prevented from jiving grabbed the fire hoses and soaked the officers. The newspapers were in uproar.

attitude of such critics was thrown into further confusion when white boy Elvis Presley started to become massively popular. His music suffered prohibitions at various times too (and still does apparently: a musical called *All Shook Up* was banned in Utah as recently as 2013). The US right's pseudo-moral disapproval of young, cool music may have emerged from fears about interracial socialising and sex, but its rhetoric greatly resembled that found on the atheist side of the Iron Curtain. In the Soviet Union, '*sexual rhythms*' and '*suggestive lyrics*' were regularly claimed to be in danger of tempting the innocent off the path of virtue, towards acts of depravity or social disobedience.

In the US, the disapprobation soon combined with the anti-communist propaganda of the fundamentalist Christian US right. The firebrand writer David Noebel – who regularly warned of the Red Threat to the US – claimed that Communists were using pop music to brainwash young people. Such openly left-wing folkies as Joan Baez and Pete Seeger were the first to attract his indignation, but he gradually became convinced that more mainstream artists – like Bob Dylan, The Beatles, and in particular John Lennon – were intent on corrupting US youth, and were deliberately being used by the Soviets to do so.

But of course the reverse was true. The Americans and the British were broadcasting music into the eastern bloc, deliberately targeting the young with programmes attempting to convey the attractiveness of western values. They were successful: jazz and rock'n'roll became the cornerstones of stilyagi identity, western radio provoked their appetite and – as a recording source for bootleggers – offered a means to satisfy it.

DANCING ON BONES

The stilyagi era roughly corresponds with that of Bone Music, and the stilyagi made up a significant proportion of those buying x-ray bootlegs of western jazz and rock'n'roll.

ABOVE 'COMMUNISM HYPNOTISM AND THE BEATLES' DAVID NOEBEL

Some even cut their own discs with homemade machines. Having access on records that you owned to the music that you loved was a revolution for Soviet kids. Now they could be played repeatedly, at any time, anywhere and with anyone you wanted. They showed off your style, your taste, your identity, they connected you with others who were like you; they were a rejection of the norm, a symbol of resistance – especially if they were underground, illegal records.

Victor Dubiler grew up in Donetsk in the Ukraine. He was an avid jazz fan from an early age (and went on to be one of the first promoters of jazz festivals in the USSR). He would balance his portable record player on the window of his parents' apartment and would proudly play his discs of western tunes into the communal courtyard – to the delight of his friends (and the despair of his older neighbours). But that was in the more relaxed climate of the early 1960s; in Stalin's era, it would have been a very risky act indeed.

Even more exciting than listening to music was dancing to it. Wild dancing of any sort and especially boogieing to western tunes or Latin rhythms had always been seen as a moral slippery slope in the USSR, as we saw with the prohibition of the foxtrot before the war. In 1952, an official Komsomol report lacerated various

'dance "speculators", who distort the tastes of Soviet youth by "propagandising degenerate western foxtrots, languid tangos, and vulgar rumbas",' and who, even under pressure, had wilfully continued to '*teach ballroom dances in a vulgar foxtrot style*'. This must be stamped out. And it was, said Mikhail Farafanov:

> *When I was 16-17 years old, I went to youth dance nights, and there were no foxtrots allowed. Everyone was dancing to Lezginka or Kabardinka. If someone did the foxtrot, the lady superintendent would come up to us and say, 'You are not dancing in the right way, you cannot dance like that!'*

Aleksei Kozlov said that the social evenings specially arranged for young people were deadly boring, since they were supervised by teachers and counsellors for the Pioneers (the Soviet ideologically driven equivalent of the Scouts) and everything was controlled: clothes, hairstyles, manners and dancing styles. Only old-fashioned dances were allowed: the padegras, the padepatiner, the polka or the waltz. The foxtrot or tango might be permitted, maybe once per evening, depending on the mood of those supervising and as long as the dancers remained restrained. Promoters became cunning, announcing events such as lectures about forbidden dances – '*with demonstrations*', but as soon as the students did anything wild, a sign was made to those in the DJ room, the record was removed and a sedate ballroom tune was put on. Even Khrushchev, credited with ushering in a more liberal era, strongly objected to the Twist:

> *Why should we give up our folk dances? Not just Russian or Ukrainian, Uzbeks, Kazakhs, any of our peoples – their dances are smooth and beautiful. But this! They do such gestures with certain parts of the body? It is indecent! And this is new? Comrades, let's still stand for the old days. Yes, for the old days and not to succumb to this decadence.*

But then he also claimed that jazz '*gave him gas*'.

Against such a background, secret stilyagi parties were terribly exciting. If a suitable discreet venue (such as a '*hut*', or empty apartment) could be found, girls and guys would rendezvous to drink, smoke, play records loud and go wild to jazz and boogie-woogie. Kozlov recalled that three dances became *de rigueur*: 'The Canadian' and 'The Atomic' based on the lindy hop and the jitter bug, and 'The Triple Homburg', a slow foxtrot with male and female bodies pressed close together, special body movements and a particular wiggle of the head.

Of course, if discovered, such parties would be broken up. Kids would be rounded up, names noted down, records confiscated, equipment smashed, repeat offenders might be expelled from educational institutions and the Komsomol – which was probably no great tragedy for a working-class stilyagi but was certainly an issue for anyone from the middle-class. Young people couldn't actually be prosecuted for attending, or for wearing lime green, orange jackets or ultra-skinny trousers – there were no criminal articles identifying forbidden clothes – but they could be harassed. The fight against fashion was conducted by the voluntary youth organisations. The Komsomol operated an enforcement patrol called the Druzhinikki, which roamed the central streets of big cities on the lookout for wrongdoings and violations of whatever was considered proper. The perfect targets for such raids were of course the stilyagi. If they were caught on the street going to or from a party, they might be menaced and have some pretty nasty things done to them, including the slashing of trousers or kipper ties and the forcible cutting of hair.

ABOVE **MIKHAIL FARAFANOV, 1960S**

The encouragement of this kind of vigilante policing was one of the more sinister aspects of the Soviet system and not one experienced by the western teenager. Aleksei Kozlov said that it got particularly bad after the International Festival of Youth in 1957, when lots of young male US students were in Moscow. A flood of Russian girls entranced by these handsome strangers and keen to experience something exotic, approached them with abandon, for quick liaisons in the darkened areas around the tourist hotels. As soon as the authorities found out what was going on, they sent in patrols with electric lights to root them out. The foreigners were sent back to their hotels, but the girls had their hair forcibly cut so they could later be identified and shamed.

REBELS WITHOUT A CAUSE

Artemyi Troitsky says that it wasn't only the establishment and Komsomol types who despised the stilyagi. His mother and father, who in many respects were pro-western and broadminded, thought negatively of them too:

My parents were very clever and well educated people, they had graduated from the historical faculty of the Moscow State University and they knew a lot about western culture. They studied literature, they read prose by Hemingway, they loved the French

Impressionists and chanson but they disliked the stilyagi. When I later asked them why, they told me: 'We thought they were vacuous and superficial, only interested in clothes, dancing and parties.' They thought this was undignified behaviour for intelligent young people. There was no ideology in their contempt, it was just the attitude of young intellectuals towards young partygoers.

That attitude was also shared by some involved in the x-ray bootleg underground and who were anti-establishment themselves. Nick Markovitch blanched when asked if he'd been a stilyaga; Kolya Vasin loved rock'n'roll but thought the stilyagi shallow; Rudy Fuchs loved all sorts of music beside jazz and rock'n'roll, and wouldn't pigeonhole himself as a stilyaga; Mikhail Farafanov – who sold them records and wore western-style clothes himself – found them faintly embarrassing. He says that many young people he knew loved jazz but did not want to stand out by dressing controversially or aping western fashions:

A stilyaga was in general a person who made something that he considered fashionable out of Soviet clothes – he would make shoes with a thick sole, narrow pants, wear long foolish hair styles. Me and my friends were dressing the way Americans were actually dressing. We were wearing button-down shirts, American shoes, and raincoats. We were sometimes called stilyagi, but usually we treated them with contempt, because they were often very dull people who just copied the exterior.

As a bootlegger he couldn't afford to stand out too much, but even so, his clothes once caused him a frightening and potentially fatal experience when he was in the far north

to sell records. He was travelling near Vorkuta on a bus and wearing an American raincoat. Some young guys took exception to the way he was dressed and the way he spoke; they made the driver stop the bus, dragged him to the side of the road, tore off the raincoat and beat him up.

'THE EXCHANGE'

For Aleksei Kozlov, meeting with and becoming one of the stilyagi set was part of his evolution – both as a young guy disillusioned with the Soviet system and as a musician. Through them he heard more jazz, met players and became set upon becoming one himself. One of the stories he tells is of 'The Exchange', a place in Moscow where music lovers and musicians of various types would gather. After the war, it was at the corner of Neglinnaya and Pushechnaya Streets and from the end of the 1950s, in an alleyway between Marx Avenue and October 25th Street. Promoters would come there to hire musicians, so that The Exchange functioned as a kind of unofficial agency and a discreet meeting place for jazz players – many of whom had been forced play in other styles or give up altogether. Alexei first started to go there in 1956 hoping to learn new piano styles, particularly the left-hand technique used to play stride and boogie-woogie; The Exchange also operated as a kind of underground school where players could learn from each other, swapping tips on style, method and harmony. Sheet music and even instruments could be bought, sold, borrowed and swapped – along with x-ray bootlegs of the latest hot American and British tunes.

Alexei was finding his way, enjoying playing rudimentary jazz piano and a bit of double bass, but his real inspiration was the US saxophone player Gerry Mulligan. The sax of course was banned as an anti-Soviet symbol of US culture beloved only of hooligans, but one day he found a pre-war German alto hidden under the stage at the youth music club he attended (it had a swastika on it, he told me, so had presumably been looted during the war). In an unusually

ABOVE **VOICE OF AMERICA POSTAGE STAMP**

liberal and possibly risky act, the club director allowed him to borrow it. Over the next few months he learned to play – getting tips from jazzers at The Exchange, buying home-made reeds from an old guy he met and playing along with old jazz sides and Bone records.

As the 1950s turned into the 1960s and the thaw opened Soviet culture up to more western influences, jazz gradually became more tolerated. The first official jazz event took place in Leningrad in 1958 via a '*lecture concert*' (a talk with taped or live music intermissions) designed to move the audience away from dancing towards sedate listening. In 1960, Moscow's first jazz club opened – run by the Komsomol – and by 1961, it's estimated there were around 600 jazz groups, 100 of which were officially recognised. Improvisation and hip-shaking boogieing was still played down in favour of ordered virtuosity and chin-stroking appreciation to ensure jazz could be described as an art form rather than an expression of western-worshipping hedonism. Besides, by then the authorities had other targets: Elvis Presley, rock'n'roll (which unlike jazz had no history in the USSR), kids with home-made electric guitars and the much more threatening dissidence of the emerging '*bard*' movement. By the time Benny Goodman toured the USSR in 1962 to wide public acclaim, loving or even playing jazz was no longer really a badge of the non-conformist.

THE TIMES THEY ARE A-CHANGING

Aleksei Kozlov was a serious, cool, culturally aware young man. Music was much more important to him than fashion and as his star rose, he left the stilyagi culture behind. Its style had largely been an imagined version of what kids in the west were wearing, filtered through memories of a few films and scattered images from old magazines. Vasily Aksyonov noted that the rich Golden Youth kids were now

calling themselves 'Stateniks' and were increasingly snobbish towards those who didn't have real American gear:

Our gang in Kazan did everything it could to ape American fashion; our girls knit us sweaters with deer on them and embroidered our ties with cowboys and cactuses. But it was only imitation, do-it-yourself. This was the genuine article, made in the USA.

Stilyagi style started its decline after the International Festival of Youth of 1957 and the American Exhibition of 1959. Now many real foreign young people were showing up in Moscow, and the shocked stilyagi found they were as outdated as Glenn Miller's music. There were no stilyagi in America apparently! The trendy western kids wore beatnik-style turtlenecks and jeans; things that the stilyagi had never heard about. It was embarrassing. There seems to have been a split with some of the old guard stubbornly sticking with the more rock'n'roll style and younger people migrating towards the 'beatniki' look. Simultaneously, with more access to consumer goods in the Khrushchev era, even mainstream kids were now rejecting the conformity of Pioneer-style outfits and choosing their own gear. Fashionable styles were generally more integrated and it was becoming more difficult to stand out.

The death of most subcultures is often signalled either by the arrival of a new and more exciting mode, or by their adoption into the mainstream. The stilyagi were no exception. The movement finally petered out around 1964 (as did the Bone Music era), though Mikhail Farafanov says that even then a few lingered on, lost in time:

There was a very cool guy among us whose name was Sasha Zaskok. He was a man who knew literally everything about jazz. When we heard a tune he would instantly start singing it. He knew what it was in moments. To my pleasure after many, many years, maybe 10-12, I met him and I invited him to my place but I was totally disappointed – he was still wearing the same old suit, he was interested in the same musicians and I was already so far away from that.

Even though they are sometimes portrayed as bravely taking on the might of the Soviet establishment, the stilyagi weren't really political. They were rarely taken seriously enough to be considered dissidents, although '*kow-towing to the west*' was considered a crime in Stalin's time. Their persecution was justified on the basis of the Soviet crusades against '*cosmopolitanism*' and '*hooliganism*', the latter being a catchall term for any activity the authorities considered anti-social. They were more hipsters than punks – rebels without a cause – but despite this there are many things to admire about them. They took risks and were publicly anti-establishment at a time when it was dangerous to be so. And as Artemyi Troitsky has said, they were the only real example of an overt Soviet subculture, however ersatz and derivative it seemed, and it was a subculture that survived for almost 20 years – a long time for any youth movement. In their own way they were inventive, with a *bricolage* DIY style that adapted what they found around them to defy social convention and the oppressive monotony of ordinary life.

And this – along with the spread of the x-ray record underground – was itself an admirable statement of individuality and defiance of ideology in a time of cultural repression.

PROPAGANDA AND PERSECUTION

An old guy sits cradling a guitar in his apartment in a crumbling 19th century building in St Petersburg. Around the room are other guitars, other instruments and shelves tilting and heaving under the weight of hundreds of books, boxes, records, magnetic tapes, cassettes and CDs. There are old recording machines, gramophones, tape decks, microphones, fragments of electronic equipment covered in dust, a crazy treasure trove. On what little wall space remains, there are photographs, posters of Elvis Presley, Bo Diddley, Kurt Cobain, Arkady Severgny. Later, musicians will arrive. Vodka and brandy will be served, snacks laid out and a party will begin, with stories and songs from the old days, songs written by the old guy or his friends, Odessa songs, criminal songs, gulag songs, rock'n'roll songs. It is a scene that has been played out many times over the years – in this apartment and in all the places he has lived in a long life given to music.

THE CULTURE TRADER

Rudy Fuchs (aka Rodion Fuchs, Rudolf Solovyev or Rudolf Izrail'evich) is happy to talk about his youth and his crazy adventures in Leningrad – although you get the impression he would be even happier singing a song or playing you one of his favourite records. That might be a rock'n'roll tune, it might be a Russian criminal song or an émigré tango – it might even be something by a British crooner of the 1930s-40s since Rudy's tastes have always been wide. He even enjoys some of the Georgian folk tunes so beloved of Stalin. The important thing for him is that the music has energy, passion – and conveys a sense of real life.

'There were two types of culture,' he says. *'Official culture and underground culture. I was always for underground culture. All my life. Even now.'*

Rudy was an x-ray bootlegger. In the 1960s, he became a target for vilification in the Soviet press, was arrested twice and ended up serving time. Like Mikhail Farafanov, he was born in 1937 and loved music when growing up, but realised early on that what was officially on offer was not what he wanted. At his aunt's place one day, he found a broken short-wave radio set that had escaped requisitioning during the war. Already quite savvy, he fixed it up and tried to tune into foreign radio stations broadcasting émigré songs or western tunes. He remembers his delight at catching the Ray Noble orchestra with Al Bowlly singing 'You Oughta Be in Pictures':

That was the first western tune I really loved when I was still at school, maybe in eighth grade [about 14 years old]. It was very popular with me and my friends. One day before the class started, we wrote 'You Oughta Be in Pictures' on the blackboard. It was during Stalin's time, so that was dangerous!

He started collecting pre-war records of tangos and foxtrots and spent hours trying to find them at the stalls at the 'baraholka' markets, paying with rubles saved from his lunch money and rushing home to listen. The baraholka were a little like western flea markets. In Russia, they dated back to well before the Revolution, and played an enormously important role for all Soviet citizens, because so many things were unavailable in shops. Rudy said that once officials closed down all the baraholkas, apart from one in Odessa, so many traders – and customers – simply upped sticks and caught the train to Odessa. *'Nobody was interested in the opera or theatre; everybody was going to the baraholka in Odessa!'*

He finished school in 1955 and later that year heard rock'n'roll for the first time on Radio Luxembourg. It was an epiphany. He needed to hear it again – to be able to play it whenever he wanted – and he knew the most likely place to find a record like that was at the baraholka at Ligovsk. A genuine western disc in good condition would be way too expensive, but one Sunday he was there negotiating with a sailor about a slightly damaged record when a middle-aged man approached, pulled him aside and showed him a whole pack of flexible discs on x-ray: swing, rock'n'roll, Louis Armstrong's 'Skeleton in the Closet', Bo Diddley's 'Who Do You Love?' and more. This man was Stanislav Philon, the Leningrad bootlegger we met earlier.

Rudy bought 'Boogie-Woogie Bugle Boy' by the Andrews Sisters, and brought it home. It would barely play, it was a bad recording, but he was immediately hooked. He bought more music from Philon and gradually met other people on the scene, including Boris Taigin who he first knew as an underground poet. Taigin showed him his poetry but kept his involvement with the Golden Dog Gang secret for a while (he had after all served a prison sentence by then and informers were everywhere).

Rudy decided to get himself a machine so that he could make his own records. His first was just an amateur apparatus attached to a gramophone. He repeatedly gave blood at a clinic that paid a fee for donations to raise cash, and a technically savvy engineering student assembled it according to drawings from *Radiofront* magazine.

I got some x-rays; I had friends at a medical clinic and asked them to give me some. I'd put a record on the player; make connection with the hand-made machine. I experimented step by step, but spoilt a lot of material along the way because it wasn't easy to get quality results... They were bad recordings but I was happy and my friends were happy!

Soon he tried selling some of his records at Bolshoi Prospekt near the Melodiya store – his first foray into the world of underground business. He was training to be an engineer and told his parents he was studying at the Shipbuilding Institute after college. Instead he spent the evening cutting records. He started to organise a secret meeting of jazz and rock'n'roll lovers – the 'Club of Cheerful Gentlemen', and became celebrated amongst his buddies because he had received a letter from Elvis Presley; he had written The King a message that was smuggled out to be posted by a tourist and The King had apparently replied!

Given all this activity, it wasn't long before he fell foul of the authorities. In May 1960, an informer in his circle ordered a large batch of Bone bootlegs. Rudy was up all night making them but at six in the morning the doorbell of the communal apartment rang. His frightened mother opened the door to a group of policemen with two kids who had been caught dealing records as witnesses. The evidence was on the floor all around them: mountains of swarf and bundles of freshly made discs. Rudy was taken to the police station on Rakov Street, along with all the x-rays, his collection of original records and his cutting machine. Twenty more bootleggers and dealers were there too, from all over the city, including Ruslan Bogoslovsky. Rudy remembered that Bogoslovsky's lathe *'shone with nickel and chrome'*, unlike the scruffy home-made machines he and the other bootleggers used. He was lucky to escape with a suspended sentence as a first time offender – the incorrigible Bogoslovsky was to receive yet another prison sentence.

Музыкальные подонки
Продают рентгенопленки,
Есть желудочная самба
И межреберная мамба.

LEFT FROM YURI BLAGOV'S POETRY COLLECTION: 'BULL BY THE HORNS'

Художник А. ДАВЫДОВ.

PYGMIES AND PARASITES

Following this bust, A. Yurov's article '*Streetwise Pygmies*' appeared in the September 1960 edition of *Krokodil*:

> *Gleb Ivanovich Uvarov and his colleague Boris Mikhailovich Lapin were caught in the heat of their work duties. They were carefully recording 'Murka', 'Rock Together' and 'Uncle Zui'. Meanwhile, as a part-time student of the Shipbuilding Institute, Mr Fuchs was busy with some self-education. He was peacefully reading the magazine Komsomolskaya Patrol – apparently in order to learn how to avoid meeting the patrol! It is Fuchs who has supplied the market with such exquisite pieces as 'I Want You to Be My Baby', 'Skeleton in the Closet' and the like.*

КНИЖНЫЙ ЖУК.

The author goes on to describe various other black-market activities those arrested were supposedly involved in: selling cigarettes, nylons, perfumes, bikinis and western-style clothes; learning English in order to do craven deals with tourists; travelling around the country and trading in foreign currency. He seemed most bothered by the 'freeloaders' who didn't have an official job.

Throughout the 1950s, the state waged a propaganda war on those who made, sold or bought Bone records. *Pravda* and *Krokodil* published contemptuous condemnations,

ЖУК МАНУФАКТУРНЫЙ.

STREET DEALERS

Employment – or lack of it – was a big public moral issue in the USSR, all the way through to perestroika, and not just for those involved in obviously illicit activities. It was illegal not to have a job. The writer Joseph Brodsky was sent to the north for compulsory labour because he stated his job was 'poet' in a court trial. Members of the voluntary peoples' patrols would go to cinemas and other public places to question anyone who was not at work from nine to five without good reason. Many artists and musicians took lowly jobs like elevator operator or nightwatchman just because these had short working days and wouldn't draw attention.

КИНОЖУК.

SOUND LETTER USED AS BEATLES BOOTLEG

THE BEATLES WERE TO DRAW THE PARTICULAR IRE OF THE PROPAGANDISTS WHO OBSERVED THEIR METEORIC RISE TO GLOBAL FAME AND THE VIRAL HYSTERIA OF BEATLEMANIA WITH INITIAL SNEERING DISDAIN — RAPIDLY FOLLOWED BY ALARM AS THE CONTAGION SPREAD TO SOVIET YOUTH.

Perets magazine's dismissal of the band as '*Four crooks with guitars*, who modestly call themselves "beatles" and go on stage, imitating the voice of a half-butchered piglet, or a mad bogeyman' might have drawn some sympathy in conservative quarters in the west, but Alexei Gabrilovich's 1966 film *The Mannequin Factory* went much, much further. Purporting to show how bourgeois society affected the young in capitalist countries, it juxtaposed horrifying images of Vietcong appearing to be torched alive by US soldiers, the Ku Klux Klan lynching black kids... and The Beatles at Madame Tussaud's wax museum in London.

sometimes seasoned with a sneering kind of pity for those involved. And it wasn't just the media: the volunteer citizen patrols assisted the authorities in their efforts, following people, passing on information, even acting as vigilantes. Many members of the intelligentsia also regarded the bootleg culture with distaste; it was, after all, a street culture – like punk in the 1970s or the soft drug trade now. Some artists too were disapproving it seems. One, the poet Yuri Blagoff, delivered a withering verse next to a cartoon of a skeleton dancing on a pile of records in his *Bull by the Horns*, collection published by Pravda in 1962. It goes something like:

Musical scumbags sneak and roam
Selling records on the bone.
How about spine with a samba?
Or perhaps some pelvis for your mamba?

In *Shadows on the Pavement*, a newsreel film from the late 1950s, cool-looking dudes in American style clothes are spied on from a surveillance van as they sell Bone discs near Moscow's GUM shopping arcade. Real footage is intercut with faked scenes showing records being cut onto x-ray and other kids grooving to rock'n'roll. The bootleggers are arrested, led away by police, interviewed and finally shamed by having their photographs published on street posters. An apparently deeply concerned narrator provides a sombre commentary:

These young men avoid school in favour of the streets
where they sell home-made records on x-rays. But these
x-rays reveal the anatomy of their terrible souls. How
do you see the world through this x-ray rock'n'roll? This
is a world of shadows... and you think this is real life?

Whilst the rhetoric seems over dramatic, it reflected the official claim that rock'n'roll, and the culture around it corrupted young people. It was an anxiety shared at times

in the west as we have seen, but in the Soviet Union of the early 50s, any genuine concern was hardened into harsh action by ideological hatred of western culture. In 1953, The Ministry of Science and Culture issued an official edict on the matter, claiming that American jazz could be heard in many public places and was being distributed on 'plastic' discs – even near official music shops, along with the music of forbidden artists like Pyotr Leshchenko. Illegal production should be shut down because those who heard the music or bought the discs inexplicably wanted more. Rudy speculated that the issue was in fact as much commercial as ideological. Evidently the bootleg culture was becoming extensive enough to threaten sales of the approved popular music that was aimed at the masses.

In his 'Undercover Music' article for the 1956 *Leningrad Evening* newspaper, M. Medvedev grudgingly acknowledged that taste was one of the motivations for the illicit trade:

There aren't enough records with good dance music in shops. And those which do exist do not suit record buyers. Recently, for example, the Grammplastmass artel in the town of Krasnoe Selo released two records: 'You'll Say No' and 'Forgotten Tune', performed by a pop orchestra. But customers do not buy them. Nobody wants to dance to such gloomy music. This is what the speculators take advantage of.

Instructions were given that the Ministry responsible should change the musical style of officially produced records, to make them appeal more to youngsters. Meanwhile the Soviet press tried to depict the bootleggers as they depicted the fartsovshchiki, the black marketeers: greedy chancers, spongers and parasites living immoral lives; degenerate low-lifes indulging in private enterprise (a great sin) and encouraging base attitudes in Soviet youth by corrupting them with foreign degenerate culture.

In *Smena* in 1960, the '*Breakers of Souls*' article had delivered a brutal assessment of Rudy's life. The fact that he was a student – seemingly unapologetic about what he did and had a collection of articles about rock'n'roll in the west – deeply upset author Georgy Baldish:

In his authoritative opinion, our young people need new spiritual food. No, he's not afraid to leave a mark. This is what his album, a kind of rock'n'roll gospel, is all about. There's a naked woman on the title page in a flesh pink undershirt. There are black barefoot prints on her back. The album contains clippings from newspapers and magazines about the fans of a dance that combines epileptic jerking with jiu-jitsu techniques. Fuchs, savouring it, re-reads stories about how English Teddy Boys uprooted the seating and ecstatically threw beer bottles during a movie about rock'n'roll. He is delighted to know that in one of the concert halls of Holland, demon-possessed dancers smashed gilded furniture into pieces, and how in Oslo, fans broke shop windows, threw stones at passing buses – all to the rhythms of rock'n'roll.

It is safe to say that Baldish did not like rock'n'roll. Elvis Presley had the '*face of a burglar, bull's eyes, and a mop of black hair dangling over a narrow forehead*'; Paul Anka was '*a greasy sniveller with a vulgar cat face*'.

In *Krokodil*, A. Yurov was outraged at both the leniency with which bootleggers might be treated, and at the effect their x-ray records had on the young:

It's true that from time to time they are caught, their equipment is confiscated and they may be even brought to court. But then they might be released and be free to go wherever they like. The judges decide that they are, of course, parasites, but are not dangerous...

They are getting suspended sentences! But these record producers aren't just engaged in illegal operations. They corrupt young people diligently and methodically with a squeaky cacophony and spread explicit obscenities. And finally, they employ dealers of their vulgarity, dozens of slackers to promote their stuff.

Baldish shared Yurov's conviction that the fate of Soviet youth was at stake, but seemed more confident an appropriate punishment would be meted out.

Now these 'breakers of souls' will take their place on the defendant's bench, and one hopes that the court will find an opportunity to punish the executors of this ideological business and will forever discourage them from profiting by corrupting the young.

In 1958 the authorities did specifically make dealing in x-ray records illegal. Prior to that the situation in law had been vague. At different times, bootleggers were charged under articles relating to anti-social behaviour, to racketeering, to illegal enterprise, to operating without a licence and of course, for promoting 'cosmopolitanism' and western values. Yet despite the hysterical claims in the media, Rudy, the Golden Dog Gang and their bootlegger like were not really ideologically motivated at all. They had not set out to break the system, to corrupt Soviet youth or to kow-tow to the west, even though they were accused of all this. They simply believed that people should be able to listen to and share the music they loved any way they wanted. Many admired the west but were hardly traitors. Mikhail Farafanov said:

I loved my country; I loved the Russian language and literature, our art, our music. I only wished that we had more freedom.

As a lover of rock'n'roll, Rudy nevertheless remained a fan of the old Russian songs, and is even happy to acknowledge that some official music was good. He believed there was a vibrant current of energy stretching right back to pre-revolutionary music, which then ran through the émigré, criminal, gypsy, street, and blatnaya songs and that could also be heard crackling amongst the static of boogie-woogie and rock'n'roll records. It was a primal energy, the sound of a basic human lust for life.

Baldish got his wish: in 1965 Rudy was arrested at his apartment, once again busted, sentenced and this time sent to prison for two years. By now he had a large collection of original western records, to be rented out to fellow bootleggers:

I was stupid and didn't pay attention to the dangers sometimes. They watched me, using the Komsomol patrol and then sent an agent who took a large quantity of records. He didn't call back and I began to feel that it was dangerous to go out onto the streets. When I did, they arrested me and they went to my apartment, where there were a lot of records. They got everybody in Leningrad then involved in this activity and gathered us all in one big room in the police station. They even tried to make me their official informer. I agreed but of course I wouldn't really do that and I did not give them real information. Once they understood that I wasn't giving them real information, they put me in prison.

Mikhail Farafanov had his own run-ins with the law in Moscow. He was often watched by the KGB, even at the pool where he practiced swimming. Evidently agents were suspicious of his activities, but he became adept at spotting them and would even tease them: 'Hey you, cop, geezer, why are you following me?' Many were former soldiers,

uneducated country guys who came to the city for economic reasons; anti-intellectual and with a chip on their shoulder. He felt they were fair game.

At that time, there was a joke: 'Why do policemen go round in threes? Because one can read, another can write and the third enjoys the company of scholars...' They were primitive people; they were easy to lie to... I was a resourceful guy who found a way out.

Primitive or not, intelligence, resourcefulness and cultural sophistication were little proof against a system that could bring down a hammer to crush and a sickle to cut lives short when it chose. And Mikhail served time too, albeit not for bootlegging.

But all this propaganda and prohibition, all this punishment and persecution turned out to be futile. The public appetite for Bone Music was simply too great, and the authorities were always one step behind. According to Rudy, many of them listened to the same music he did and they didn't believe the official ideology either. The entire system was corrupt: records and gear that were confiscated from bootleggers would mysteriously vanish; the western clothes and gadgets taken as evidence reappeared later at the baraholka.

The public vilification, raids and arrests continued into the 1960s and beyond, even as magnetic reel-to-reel tape and cassette were replacing x-rays as the bootlegging medium. The Brezhnev era reversed some of Khrushchev's liberalising changes with a new attempt at cultural control, but when recording with a tape machine at home was possible, there was really very little to be done. As with Prohibition in the US, the authorities finally bowed to the inevitable, and stopped bothering trying to implement laws with no chance of success.

ABOVE **ANTI-SOCIAL SATIRICAL POSTER**

Rudy made good use of his two years in a prison in Vyborg. He learned to play guitar and sing and write songs – he had lots of time and some good teachers.

I tried to bring culture there too. I worked in the library teaching the criminal guys. When I came out, I started again, from nothing – no money, no equipment, no friends, nothing. Some they broke but some they didn't, it just made them stronger.

He went on to be a producer of various underground musicians and was instrumental in the career of Arkady Severgny, one of the greatest unofficial Soviet singers. After leaving the USSR for the US in the 1980s, Rudy would set up Kismet, a record label releasing music from the Russian underground, and also promoted live concerts for Russian artists abroad. Looking back, he is reflective:

I'm not angry with them. They were doing their job. They were implementing party ideology. There was a freedom in the music and they didn't like it. There were two different cultures: official culture and underground culture. I wanted to explain to people who didn't understand about underground culture; I wanted to be someone who brought that culture to different people. Maybe God told me to do it. I have done it all my life and I will continue to do it until the end.

BONE
RECORDS

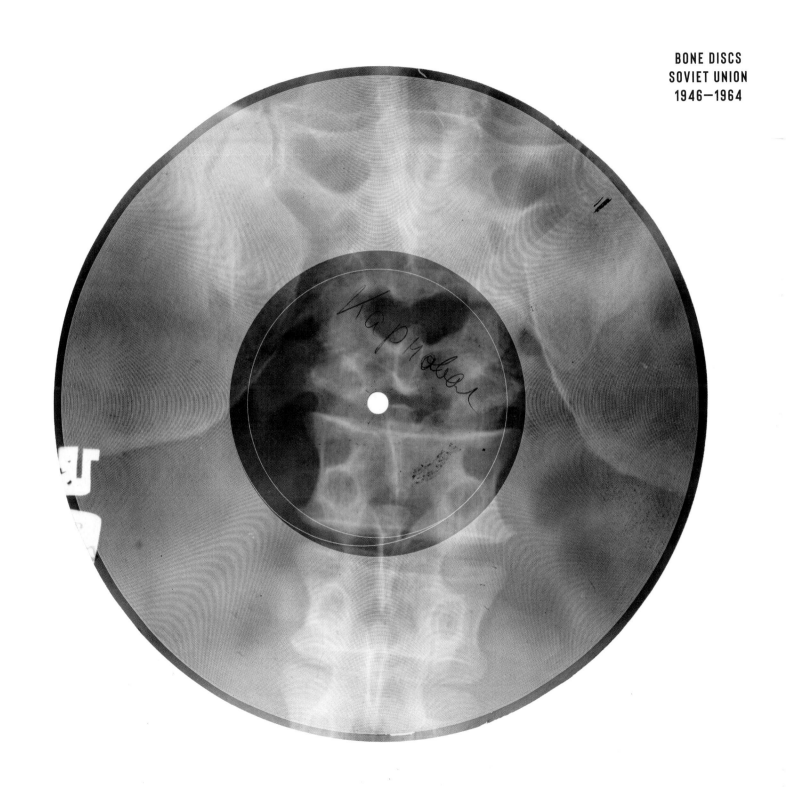

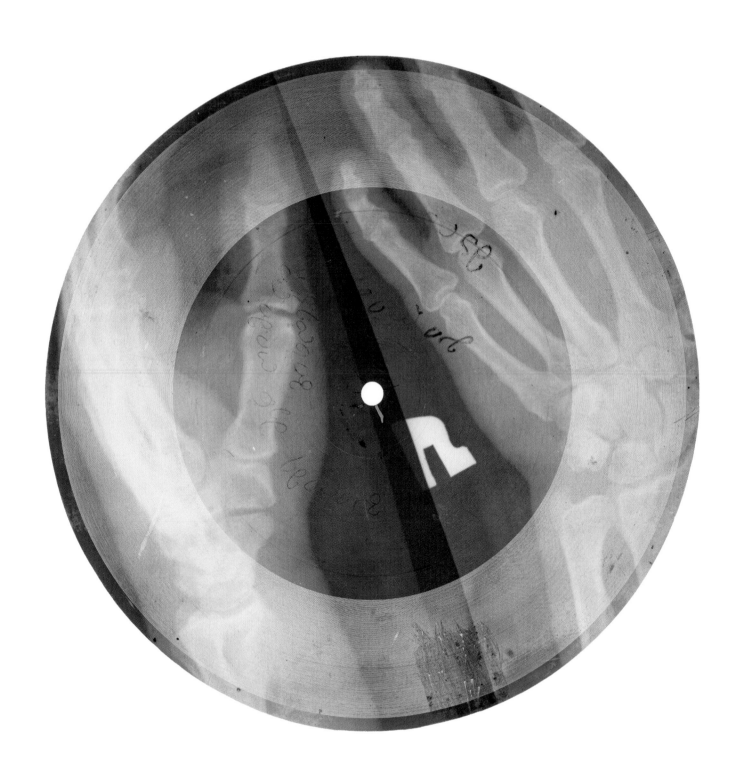

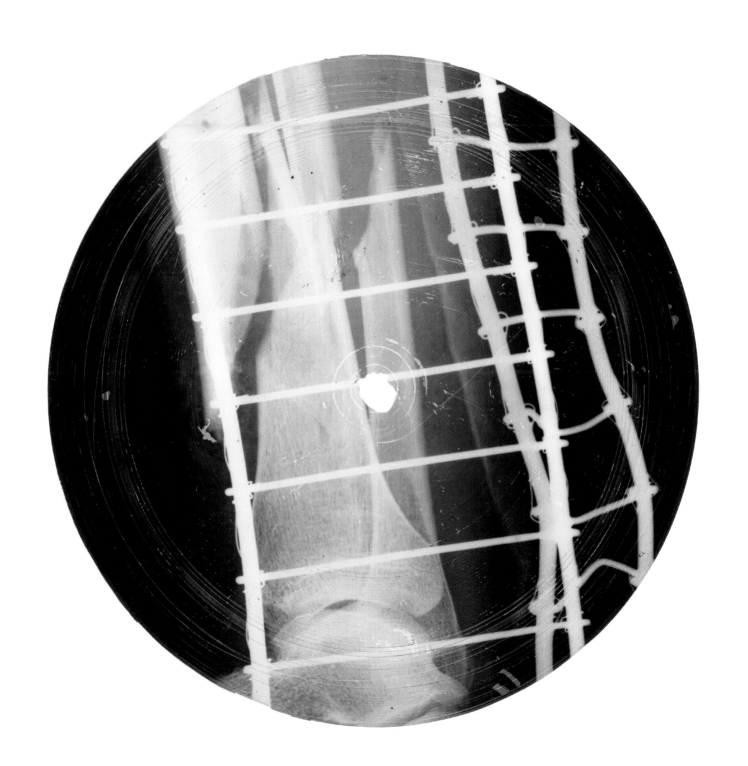

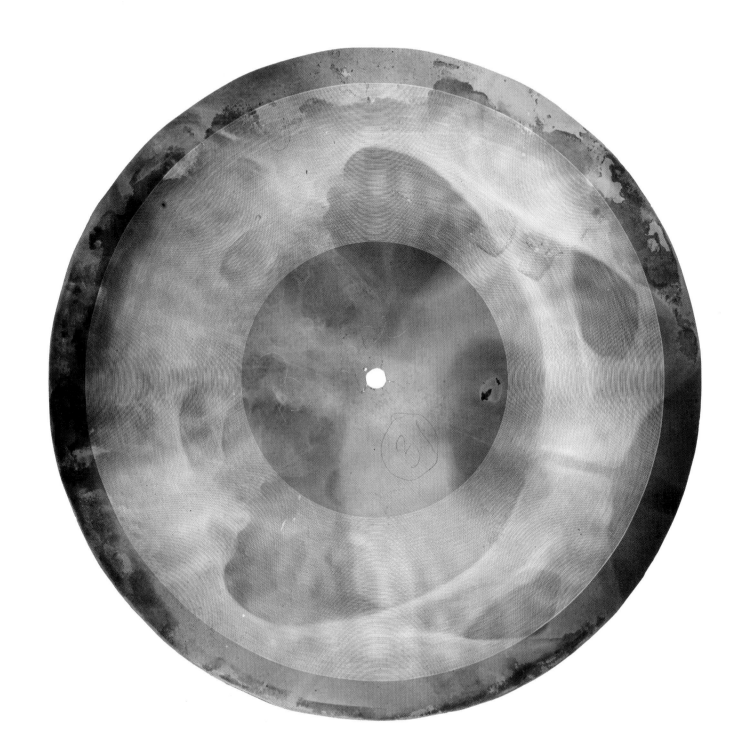

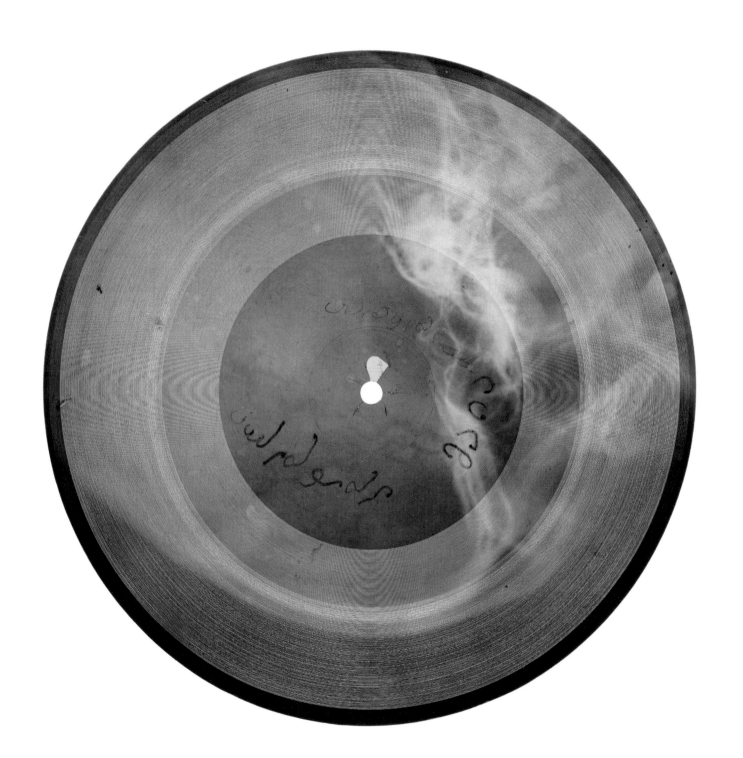

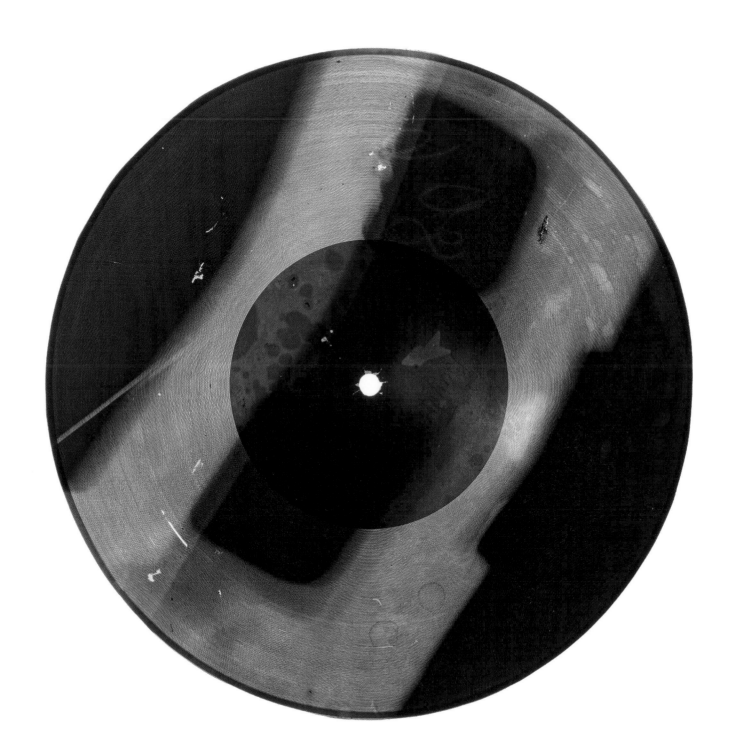

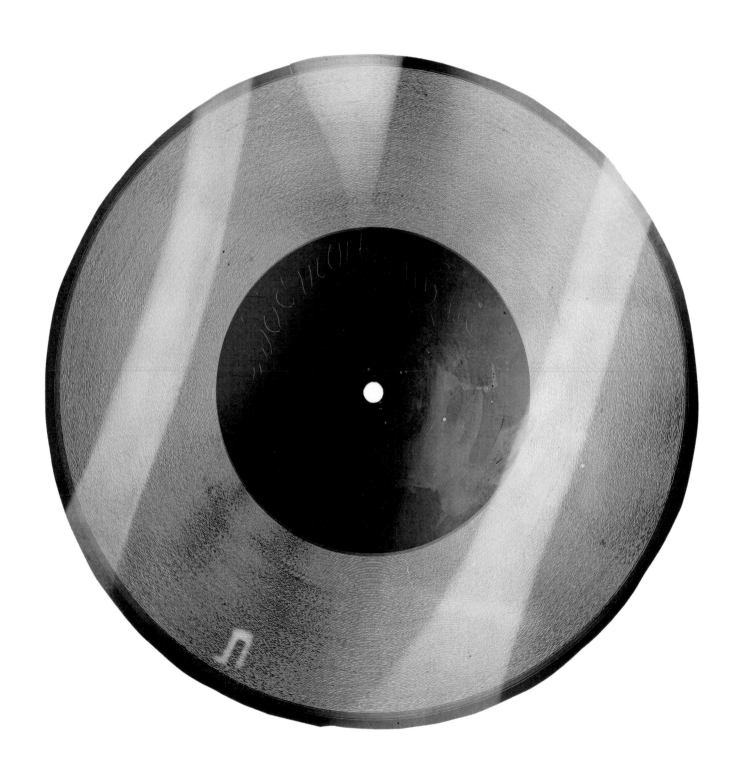

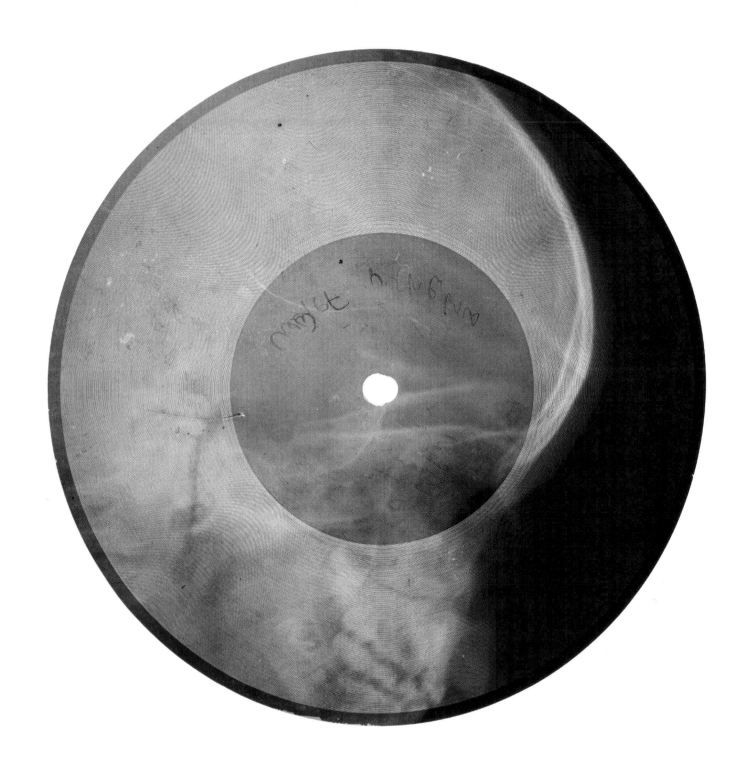

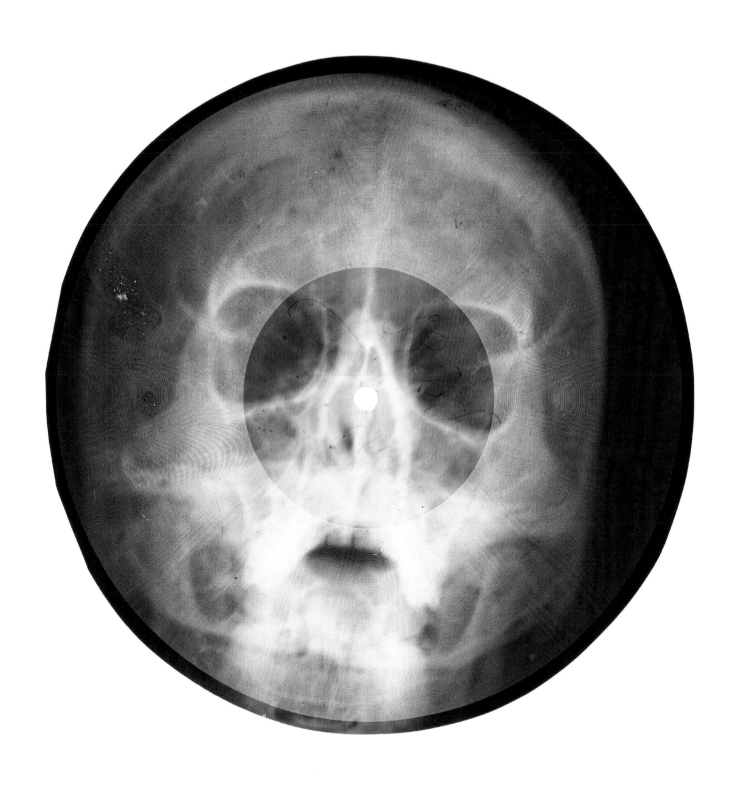

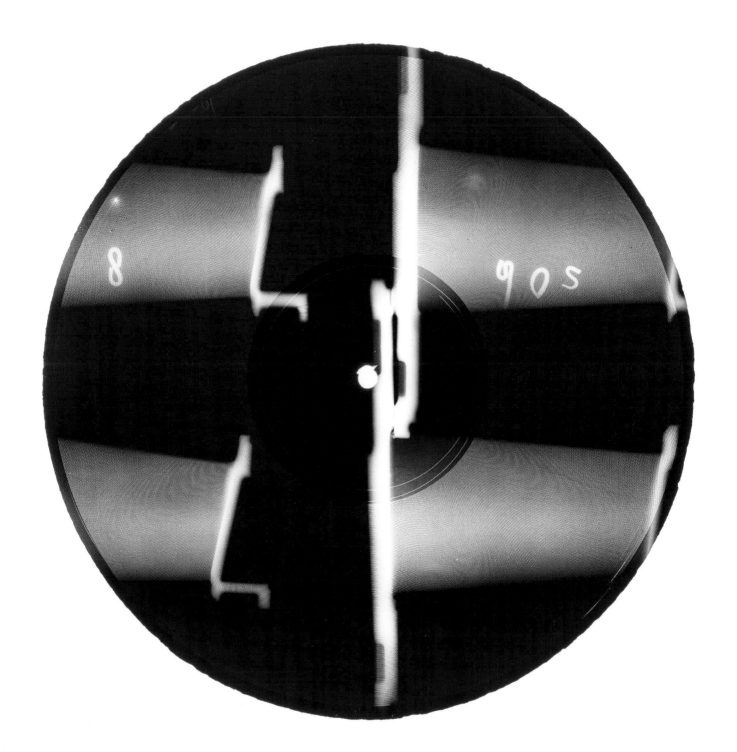

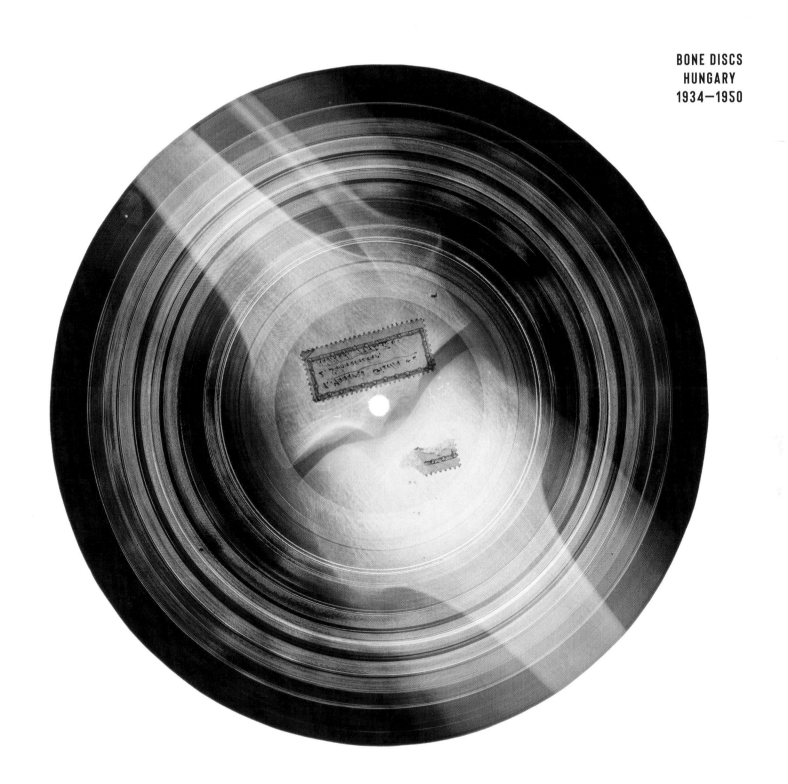

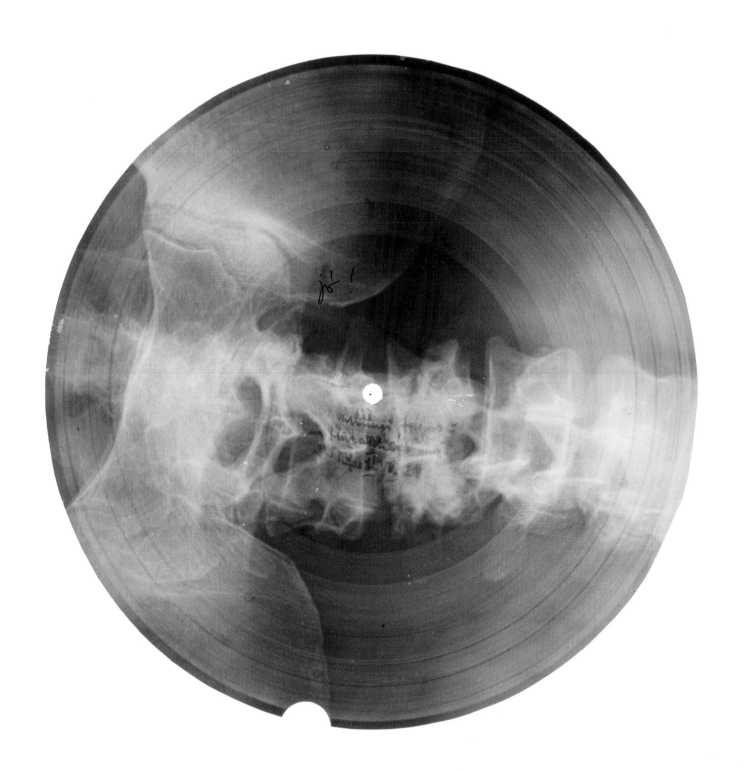

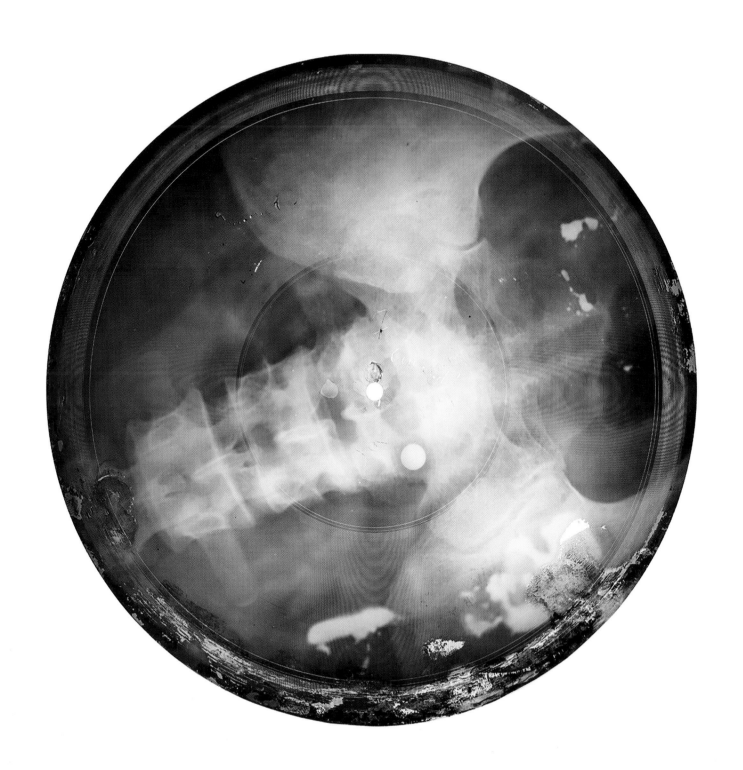

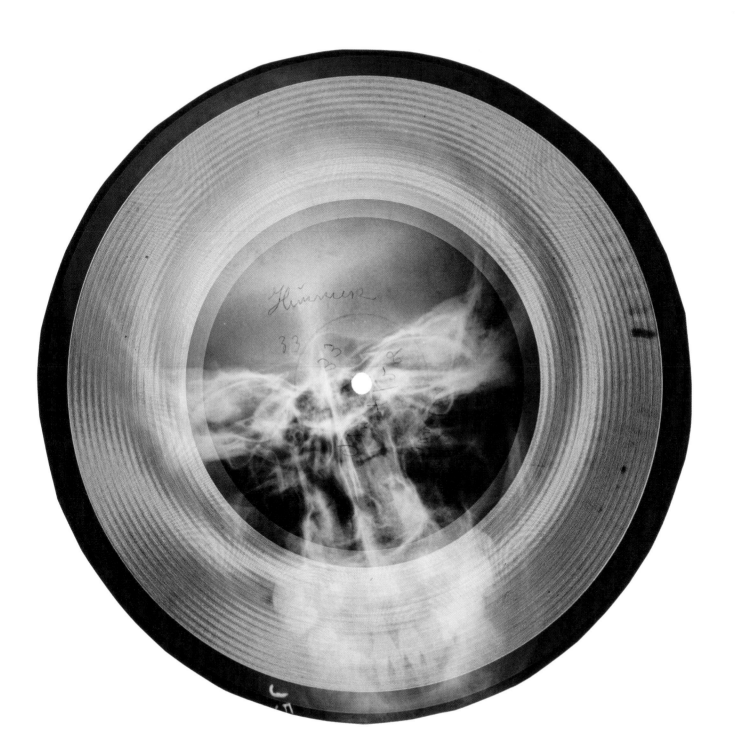

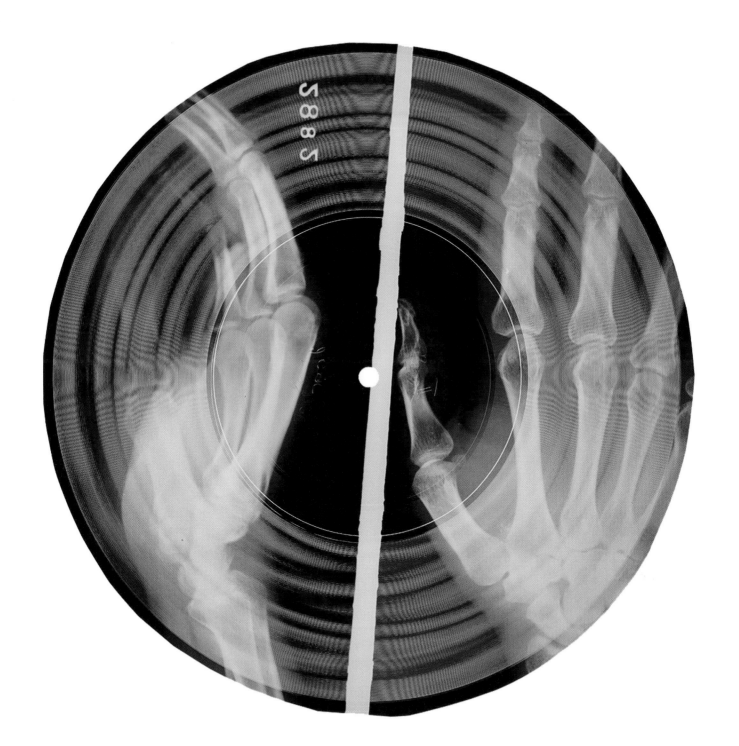

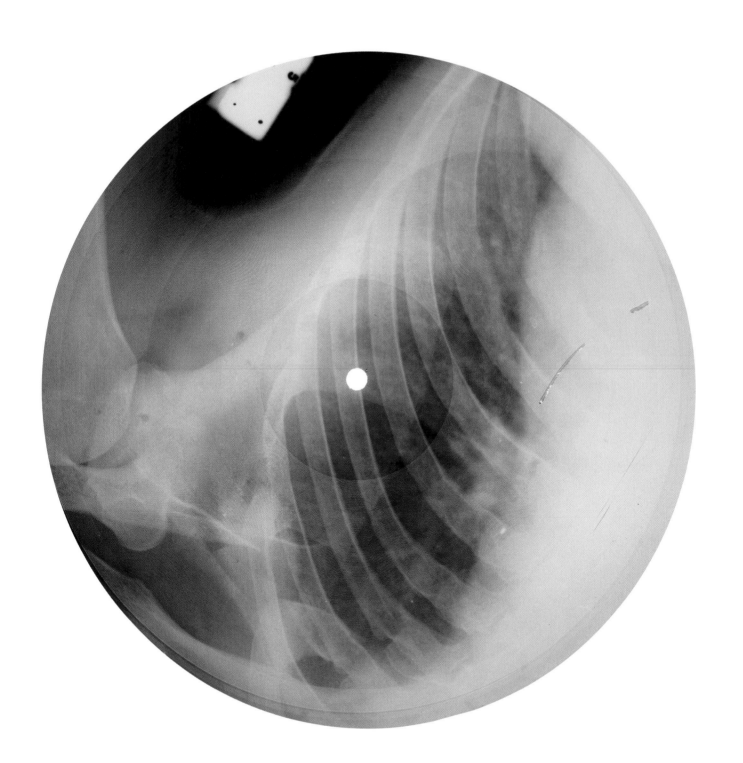

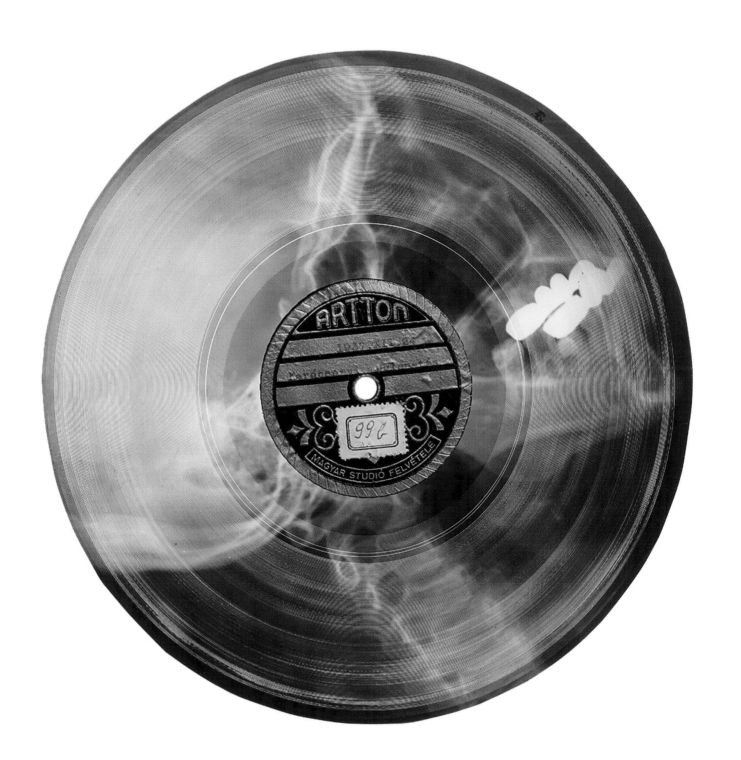

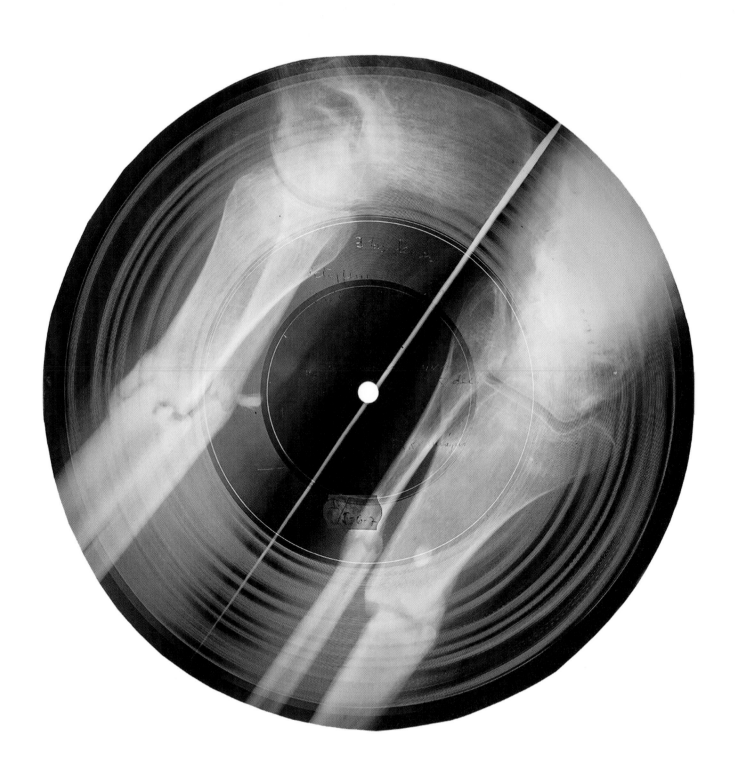

SOUND
LETTERS

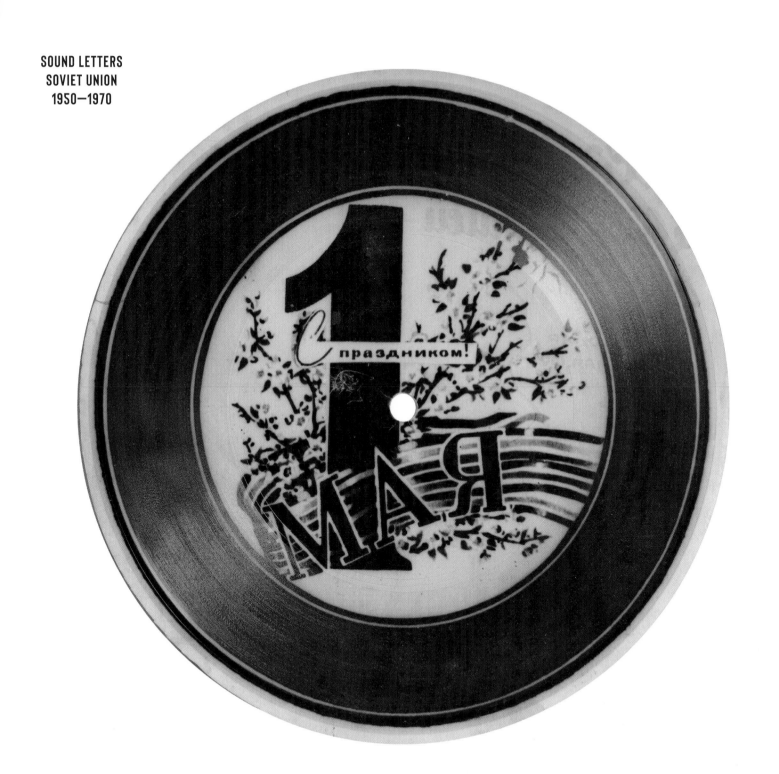

Симферополь. Железн

Simferopol. Railwa

Simferopol. Am

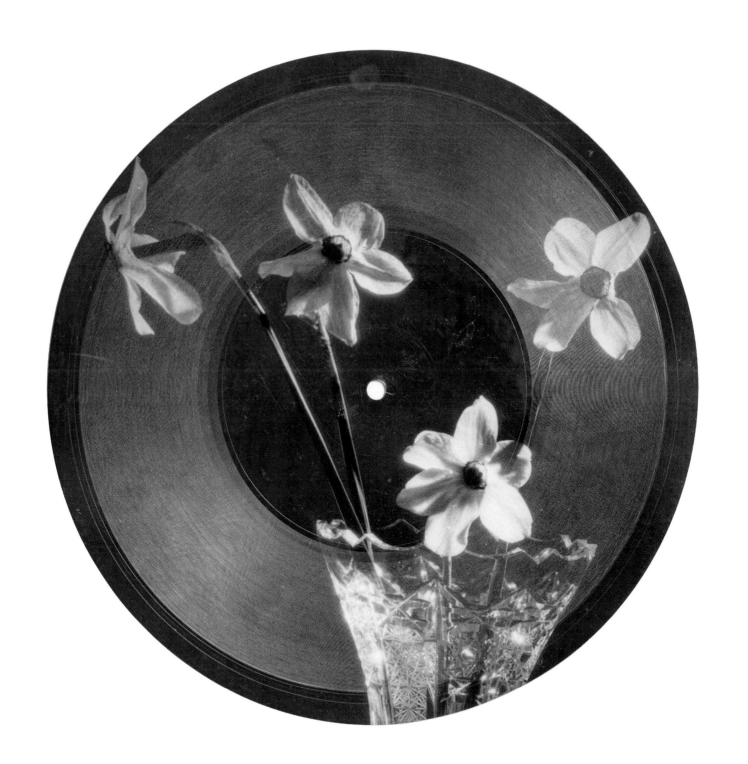

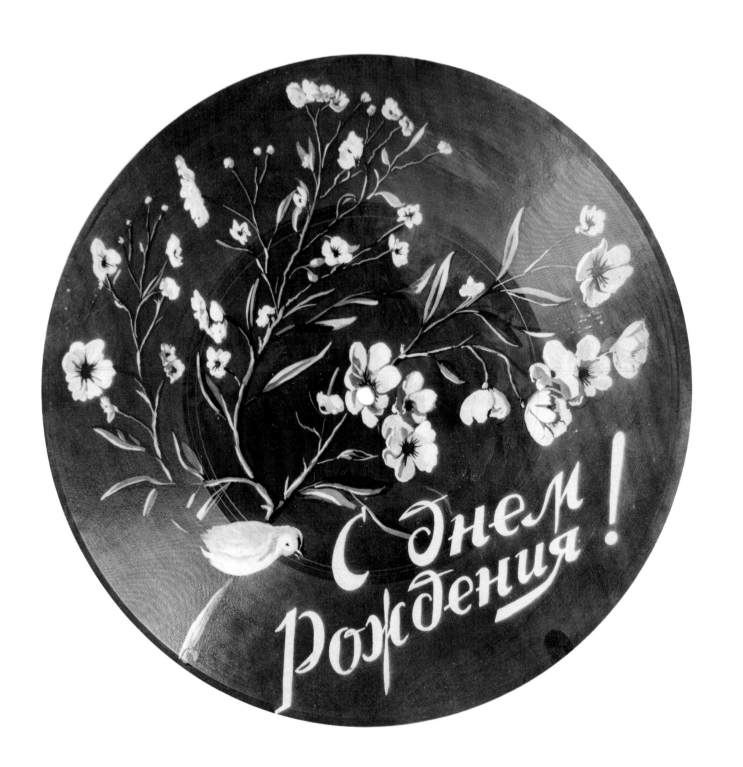

Львів. Пл. А. Міцкєвича.

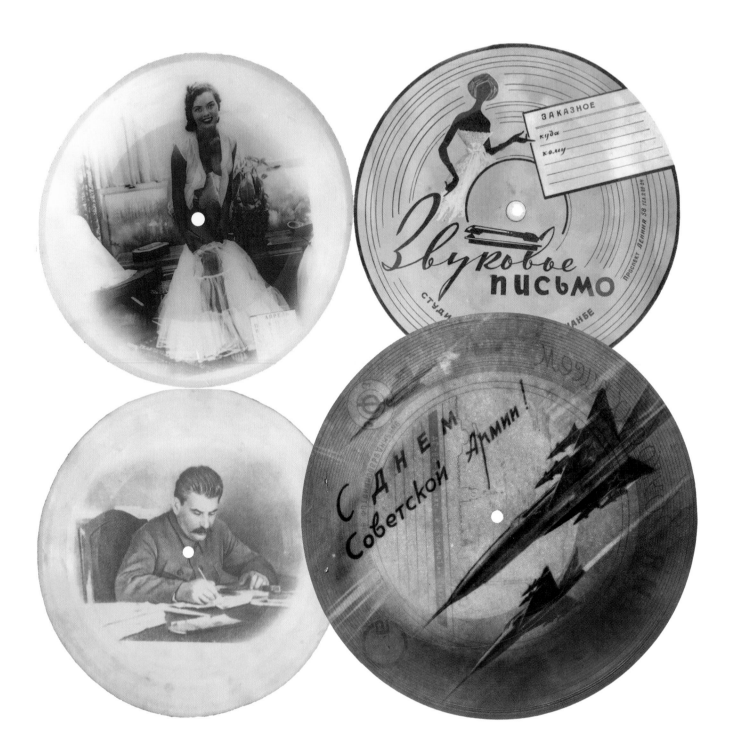

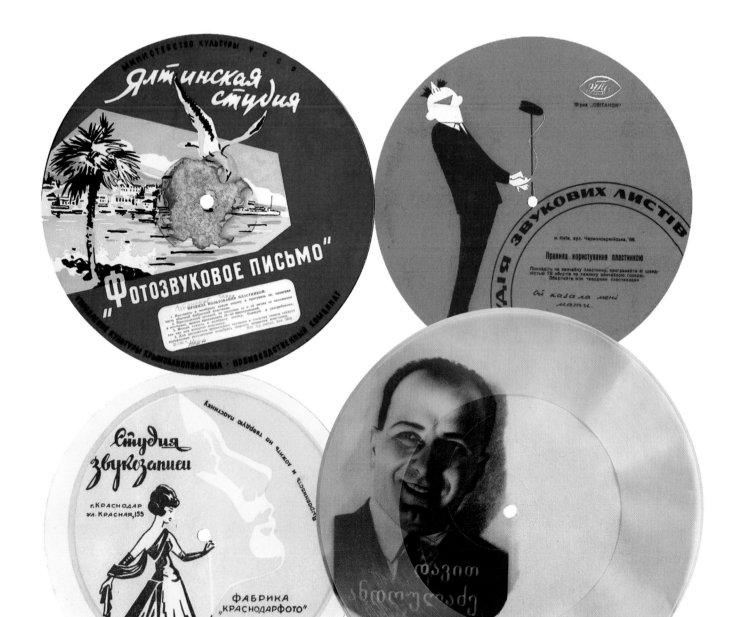

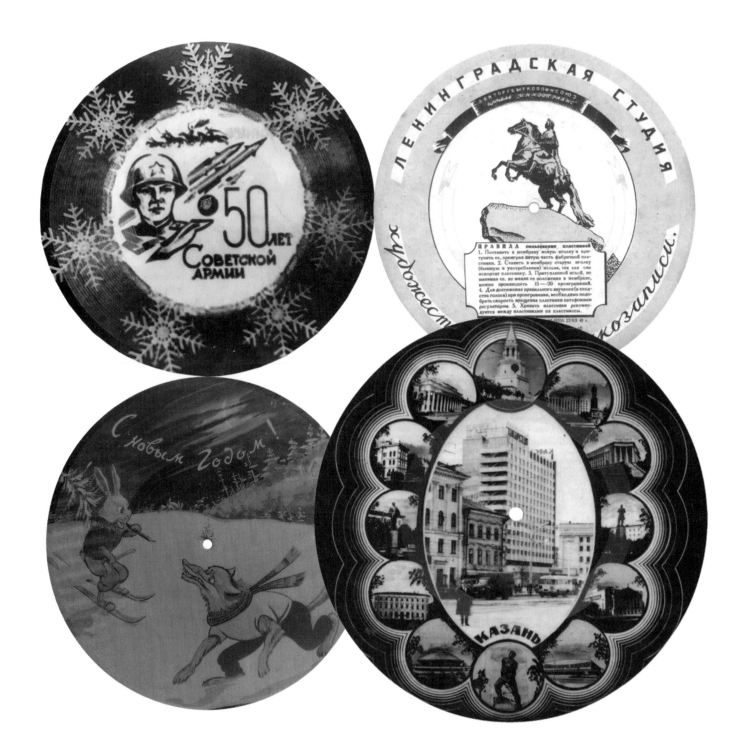

В ателье ЗВУКОЗАПИСИ

По почтовой номенклатуре есть письма обыкновенные, заказные, спешные, ценные... Но к каким из них можно отнести письмо, в котором ничего не написано, а в конверт вложена только тоненькая целлулоидная пластинка? К таким „ненаписанным" письмам почта уже привыкла. Они поехали в поездах, полетели на самолетах. Их стали получать зимовщики Арктики, моряки Дальнего Востока, жители отдаленных районов страны. Они не читали, а слушали письма. Звукозапись обогатила средства почтового обмена.

Поток „говорящих писем" шел вначале из Центрального парка культуры и отдыха, а затем из павильона звукозаписи на Всесоюзной сельскохозяйственной выставке. Павильон на выставке был открыт фабрикой граммпластинок Ростокинского райпромтреста. В марте тот же трест открыл в проезде Художественного театра ателье звукозаписи. Ателье так и названо — „Говорящее письмо".

Посетитель попадает сначала в маленькое комфортабельное фойе, изолированное от уличных шумов. Фойе оборудовано звукоизоляционными перегородками, окна закрыты ширмами из парафинированной материи. Здесь посетитель делает предварительную запись текста письма.

Затем он проходит в студию, где „наговаривает" письмо у микрофона. За стеклянным окном студии расположена аппаратная. Там находится звукооператор, который „пишет" на пленке текст выступления. Для записи служит обычная рентгеновская пленка, которая выдерживает 150 проигрываний. Продолжительность записи — одна, две и три минуты.

В ателье записываются музыка и речь, сольные и ансамблевые выступления. Через пять минут пластинка готова. Она проигрывается в кабине прослушивания, а затем вручается посетителю.

В ателье можно встретить людей всех возрастов и профессий. Сюда приходят люди, родственники которых находятся на зимовках или в дальних экспедициях, актеры, записывающие отрывок роли или вокальный номер для самоконтроля. Недавно в студию пришел тов. Н., в прошлом — слепой, которому вернул зрение лауреат Сталинской премии проф. Филатов. Тов. Н. послал профессору в Одессу задушевное „говорящее письмо".

Среди москвичей ателье пользуется немалой популярностью. За первый месяц в нем произведено свыше 300 записей.

НА СНИМКАХ:

В овале — в фойе. Посетители делают предварительную запись текста.

Слева — в студии. Перед микрофоном — лауреат Сталинской премии, заслуженный деятель искусств С. Эйзенштейн.

Справа — в аппаратной. Начальник ателье звукозаписи Я. Зицерман производит очередную запись.

Фото М. Степаненко

BONE
MACHINES

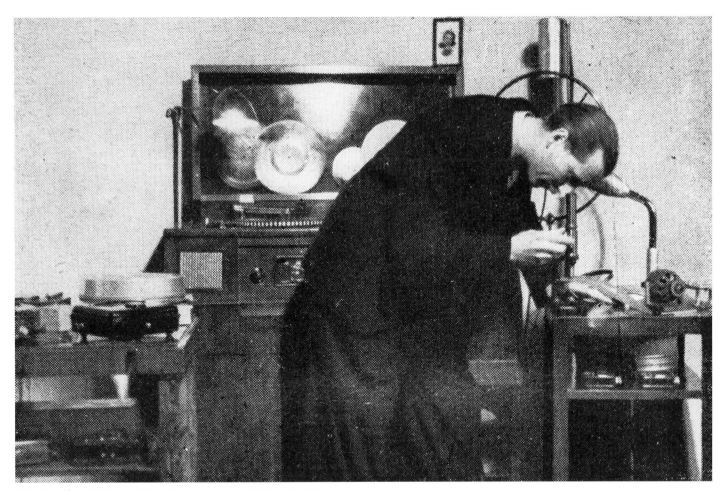

ABOVE ISTVÁN MAKAI CUTTING BONE RECORDS, FROM HIS MANUAL, C.1938

THE LATHE-CUT RECORD

If you could travel along the spiral grooves of a record in super close-up, you would see long curving valleys with a landscape of complex contours, peaks and indentations on either side. This landscape is the detailed physical analogue of the audio recorded onto the disc: sounds as shapes. When the needle of a record player is dropped into the groove, these tiny shapes cause it to move in a specific way, which is then amplified and transformed back into audio, via vibrations through the air to our ears.

In other words, it's magic.

To get the sound onto a conventional vinyl record, a pressing technique is used: a metal master mould stamps the entire record at once into soft, hot plastic, pressing in the grooves with all their minute details. It is a process that has been used for over 100 years, all around the world.

In the Soviet Union, record presses could not be accessed without official approval, and were too complex to be built and operated secretly, so bootleggers needed an alternative means to make their discs. As we have seen, they found it in the recording lathe, a table-top machine that operates as a kind of gramophone in reverse. To make a record with a lathe, a cutting head vibrates: when an audio signal is fed in it '*writes*' (meaning scratches) a groove into a spinning blank disc. This disc can then be played back just like a conventional record. While pressing is a mass-production method with which multiple identical discs can be made quickly, lathe-recording produces one disc at once, usually in real time, with each being slightly different from all the others.

Lathe technology has been used in professional studios since the early 1930s, and is still used to make master matrixes, dub plates and records when only very small quantities are wanted. The lathes developed in the west were originally used to make one-off recordings in studios, such as the transcription discs of programmes that radio

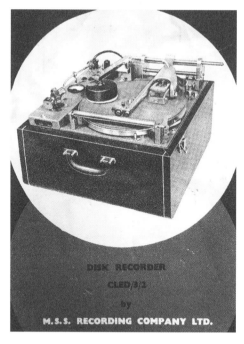

ABOVE MSS
LATHE MANUAL

stations used for broadcast, or the recordings that journalists and archivists made in the field.

Later, lathes began to appear at railway stations, tourist attractions and in department stores, inside automated kiosks such as the 'Voice-O-Graph', so that the public could make souvenir recordings. Anyone could enter the booth, insert a few coins, speak or sing into a microphone and emerge with a record (famously the gangster Pinkie uses one to record a vicious message to his girlfriend in the 1947 film *Brighton Rock*). In the US, domestic machines – such as the Wilcox Gay, the Recordio or the Meissner – became available for well-to-do customers to make recordings at home. The discs they used ranged from aluminium to cardboard, with correspondingly variable results.

In the Soviet Union, direct-to-disc amateur recording had also been around since before World War Two. In 1937 an entire issue of *Radiofront*, a magazine for audio enthusiasts, had been devoted to ingenious recording devices, and to such pioneers as the engineer Sergey Kolbasov, who designed his own equipment to record US and UK jazz from the radio (shortly afterwards he was arrested by the NKVD and shot, for being '*an English spy*'). In 1940 *Radiofront* described how to add a mechanical attachment to a conventional

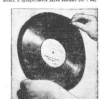

gramophone, to adapt it for recording. Such articles were ostensibly written to help patriotic amateurs archive official speeches from the radio – but it is very likely they would have been used privately for other, less official, purposes. Clandestine recording on a larger scale really got going in the second half of the 1940s, when the bootleggers built their own lathes, often based on professional machines such as German war-trophy Telefunkens and Neumans ('*Telefunken*' would subsequently become a generic name for these machines, much as we might call a vacuum cleaner a '*Hoover*'). Lathes are relatively complex, taking a fair degree of engineering skill to construct – but as the knowledge spread, more and more skilled amateurs learned how to do it. One feature of Soviet life was the plethora of engineering clubs with access to machine tools, aimed at training young people in metalworking skills and electronics. Sapphires for the cutting heads could be obtained from unofficial markets, with other components re-purposed from various devices. Still, jack-of-all-trade bootleggers like Ruslan Bogoslovsky (who built his own machines) were unusual. Most started as Rudy Fuchs and Mikhail Farafanov had, by finding someone with the right skills and commissioning them to do it. Regarding his first lathe, Mikhail said:

Somewhere in my circle there was a guy, 'Piotr Petrovic', who knew a guy, 'Ivan Ivanich', who knew a guy... and so on through a chain of people. It was the same way that we found sapphire needles, tools and cutters. A sapphire is a bad copy of a diamond but it is also hard, and difficult to get, but we got it.

As music lovers themselves, audio quality was very important for Mikhail, Rudy and Bogoslovsky. Mikhail stopped working with his first partner Valentine Lavrov, over disputes about the product they were selling:

Lavrov used to work with bad equipment. There wasn't even a groove on the record sometimes, it was so uneven. He made very poor quality records and it irritated me, so I looked for my own way to do it and I bought my own gear. At first the equipment I got was also poor quality... but I started recording and tried to do it better and better as much as I could, since I got pleasure from a job well done – sometimes even more than from the money that I got.

He was successful enough later to buy a smuggled Neuman lathe, which hugely improved the quality of records he could make, as well as the quantity. Just like the Golden Dog Gang's stamp of authenticity, in an increasingly crowded marketplace, this gave him an advantage: customers trusted him and would come back for more.

Operating the machines was both laborious and time-consuming. Every disc made was unique. The end product was dependent on the quality of the source material, the equipment used, the skill of the operator – and of course the medium.

THE SECRET LIFE OF X-RAYS

In Europe before the war, operators of lathes could obtain blanks such as Decelith, a German soft rubber disc, or Pyral, a French lacquer-coated aluminium disc. But these would have been impossible to get in the Soviet Union; no local equivalent could have been sourced without arousing suspicion, so an alternative had to be found. At some point in the 1930s, it had been discovered that it was possible to cut music into grooves on x-ray film, often with very good results. In fact, for a surface to be good for recording, it only needs to be soft enough to take a groove and firm enough to hold it. This was true of a variety of materials, and some discs were made from scientific and printing films, while some early bootleggers – such as Sergey Malakov – used air force aerial maps until they became too difficult, or too risky, to obtain because of their military origin.

The main advantage of x-ray film was that it was cheap and easily obtainable without the knowledge of the authorities. At the time x-rays were made from a highly flammable silver nitrate film, which could spontaneously combust in certain conditions, and after various accidental conflagrations, Soviet hospitals had been issued an order to destroy used film within a year. For the medical operatives charged with the onerous task of disposal, it was a matter of convenience and a little private enterprise to do a deal after hours; for the bootleggers, a continuous supply of recording materials could be obtained in exchange for a few rubles or a bottle of vodka. Mikhail Farafanov said:

We'd go to clinics, get acquainted with the x-ray technicians, and ask for the x-ray film, buy piles of old x-rays, ribs, or skulls from them, It couldn't even be called stealing. The country was poor, people were taking away some tools from the factories, someone on the collective farm was pouring out milk for themselves. It was natural... they wanted to eat. The same is true here. I found people who needed money, and I bought the films from them. Sometimes they were just thrown away – like industrial waste – and sometimes we would find them and we'd pick them up.

Back home, the x-rays would be cut into circles, placed on the platter of the lathe, ready for a disc to be made. Some film was better than others. As quality mattered to Mikhail, he much preferred it in its undeveloped state:

Old film with bones and ribs and tuberculosis was dry and would hiss and sometimes at the beginning of the record it was OK, but the closer it got to the centre, the stronger was the hiss: "sh sh sh..." Some people sold these, but not me, I threw them away. I learnt how to see if the film was bad or good – you tear it apart, if it tore easily then it was good, if it went with a crackle and left sharp edges like on a Picasso painting, then it was not good. But sometimes I could buy packs of new film. When you took it out, it was yellow and fresh. This was a guarantee that it wouldn't hiss, because it was soft and smooth and very pleasant to record on.

VARIATIONS IN BONE

At 78rpm, a typical x-ray of about 25-30cm in diameter can only contain a fairly short piece of music, perhaps around three and a half minutes. This was fine for the Soviet émigré and blatnaya songs and for most jazz and rock'n'roll tunes, but of limited use for classical works, long poems or speeches. As a result, the early recordings of such pieces made on x-ray by Hungarian engineer István Makai had gaps in them when a full disc had to be changed for a fresh one: 10-15 seconds if he was quick. In 1939 he came up with a novel solution – a double lathe. These kinds of sophisticated machines existed for transcription purposes in radio stations in the west, but took considerable technical know-how to construct. They work by mechanically linking two independent lathes. Each has a blank disc placed on its turntable. The first is set recording at the beginning of a performance. As the cutting head nears the centre of the disc, the second is automatically triggered to start. As the second runs, the operator fits a new blank disc to the first, which is in turn triggered when the second lathe's cutting head approaches the centre, and so on. Given the complexity of making a single x-ray recording, this was an impressive act of choreographed co-ordination. The resulting set of discs could hold any long performance in its entirety – although of course it could only be played back with continuity on a double-deck gramophone system until transferred to tape.

An alternative solution was to fit more audio on a single disc. Another Hungarian, the amateur recorder László Blahunka, said that he and his father experimented and were able to make discs lasting six to eight minutes, by '*doubling the number of grooves*' they cut onto the disc. He didn't explain how – perhaps they used some method like the US microgroove system invented for vinyl records in 1946. Boris Taigin said that Ruslan Bogoslovsky built a lathe that recorded at 33rpm after his release from prison in 1953. The discs made with such a machine could contain double the usual length of audio. The quality would be lower but a skilled engineer like Bogoslovsky could use various refinements to improve it again.

István Makai experimented with heating the cutting head and using different needles at very specific angles to improve quality, and his wife said they would '*grease*' discs to soften them before use. *Radiofront* magazine recommended wrapping discs in a wet towel for two hours and applying the oil used in sewing machines to them as they were cut. Ingenious operators experimented in other ways: at least one of the records in Attila Csanyi's collection was cut '*backwards*' – so that the groove ran from the centre of the disc outwards. Mikhail Farafanov said that Sasha Likhachev, a bootlegger he worked with, made both his gramophone and his lathe run at twice normal speed: as a result, he could record in half the time.

Most of the discs produced in the USSR were single-sided and often bonded onto a circular piece of card to make them easier to play (by contrast, the Hungarian discs were usually recorded on both sides of x-rays made from thicker film). The sound quality of the latter, when they still function, is nearly always excellent, but the cellulose nitrate film can discolour, become sticky or brittle, or even degenerate into brown dust, unless kept in the right conditions. As it decays, the record will become unplayable – although the efflorescence and chemical degeneration can make it look startlingly beautiful.

Under the best conditions, lathe recording of any sort is an art. The Hungarian amateurs had the considerable advantage of following István Makai's written instructions and detailed diagrams, and of course until the war they could also work perfectly openly. The Soviet bootleggers had to learn by copying each other or by word of mouth. They had to operate secretly in rudimentary workshops with home-made equipment, recycled materials and an uncertain audio source – and at the risk of their freedom.

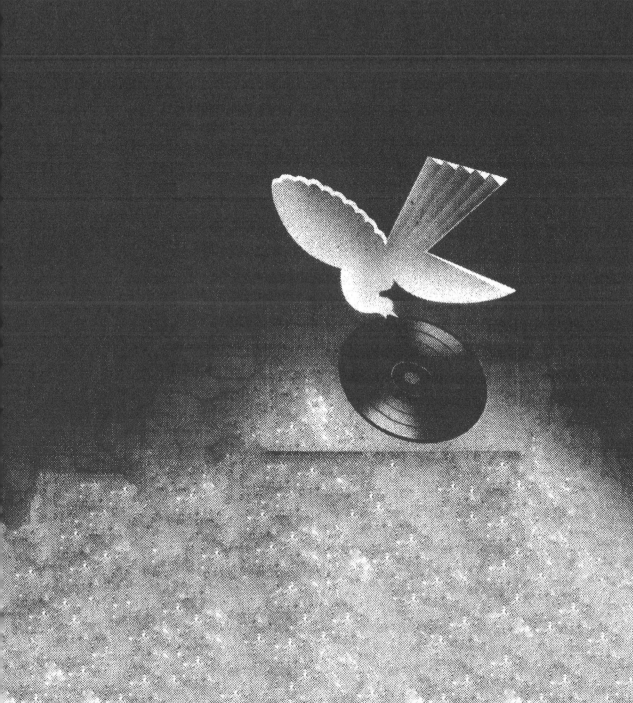

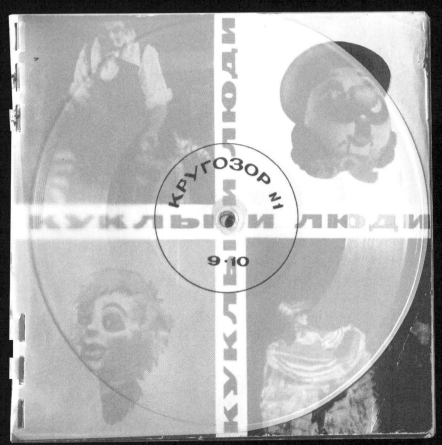

Мы умеем презирать и выносить приговоры.

Мы, люди, одинаково клеймим их. И потому, что мы люди, и нам даны человеческие чувства, мы умеем смеяться и недоумевать, негодовать, и быть непримиримыми.

LETTERS
IN SOUND

Apart from their cultural position as unique audio artefacts, Bone records can be seen as part of two longer recording media histories: that of the '*talking letter*' (the '*sound letter*' or '*audio postcard*') and that of the records known as flexi-discs.

LEFT SOVIET LATHE DIAGRAM

143

FLEXIBLE SOUND

I n the west, recordings made on a variety of flexible materials began to appear in the early 1930s. Some were produced as novelties, with pictures on their surface; others were intended to be '*unbreakable*' (in contrast to fragile shellac gramophone records). Later they were ingeniously combined with paper, to make greetings cards and advertisements. By the late 1950s, the latter had become a commonplace offering in magazines or for a range of giveaways. In the 1960s, flexi-discs were adopted by bands and record labels as a cheap promotional device (the most famous example is probably the annual audio Christmas card The Beatles made for their fan club). In the 1970s, the use of the flexi reached its artistic apogee in the punk and New Wave era, when its cheapness made it the perfect vehicle for the DIY, independent attitude of those working outside the mainstream – and when the dubious sound quality was not so much an issue. The Soviet x-ray records share something with these punk flexis – not musically, but in their form and DIY spirit.

Flexible records existed in the Soviet Union from the 1930s too. Various experimental labels working under supervision and specialising in particular genres – such as film soundtracks or theatre music – produced music on a range of materials, including some beautiful translucent plastics. Later, flexis were used as a cheap alternative to vinyl for official pop releases, and various novelty tourist items, such as playable postcards not unlike those produced in the west by such companies as Supraphon or Colourvox.

The most notable official use of the Soviet flexi began in 1964, around the time tape recorders were becoming available. Impressed by an encounter with the French magazine *Sonorama* during a plane journey from Paris, Nikita Khrushchev, the reforming leader of the Communist Party, prompted the creation of '*Krugozor*',

ABOVE **SONORINE POSTCARD RECORDING DEVICE, 1905**

Beyond the threshold of every home, there is an entire planet, and beyond every window the Universe begins. We want life to enter your home in all the diversity of its colours and sounds, so that the amazing people making it happen get to know you. They will become your partners, and you can look into their faces.

The hero will tell you about his adventures, the composer and the singer will introduce you to new music, the poet will read you new poems, and the band will invite you to dance!

Krugozor No.1 1964

a similar monthly cultural publication to be aimed at young Soviets, combining music, features, and journalistic reports – but with added propaganda. Leafed in among the pages were six flexi-discs of audio. Like *Sonorama*, *Krugozor* was a masterpiece of design – with a square format and a spindle hole in the centre, so that the entire thing could be played on a turntable like a record. It ran until the 1990s, and was very popular. The Russian rock musician Ilya Lagutenko told me that he – like many other young Russians – eagerly awaited each edition, skipping the earlier discs (with their reports of industrial production, official speeches and stories of life around the USSR) to go straight to numbers five and six, which contained pop music. As the 1960s turned into the 1970s, the content of these final discs expanded to include jazz and some western bands – at first the most anodyne, like Boney M, but eventually, even those once forbidden and exiled to x-ray, such as The Beatles.

THE TALKING LETTER

From early in the 20th century, many ingenious uses were found for self-made, lathe-cut and wax-recording technology. In the 1930s, these were combined with flexis, to make records that could be posted with a dedicated envelope, as 'audio postcards' to be sent from tourist destinations with personal greetings to the folks at home. The US and UK military had their own dedicated versions, such as the British 'Voice of the Forces' records which contained poignant messages from soldiers at the front. In Argentina, there was an official 'FonoPostale' service at post offices, with its own special stamps and envelopes; a similar service operated in the Netherlands.

In the USSR, similar items were to play a role in the history of the Bone bootleg, as a parallel way of illicitly distributing music. The mainstream Soviet press had begun to carry articles about the evolution of such '*Talking Letter*' technology as far back as December 1936, when *Pravda* told how comrades M. Ye. Shor and N. P. Gavrilov, engineers at the studio of the Gramophone-Record Trust, had designed a special machine that allowed the recording and playback of a finished disc on the spot.

> *Thus, families of polar explorers can send a record-letter to their relatives working in the arctic, young singers can listen to themselves and correct mistakes in their singing, parents can record the voices of their children for posterity.*

The article goes on to reveal that '*the talking letters are made from an unbreakable flexible material – the waste of x-ray film*'.

As with many Soviet musical innovations, the talking-letter machine had originated in Leningrad. It was developed by three engineers, comrades Yasnogorskiy, Gurchin and Zhukov, and was first demonstrated in July 1937

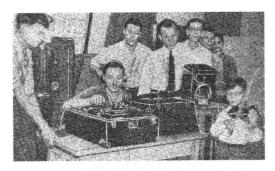

ABOVE **LATHE RECORDING AT THE ROSTOV RADIO CLUB**

An interesting novelty has appeared in Gorky Park. It is called a 'Talking Letter'. In a specially adapted studio, a visitor reads a letter in front of a microphone. A unit installed in the next room, connected to the microphone by a cable, records the spoken words onto a thin celluloid record. In a minute the record is ready to play on a gramophone and the author of the letter hears his or her own spoken words. Then this 'Talking Letter' is glued onto a postcard. Having received it, the addressee reads the 'letter' with the help of their gramophone. In front of the microphone you can make a brief speech, recite poetry, sing a song or play a musical instrument. About 300 recordings were made during three days. The sound-recording unit was built by the young Soviet radio engineer G. S. Gurchin.

MOSCOW EVENING NEWSPAPER 6 July 1938

at the 'House of the Red Army'. The focus seemed to be the arctic; relatives of polar explorers were able to record their '*heartfelt greetings and wishes onto small celluloid postcards*', to be delivered by airplanes and icebreakers to family members wintering in such faraway locations as Nova Zembla, Anadyr, Vankarem, Igarka, Cape Chelyuskin and Dikson Island.

Later that year, the inventors travelled to Moscow to demonstrate their device by recording the voices of the refugee children of besieged Spanish communists then fighting Franco in the civil war. *The Moscow Evening* newspaper reported in particular that a talking letter to the Spanish Republican fighter Isidora Dolores Ibárruri was recorded by her daughter Amaya, and sent to her mother in Spain. (Ibárruri, known as 'the Passionflower', was famous for her slogan ¡*No Pasarán! '*They Shall Not Pass!')

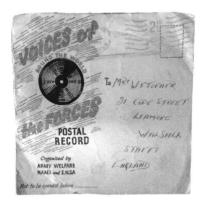

ABOVE **BRITISH VOICE OF THE FORCES RECORD**

By 1941 *Radiofront* reported that a stream of talking letters were being sent from sound-recording machines in Gorky Park, the Arts theatre and at the All-Union Agricultural Exhibition, where the machine was housed in a pavilion that '*from a distance looks like a jewellery box, with fine carving and an outer wall that appears as though it is constructed of rotating gramophone records*'. The pavilion had thousands of visitors, including collective farmers, Red Army soldiers and students, with about 50 recordings being made each day. The article describes a group of farmers attentively listening to a letter recorded by a tractor driver, comrade Leonidov, to be sent to his fellows back home in the Kursk region: '*For two days now I have been visiting the All-Union Agricultural Exhibition. There are no words to express how rich and abundant our country is. My regards to all the collective farmers, my mother Marya Ivanovna, my wife Agrafena Nikolaevna and my nephew Lyona!*'

The wider take up of such technology, although recommended by the authorities, was interrupted by the war, when most industry was re-orientated towards military efforts. But soon afterwards, 'Talking Letter' machines started to reappear for the Soviet public to use. By the 1960s there were many in public shops and studios. Artemyi Troitsky remembers that there was one called 'The Studio of Electronic Letters' when he was a child, run by the GUM department store near the Kremlin at the end

ABOVE **AMERICAN VOICE OF VICTORY RECORD**

of Gorky Street. There were similar outfits in Kiev, Tula, Minsk, Sochi and other tourist resorts, often located in cinemas or in the little indoor markets typical of Soviet towns.

Not unlike those made in the west, the talking-letter machines used blank celluloid discs, produced by the official state sound recording ateliers. The transparent celluloid recording surface was fixed to a photographic base and the records made were often surprisingly beautiful. Customers could choose from a selection of images: flowers, happy children, picturesque tourist scenes, military parades, famous people including Stalin, illustrated messages (Happy Birthday! Congratulations!) or commemorations of such significant anniversaries as the October Revolution and Victory Day – sometimes with their own superimposed photo. Songs could be selected from a menu of official Soviet pop and folk tunes and were recorded on the spot, with a purpose-built lathe. Customers could record their own short introductory message: 'Yura, I congratulate you on Soviet Army Day and wish you great happiness and true love!' says one, before the song begins. When finished, the discs were inserted into envelopes printed with details of the studio and instructions on how to play them correctly.

That was the official situation, but of course, the blank discs were increasingly used to discreetly record underground songs and forbidden tunes to be sold out of hours or under the counter with a nod and a wink. As a

result, the studios became increasingly popular with young people – though it was not necessarily easy for music fans to get exactly what they wanted. As with x-ray records, the picture on the disc was rarely representative of the content. There are some surprising combinations of image and sound: jet fighters with The Yellow Popcorn Band; a photo of The Fab Four on a tune of a Soviet massed choir; a picture of the Barry Sisters with a Georgian folk song. And again, audio quality could be very poor. The staff had to be careful, since these businesses were licensed and subject to supervision. One customer reported hearing an assistant telling a young fan '*No, I will not record The Beatles onto a view of Moscow!*' Perhaps they were being unco-operative out of patriotism – or perhaps from a suspicion they were being monitored.

The oral historian Alan Dein – who has collected sound letters recorded in the UK – has described how it is impossible to overemphasise the extraordinary effect this technology had, in the west as much as in the USSR. Previously, ordinary people had never heard how their own voice sounded to others – it was almost like magic – and these records provided them with a wonderfully personal way to connect with loved ones far away in space or time.

But most significantly in terms of Bone Music history, an announcement was made in 1946 in Leningrad that the co-operative Inkooprabis was reopening its photographic studios – and that at 75 Nevsky Prospekt, a special machine had been installed. It allowed anyone to '*have their words, singing, playing of a musical instrument or child's voice to be recorded on a GRAMOPHONE RECORD. One record costs 14 rubles. The record will be ready immediately.*'

The operator was the pioneer Leningrad bootlegger Stanislaw Philon, whose 'special machine' would inspire perhaps the greatest bootlegger of them all: Ruslan Bogoslovsky.

ABOVE **THE BEATLES SOVIET FLEXI DISC**

From the mid-1960s, songs by The Beatles were a popular illicit choice on sound letters. Andrey Lukanin, who has researched the impact of the band in the Soviet Union, writes that customers often hand-wrote the names of their songs on the sound letters. For those who spoke no English, the translation to Russian of titles given by studio assistants could produce some peculiar results:

'CAN'T BUY ME LOVE'
(pronounced as 'Kin Bah-be Lom') translated as 'Throw a Crowbar to a Woman'

'COME TOGETHER'
(pronounced as 'Kon To-ge-za') translated as 'A Horse Called Togeza'

'YELLOW SUBMARINE'
(pronounced as 'Se-lah Pah-mah-reen') translated as 'I Have Eaten Pomorin' (Pomorin was the Bulgarian toothpaste popular in the USSR)

'LOVE ME DO'
(pronounced as 'Lob v me-doo') translated as 'A Forehead Stained with Honey'

ABOVE LENINGRAD ART STUDIO ADVERTISEMENT 1946

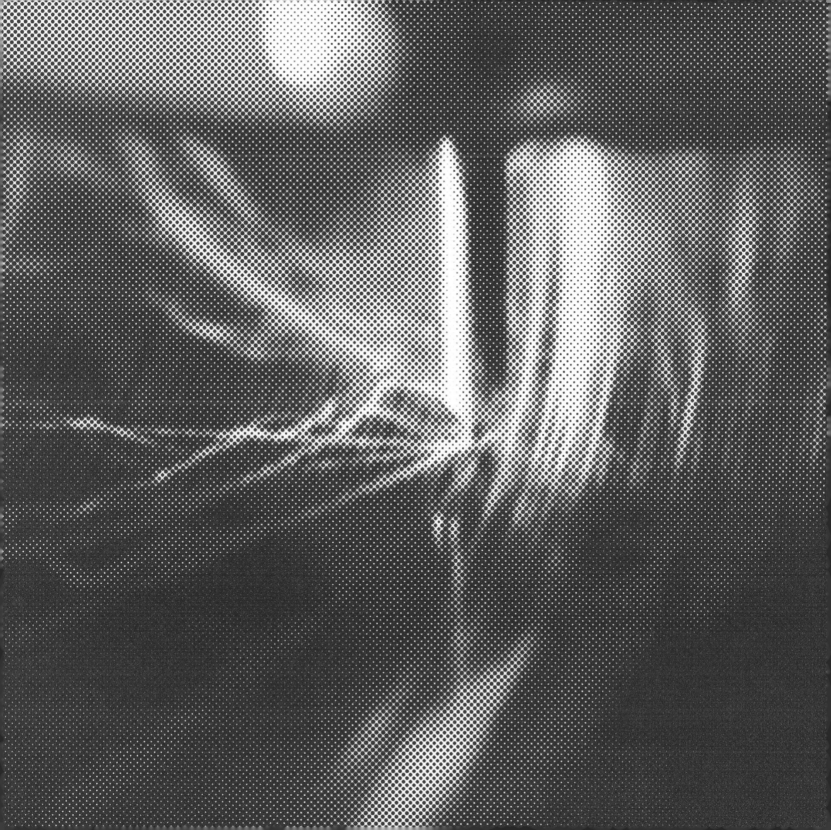

To make an x-ray record, you need three things: an audio source, a recording machine and x-ray film – plus, a certain amount of technique

И пусть на наши тротуары лождатся только узорные тени листвы, не закрывающие от нас красоту мира.

Мы не хотим, чтобы грязные тени пятнали наши тротуары. Мы все, идущие по нашей улице, живущие в нашем городе, безразлично носим ли мы на рукаве повязки дружинника, или нет.

HOW TO CUT
AN X-RAY RECORD

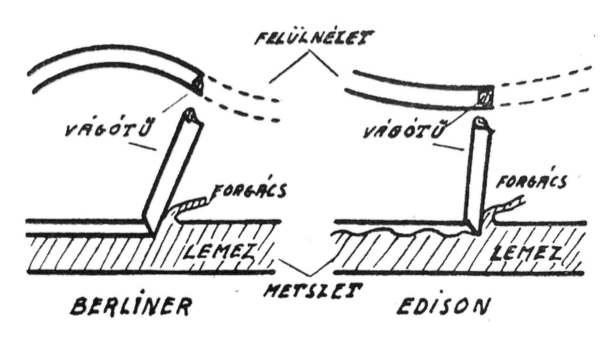

BONE SURGERY

THE X-RAY:

Radiography is now mostly a digital process, heavily regulated by data-protection laws. So physical x-rays are much harder to find than they once were. In addition, modern film is more difficult to cut with, since the material is now much tougher than in the old days. In general, the older the film the better. (The X-Ray Audio project has cut many x-ray records, both from existing audio and from live performances using 1990s x-rays – often with good results.)

Once x-ray film has been obtained, the disc needs to be prepared. Mikhail Farafanov explains:

The x-rays had a square shape. I had a tool, a pair of compasses at the end of which was a sharpened knife. That's what I used to make a circle. The x-ray film was usually 24 by 30 cm. That's enough to cut out a good record. We'd place a puncher into the mark that was left from the compasses, and make a round six millimetre hole [for the spindle].

THE SOURCE:

For the Soviet bootlegger or Hungarian amateur archivist, the audio to be recorded usually came from a gramophone, a tape machine or the radio – but any input can be used, including a microphone or a mixing desk output if the intention is to record a live performance.

THE MACHINE:

There is no way round this requirement: you will need a recording lathe. With the X-Ray Audio project we use an old MSS, a machine commonly used at the BBC in the 1940s-50s, but there are many alternatives available second-hand.

THE TECHNIQUE:

The technique has not changed much from that used in Budapest, Leningrad or Moscow in the 1930s-60s. When the blank x-ray disc is ready, it is fitted onto the platter of the recording lathe and held in place with a central weight to stop it moving (softening with a heat lamp can help make it easier to cut). The audio source is connected to the lathe via an amplifier. Now comes the critical part. Mikhail:

There was a cutting head that went up and down into which the signal was sent. You started the machine gently and you turned on the sound at the same time. There was an electromagnetic coil that vibrated when the signal came through. I put the cutter down at the beginning of the disc as it spun, and that's when it started to make the groove. It had to be in sync, so that there would be no more than two to three seconds gap at the beginning, and so that the song wouldn't be stopped early. And the weight and the depth had to be special – not too much, not too little.

As the groove is being cut, swarf (or 'chip') is scraped out of the surface of the film and spools out in long, black candy floss-like tendrils. There is a skill to catching this and pulling it away from the head with a brush, so that it doesn't catch in the mechanism or ruin the recording. Mikhail again:

I wrapped it around the centre spindle and then it would wind on automatically – sometimes it span off but this only happened rarely. It would grow longer and coil into such a big bundle. As a rule, this had to be done once or twice. I had so much of this waste material that I could stuff pillows with it. It had to be binned somewhere. It was dangerous to throw it out near the house, because it might attract someone's attention. As a rule, I used to take it and throw it away somewhere far away.

The cutting head is lifted – either when the song has finished, or as it approaches the centre of the disc. A perfectionist

like Farafanov would fade the audio signal out for tracks that were too long to fit into the available space. István Makai too was concerned to sync the audio and the cutting head, to avoid wasted recording time at the beginning of the disc, when making recordings from the radio for Sophie Török. According to his wife:

> *'We always cut at the last possible moment after intervals and announcements, in order to leave more space for the actual music. In those days the announcements were made in three languages, so by recording only the Hungarian, we managed to gain about half a minute.'*

And that's it! Your new x-ray record is ready to play.

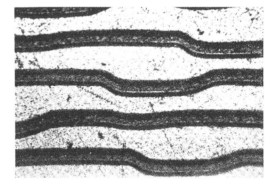

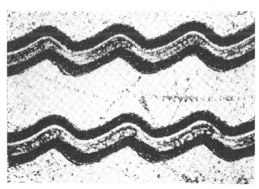

ABOVE **ISTVÁN MAKAI TECHNICAL DRAWING**

THE X-RAY AUDIO PROJECT

THE PROJECT WAS FORMED IN 2013 TO RESEARCH AND TELL THE HISTORY OF THE X-RAY RECORD AND THE SOVIET MUSICAL UNDERGROUND THAT GAVE RISE TO IT.

THE PROJECT HAS EXPANDED TO INCLUDE AN ONLINE ARCHIVE, SEVERAL PUBLICATIONS, AN AWARD WINNING FILM, A BBC DOCUMENTARY, A MAJOR TOURING EXHIBITION AND A LIVE EVENT PROGRAM. SEE *WWW.X-RAYAUDIO.COM*

STEPHEN COATES IS A MUSICIAN, WRITER AND BROADCASTER. PAUL HEARTFIELD IS A PORTRAIT AND MUSIC PHOTOGRAPHER.

ACKNOWLEDGEMENTS

THIS BOOK AND THE X-RAY AUDIO PROJECT WOULD NOT EXIST WITHOUT THE HELP, KNOWLEDGE AND WORK OF MANY PEOPLE, PARTICULARLY ARTEMYI TROITSKY ON THE SUBJECT OF THE SOVIET UNDERGROUND AND MAXIM KRAVCHINSKY ON THE SUBJECT OF FORBIDDEN RUSSIAN SONG. THEIR WRITINGS AND UNDERSTANDING OF THE ERA PROVIDED A BASIS FOR MUCH OF THE RESEARCH. SERGEY KORSAKOV MADE THAT RESEARCH AND THE PROJECTS THAT FOLLOWED ACTUALLY POSSIBLE. THANK YOU SERGEY.

BETWEEN 2013-19, WE UNDERTOOK MANY INTERVIEWS. HUGE APPRECIATION MUST GO TO THOSE WHO GENEROUSLY SHARED THEIR STORIES AND INSIGHTS: ARTEMYI AND MAXIM, RUDY FUCHS, NICK MARKOVITCH, MIKHAIL FARAFANOV, ALEKSEI KOZLOV, NINA TAIGIN, SERGEY BOGOSLOVSKY, KOLYA VASIN (RIP), ATTILA CSÀNYI (RIP), ILYA LAGUTENKO, ELEONARA FILMINOVA, GREGORY KACHACHURIN, ALEX KAN, ANDREI LUKANIN AND VICTOR DUBILER.

THANK YOU TOO TO OUR TRANSLATORS AND HELPERS IN RUSSIA: DARIA STENINA, OLGA GORVAL, ALINA KOSTINA, ANDREY BESSANOV, EKATERINA LAZAVERA, ASYA SHISKOVA, ALEX BUDOVSKY, NIKOLAI RECHETNIAK, VIKTORIA KORSAKOVA, LAYSAN GILMANOVA AND SERGEY CHERNOV.

IN BUDAPEST: THE FAMILY OF ATTILA CSÀNYI, ZSOPHIA LOSCONI, KRISTINA LOSCONI, BALASZ FERENC, FERENC FÖLDESI, JÁNOS FÜGEDI, TIBOR KOSZTOLÁNCZY, LÁSZLÓ VIKÁRIUS, HAJDÚ JÓZSEF, SIMON GÁBOR GÉZA, BARBARA NEMESKÉRI, ROBERT MALOSCHIK, SIMON-REITZI BARBARA AND VERONIKA HARCSA. WE ARE VERY GRATEFUL TO JÓZSEF HAJDÚ, RUDY FUCHS, ANDREY SMIRNOV, GREGORY KACHACHURIN, VICTOR DUBILER, NIKOLAI RECHETNIAK, NINA TAIGIN AND THE NATIONAL LIBRARY OF BUDAPEST FOR PERMISSION TO USE IMAGES OR PHOTOGRAPH DISCS IN THEIR COLLECTIONS.

AND TO ALL IN THE UK / US WHO HAVE ASSISTED AND ENCOURAGED US, INCLUDING: CECILIA MARTIN, CLEM CECIL, PUSHKIN HOUSE, ALEX KOLKOWSKI, NORMAN FIELD, MICHAEL DIXON, GREGORY WINTER, ROGER BURTON AND THE HORSE HOSPITAL, OLYA BORISSOVA, SUKHDEV SANDHU, MARK PILKINGTON, MARK SINKER, MARC ALMOND, BARRY ADAMSON, NELLY BEN HAYOUN, SOHO RADIO AND MONICA WHITLOCK.

THANKS ALSO TO YURIY BERNIKOV AND THE CONTRIBUTORS TO RUSSIAN RECORDS, ESPECIALLY SERGEY STAVITSKY, YURIY GLADKIY, ZONOFON AND YURIY PATEFED, AND TO IGOR BELYI, GARAGE MUSEUM OF CONTEMPORARY ART, NEW HOLLANDIA MUSEUM, ST PETERSBURG, YURY PELYUSHONOK, IGOR MOROZOV, ALAN DEIN, VERA TARIVERDIEVA, MARINA TSURTSUMIA, LESLIE WOODHEAD, THE BRITISH LIBRARY SOUND ARCHIVE, ARTS COUNCIL ENGLAND, ANTIQUE BEAT AND THE TEL AVIV MUSEUM OF ART FOR THEIR SUPPORT.

AND OF COURSE TO NICOLA STEWART AND ALI HEARTFIELD.